STORES & RETAIL SPACES ⁹

From The Institute of Store Planners and the Editors of VM+SD magazine

MEDIA GROUP
INTERNATIONAL
Cincinnati, Ohio

ISBN 10: 0-944094-59-7
ISBN 13: 978-0-944094-59-4

Published by:
ST Books, a division of
ST Media Group International Inc.
407 Gilbert Avenue | Cincinnati, Ohio 45202
P: 513-421-2050 | F: 513-744-6999 | E: books@stmediagroup.com
www.stmediagroup.com/stbooks

Distributed outside the U.S. to the book and art trade by:
Collins Design, an Imprint of HarperCollins Publishers
10 East 53rd Street | New York, NY 10022
www.harperdesigninternational.com

Book design by Kim Pegram, Art Director, *VM+SD*
Competition winners written and edited by the Editors of *VM+SD*
Additional entrant descriptions written by Lauren Mang, Assistant Editor, *VM+SD*
Book edited by Matthew Hall, Managing Editor, *VM+SD*

Printed in China
10 9 8 7 6 5 4 3 2 1

STORES & RETAIL SPACES 9

From The Institute of Store Planners and the Editors of VM+SD magazine

For 37 years, retailers, designers and architects from all over

the world have entered their finest projects in the ISP/*VM+SD*

International Store Design Competition. Members of The Institute of

Store Planners (ISP) gathered together to determine the best in

retail design excellence from a variety of diverse submissions.

Here are those recognized winners from the

ISP/VM+SD International Store Design Competition

judged in November 2006, and published in *VM+SD* in February 2007.

For variety's sake, we have included other competition entrants.

CONTENTS STORES & RETAIL SPACES 9

FIRST
PLACE

M&M's World Orlando
Store of the Year, Specialty Store, Sales Area Over 10,000 square feet

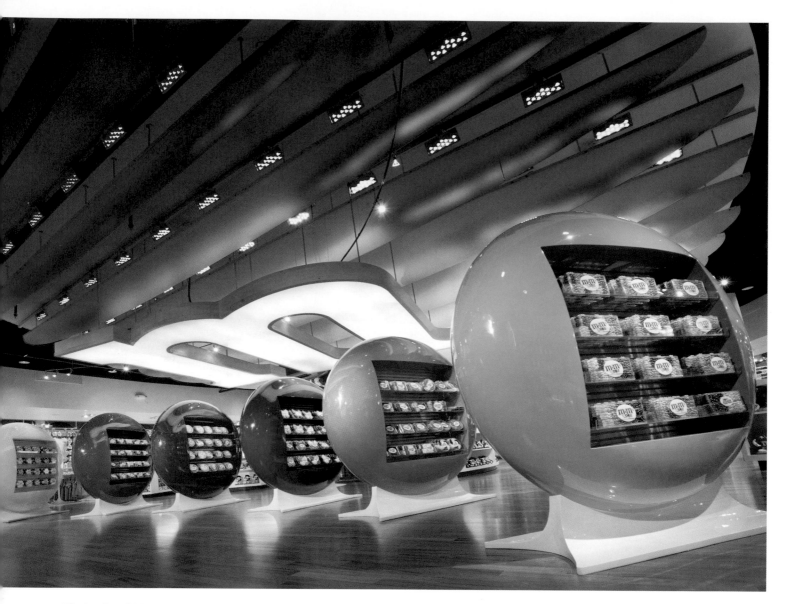

The iconic red, blue, green and yellow candies are the stars of the show in the M&M's World Orlando store. Each chocolate character has been imbued with a distinct personality and incorporated into the space in a variety of forms.

"We infused the store with a layer of brand storytelling techniques that draw visitors into the lives of the candy characters — we even designed a cool 'apartment' that they live in," says Brian Shafley, president and creative director at Chute Gerdeman, the design firm hired by M&M's parent Mars Inc. (McLean, Va.) to help create the space.

M&M's clearly liked Chute Gerdeman's design recipe: It hired the firm to create the M&M's World New York in Times Square, which opened in December, 2006. While that space shares many design features with the Orlando store, it's also home to several specific-to-New-York touches, such as the giant green M&M portraying the Statue of Liberty.

Design Chute Gerdeman, Columbus, Ohio – Dennis Gerdeman, principal; Brian Shafley, president and creative director; Wendy Johnson, executive vp, account management; Bess Anderson, director, visual strategies; Steve Pottschmidt, director, design development; Steve Boreman, senior designer; Jon Knodell, designer *Architect* CG Architecture, Columbus, Ohio – Dennis Gerdeman, principal; Scot Draughn, AE leader; Tom LaPens, AE designer *General Contractor* ICC General Contractors, Geneva, Fla. *Outside Design Consultants* Dixon Entertainment Arts, Henderson, Nev. (creative management); Premier Management Alliance, Tustin, Calif. (construction management); Illuminating Concepts, Farmington Hills, Mich. (lighting); Lewis Engineering- Columbus, Ohio (structural engineering); M-Retail Engineering, Westerville, Ohio (mechanical and electrical engineering) *Ceiling Systems* USG Ceilings, Chicago *Flooring* Alpine Terrazzo Inc., Maitland, Fla.; Armstrong Flooring, Lancaster, Pa.; Listone Giordano, South Eaton, Mass. *Floor and Wall Ceramic Tile* DalTile, Dallas; United States Ceramic Tile, North Canton, Ohio *Fixtures* B&N Industries, Burlingame, Calif.; Seven Continents, Toronto *Furniture* Continental Office Furniture, Columbus, Ohio *Large Character Elements* Outform, Manila, Philippines *Lighting Effects* Illuminating Concepts, Farmington Hills, Mich. *Metals, Glass and Special Finishes* Advanced Technology, Greensboro, N.C.; American Renolit Corp., Whippany, N.Y.; Móz Designs, Oakland, Calif.; Skyline Design, Chicago *Millwork* Midwest Woodworking & Fixture Corp., North Ridgeville, Ohio; National Mallfront and Design, Peoria, Ariz.; Universal Custom Display, Elk Grove, Calif. *Paint Finishes* Scuffmaster Architectural Finishes, Minneapolis; Sherwin Williams Paint, Cleveland *Plastic Laminates* Wilsonart, Temple, Texas; Formica, Cincinnati; Arborite, Laval, Que.; Pionite, Shelton, Conn. *Signage/Graphics* Sharp Signs, Forsyth, Mo.; B&N Industries, Burlingame, Calif.; National Mallfront and Design, Peoria, Ariz. *Sound Systems/Special Effects* Electrosonic, Burbank, Calif. *Wallcoverings/Signage/Graphics* Meisel Visual Imaging, Dallas *Photography* Mark Steele, Columbus, Ohio

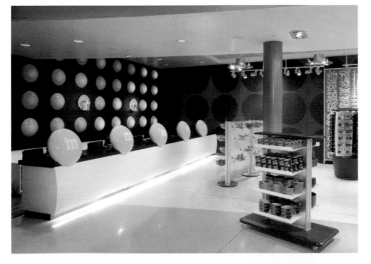

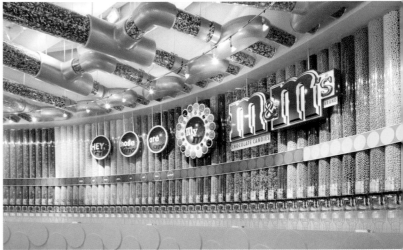

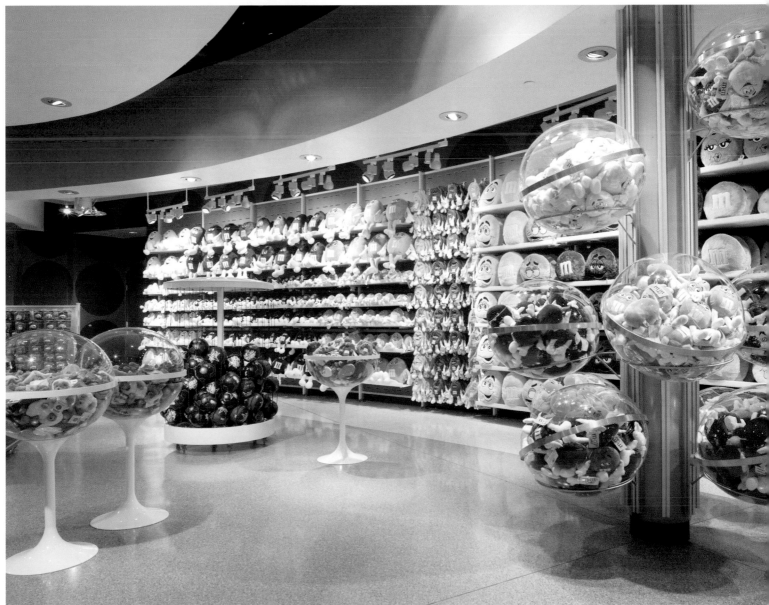

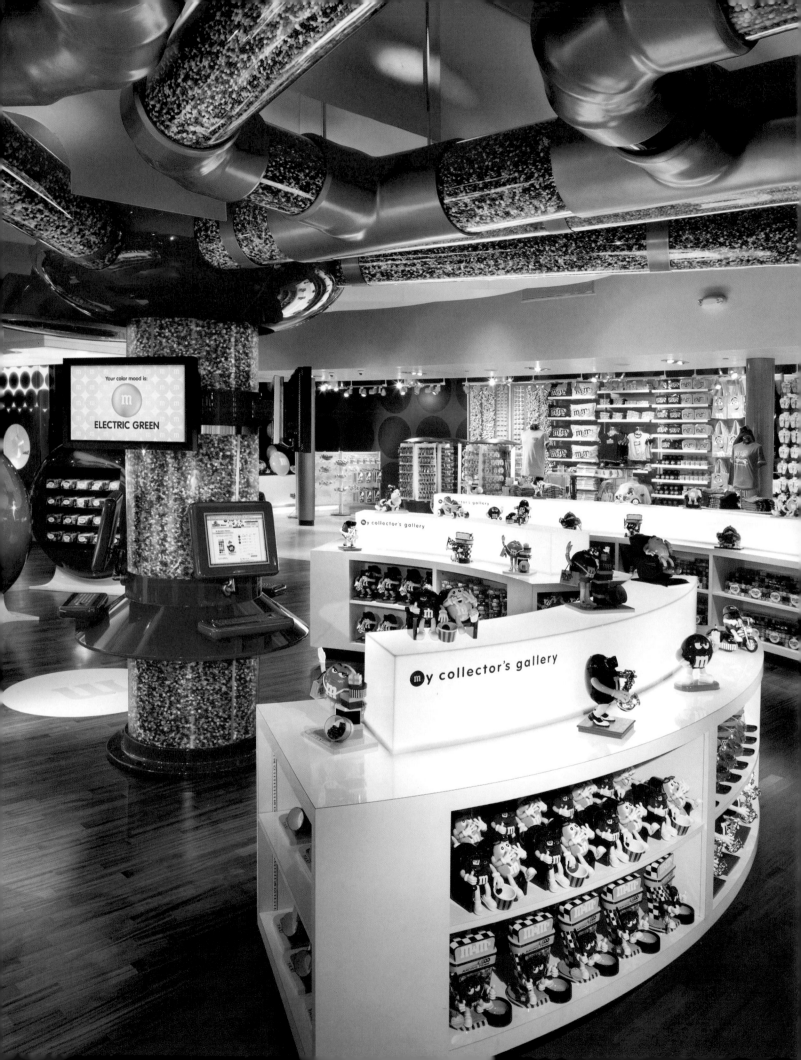

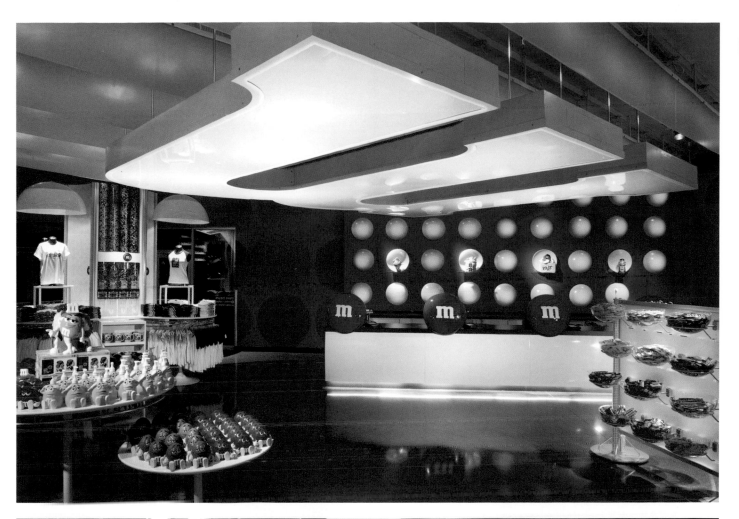

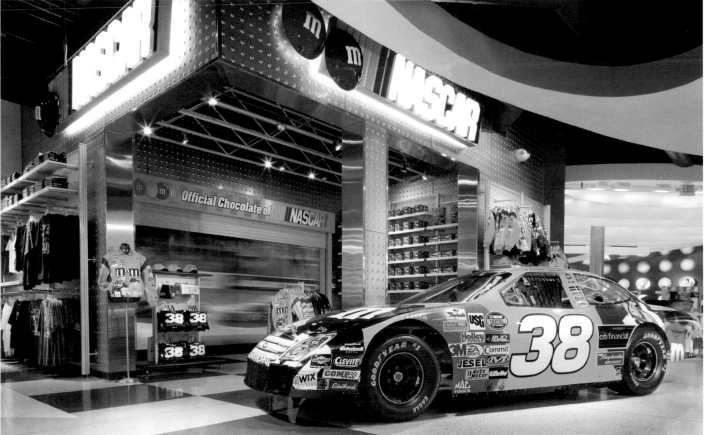

Bloomingdale's, San Francisco
New or Completely Renovated Full-Line Department Store

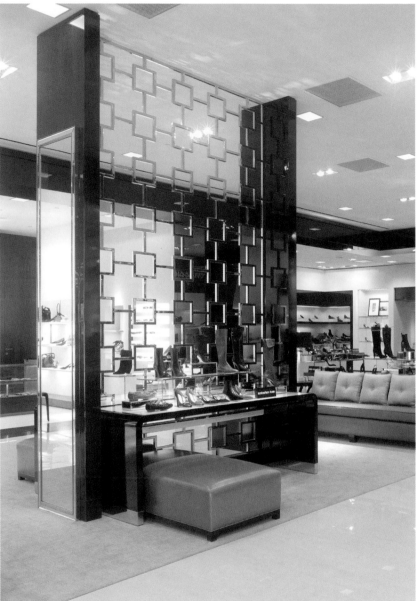

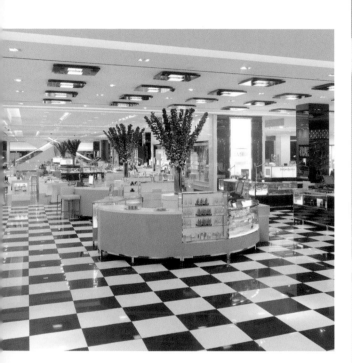

Despite the size of the Bloomingdale's 338,000-square-foot flagship store, the luxury retailer – going through some re-imaging as part of Federated's acquisition-and-consolidation program – says it was "designed to offer a more intimate and specialized shopping experience." Drama and glamour are the bywords.

As in New York, Bloomingdale's is trying to be a "can't miss" for both San Francisco's fashionable city dweller and its significant tourist trade.

The five levels, incorporating 253,000 square feet of selling space, were created as independent designs, each catering to a specific product category. Each floor also has its own display techniques, service components, music and even restroom designs.

Client Bloomingdale's, New York – Jack Hruska, executive vp, creative services; Shan DiNapoli, vp, store design and planning; Diane Koester-Sibert, project director *Design/Architecture* RYA Design Consultancy, Dallas – Tom Herndon, partner-in-charge; Mike Wilkiins, creative director/partner; John Von Mohr Jr., senior designer; Claudene Anderson, project manager; Pam Kennedy, resource design director; Doug Russell, lighting; Steven Espinoza, lighting *Outside Design Consultants* Flack & Kurtz, San Francisco (MEP engineers); Horton Lees Brogden, New York (lighting engineers) *Ceramic Tile* Innovative Marble & Tile Inc., Hauppauge, N.Y. *Ceiling Systems* Armstrong World Industries, Inc., Lancaster, Pa. *Fixtures* Preferred Retail Solutions, Syosset, N.Y.; Moon Design Mfg., Vista, Calif.; Quantum Casework, Weston, Fla.; Mass Merchandising, Islandia, N.Y. *Flooring* Concept Surfaces, Dallas; Atlas Carpets, Los Angeles; Durkan, Dallas; Mohawk Carpets, Kennesaw, Ga. *Furniture* HBF, Hickory, N.C.; Bernhardt, Lenoir, N.C.; Vaughn Benz, Los Angeles; Barrett Hill, New York; David Edwards, Baltimore *Glass* Twin City Creative Mirror, Burnsville, Minn. *Lighting* Indy Lighting, Fishers, Inc.; Visual Lighting Technologies, Lake Forest, Calif.; RSA-Cooper Lighting, Van Nuys, Calif. *Millwork* Imperial Woodworking, Colorado Springs, Colo.; Woodworkers of Denver, Denver; Monarch Industries, Columbus, Ohio; TJ Hale, Menomonee Falls, Wis. *Plastic Laminates* Architectural Systems Inc., New York *Wallcoverings* National Wallcovering, Dallas; Carnegie, Rockville Center, N.Y.; Wolf Gordon, Long Island City, N.Y.; Trikes, Dallas; Maharam, Hauppauge, N.Y.; Art People, New York; Design Tex, New York; Knoll, E. Greenville, Pa. *Photography* Timothy Griffith, San Francisco

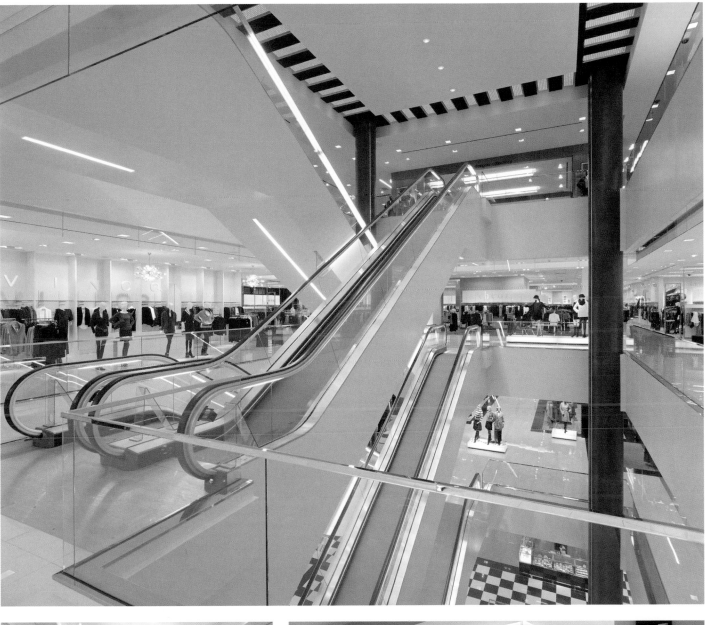

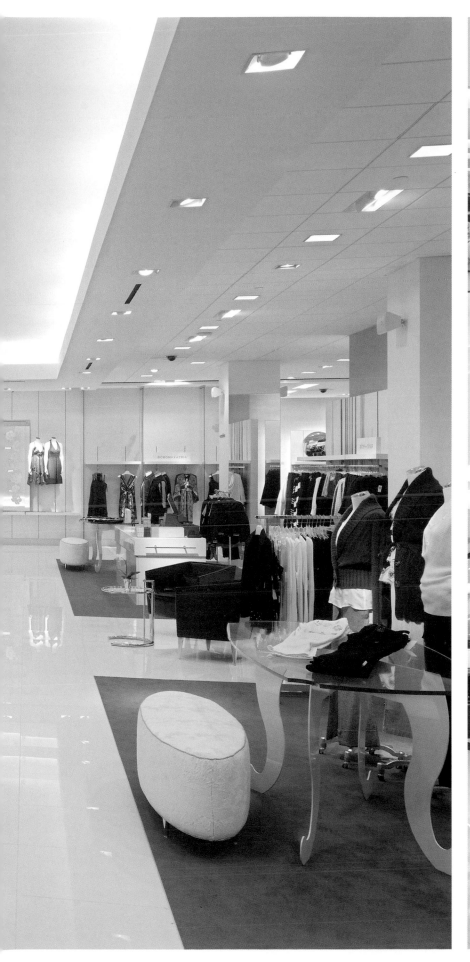

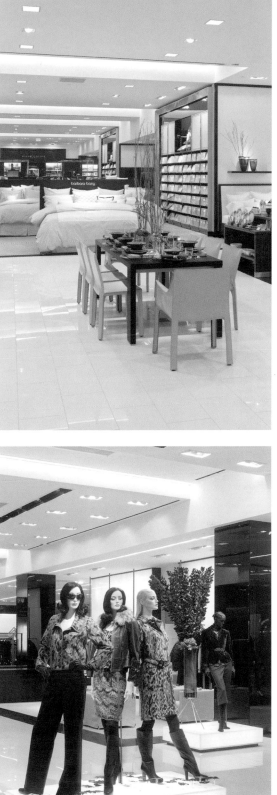

Barneys New York, Boston
New or Completely Renovated Specialty Department Store

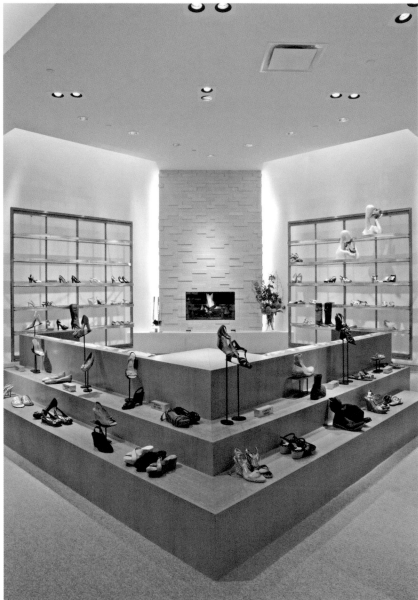

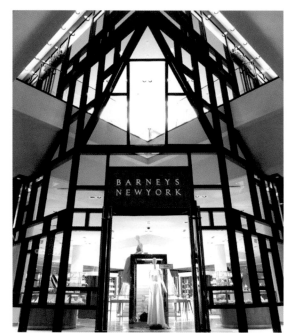

As Barneys New York embarks on a current expansion program, its mantra is "taste, luxury and humor." In Boston's historic Copley Place, the luxury fashion retailer followed that philosophy to transform a former movie complex and food court into a lavish two-story, 45,000-square-foot space.

Taking its cue from the starkness of the pre-existing shell, designers juxtaposed its geometric austerity with an interior full of luxurious materials, textures and rich detailing.

The store's entrance is a two-story façade composed of asymmetrical, black metal framework and glass (inspired by the work of Mondrian). It sets the tone for the store's focus: a two-story, Y-shaped staircase illuminated by a 45-foot skylight. The second floor offers clean, clear views, assisted by glass walls and railings.

Luxury and warmth are added to the surroundings by solid brass and nickel fixtures and rich woodwork of bleached mahogany and cerused oakwood. The ground floor has a marble mosaic flooring with anigre. The second level flooring combines precast concrete tile and parquet.

Client Barneys New York, New York – David New, executive vp, creative services; Philippe Hum, vp, store design and planning; Lisa Ghanni, designer, store design *Design/Architecture* Jeffrey Hutchison & Associates, New York – Jeffrey Hutchison, president; Luis Fernandez, designer; Agnieszka Chromicz, designer; Constance Sasso, designer *Outside Design Consultants* Gensler, New York (project architect); Johnson Schwinghammer, New York (lighting); Clive Samuels, Princeton, N.J. (mechanical/electrical engineer) *General Contractor and Ceiling Systems* Structure Tone Inc., New York *Fixtures* Patella Woodworking, Montreal; Pinehurst Store Fixtures Inc., Toronto; Amuneal Mfg. Corp., Philadelphia; ITIF Brand Logistics, Toronto *Flooring* Architectural Systems Inc., New York *Furniture* Chelsea Workroom, New York; Phoenix Custom Furniture, New York *Lighting* Targetti, Florence, Italy *Signage/Graphics* Triangle Sign & Service, Baltimore *Wallcoverings* Phillip Jeffries Wall Coverings, New York *Photography* Adrian Wilson, New York

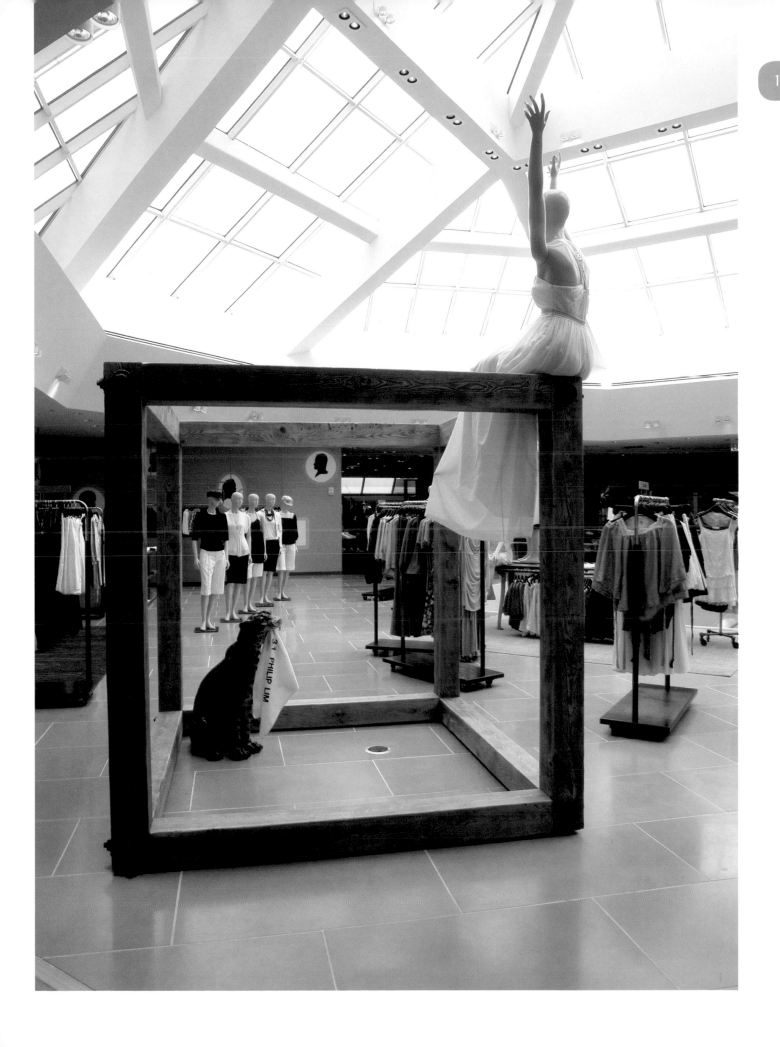

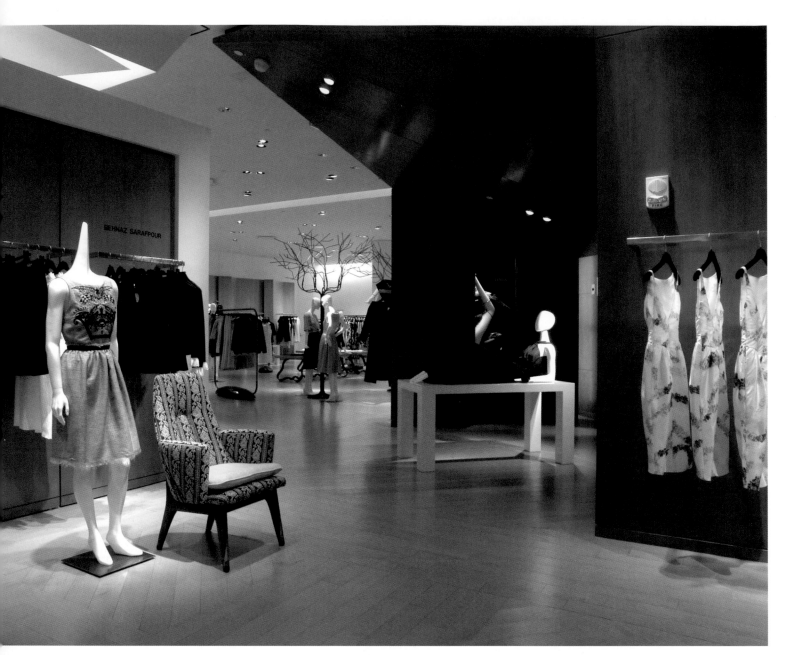

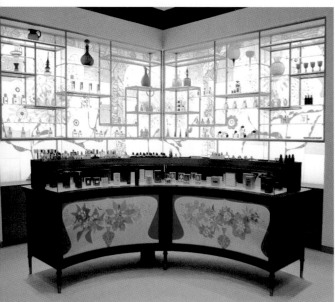

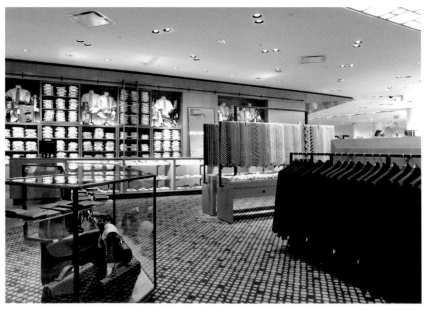

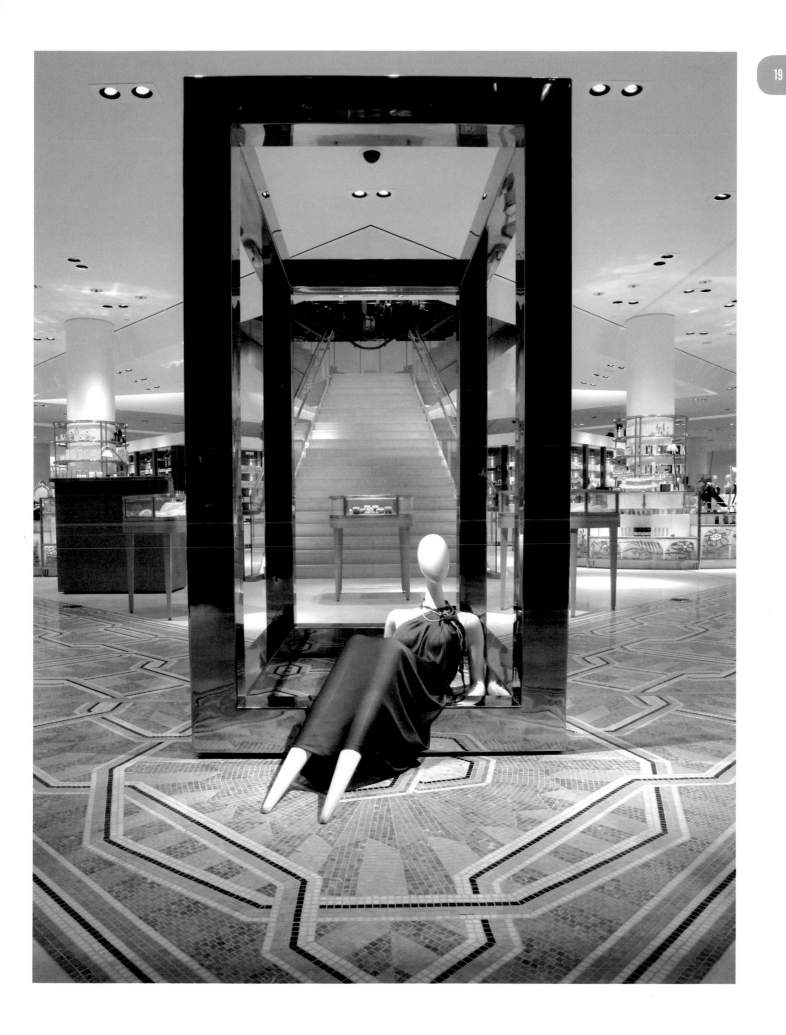

Brown Thomas & Co., Dublin, Ireland
New Shop Within an Existing Full-Line or Specialty Department Store

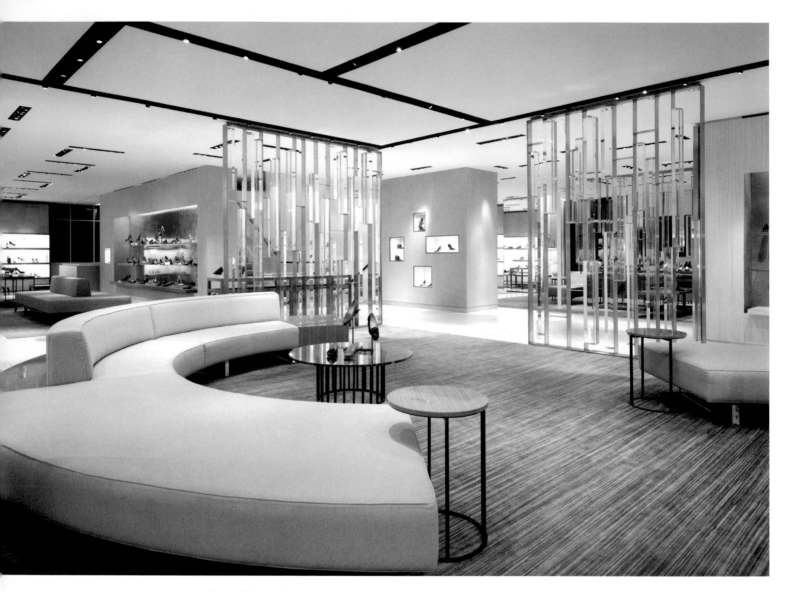

Brown Thomas is a flagship name in Irish fashion retailing. Feeling it needed "a progressive sensibility to international luxury retailing," the company hired Toronto design firm burdifilek to update 27,000 square feet within its historic Grafton Street location in Dublin, Ireland.

"We approached this with the idea that retailing at this level is about creating a fashion theatre for true style voyeurs," said Diego Burdi, the firm's creative partner. "The materials in this space needed to be completely customized with a global sensibility but also reflect the natural textural quality of the Irish landscape."

"The redesign has a distinctly feminine attitude with a handsome and sophisticated architectural language," says Burdi, "but most of all it is a beautiful contemporary interpretation of the retailer's rich cultural history."

Client Brown Thomas & Co., Dublin – Graham McNaught, project manager *Design* burdifilek, Toronto – Diego Burdi, design director; Paul Filek, managing partner; Jeremy Mendonca, senior designer; Young Kim, senior designer; Jason Sweers, senior designer; Marika Nakagawa, designer; Diane Paz, designer; William Lau, designer; Michael Steele, designer; Anna Jurkiewicz, CADD; Edwin Reyes, CADD; Anthony Tey, CADD *Outside Design Consultants* Douglas Wallace, Dublin (consulting architect); Curley Smith, Dublin (mechanical/electrical); Lightbrigade, Toronto (lighting consultant); PKS, Dublin (construction consultants); JGA, London (fire engineering consultants) *General Contractor* John Sisk & Sons, Dublin *Metal Work* Simon Metal, Toronto *Fabrics* Primavera, Toronto; Telio & Cie, Toronto *Millwork* Pancor Industries, Mississauga, Ont. *Flooring* Sullivan Source, Toronto *Furniture* Louis Interiors, Toronto *Lighting* RSA-Cooper, Chatsworth, Calif. *Laminates* Formica, Cincinnati *Acrylics* Mark Littlejohn Acrylics, Toronto *Glass* Accura Glass, Toronto *Special Finish and Wall Art* Moss & Lam, Toronto *Photography* Ben Rahn, A Frame, Toronto

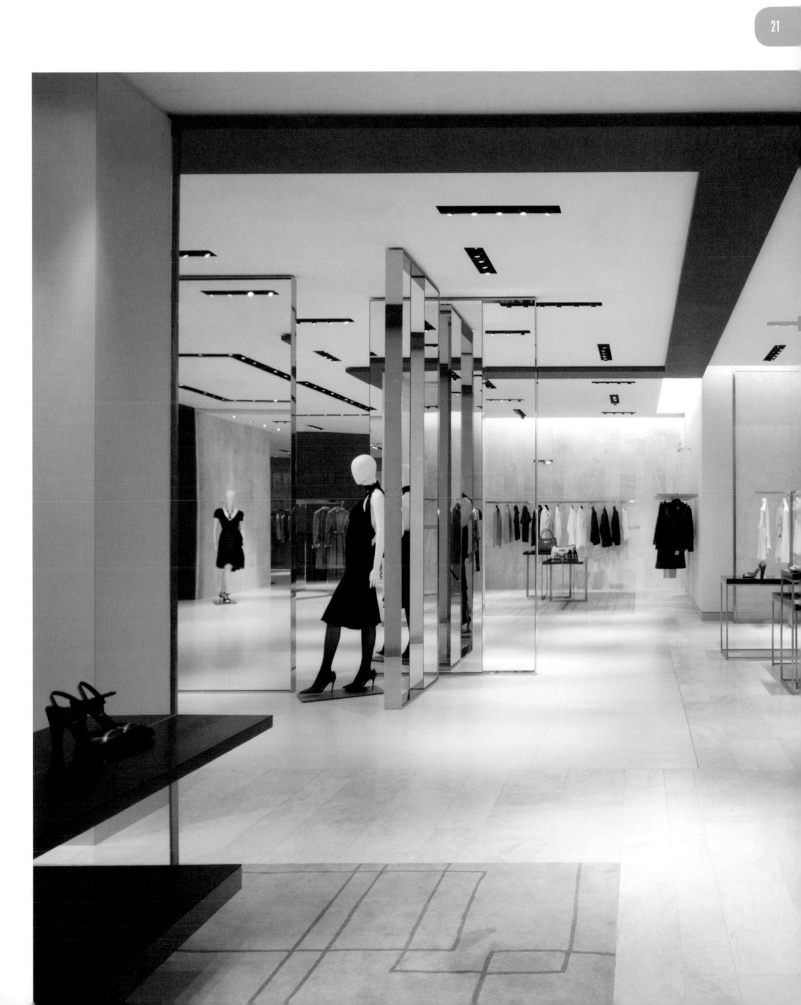

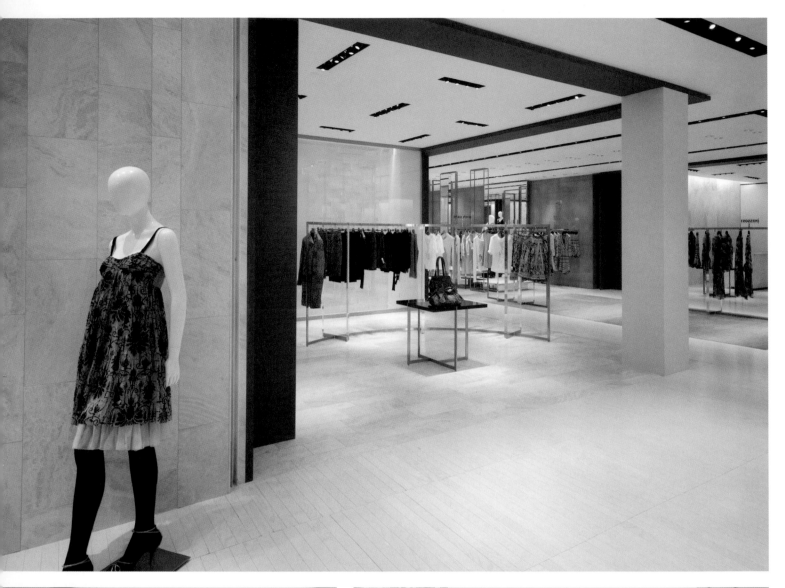

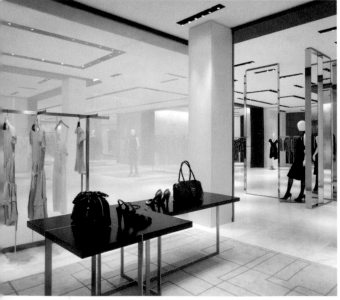

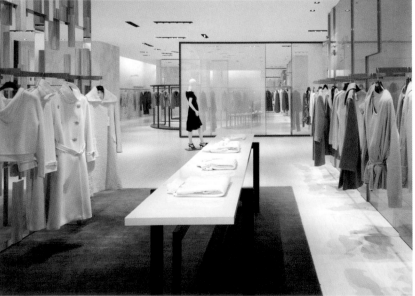

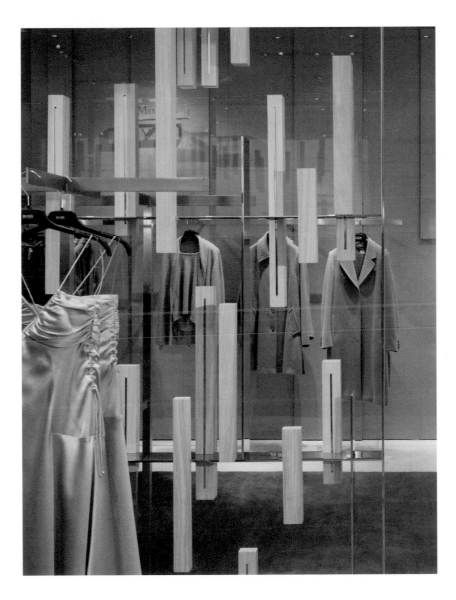

Fornarina, London
Specialty Store, Sales Area 1500 to 3000 square feet

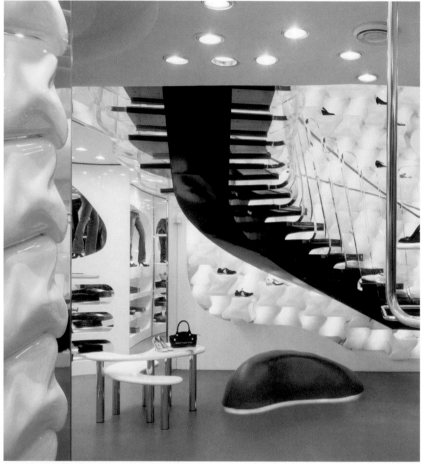

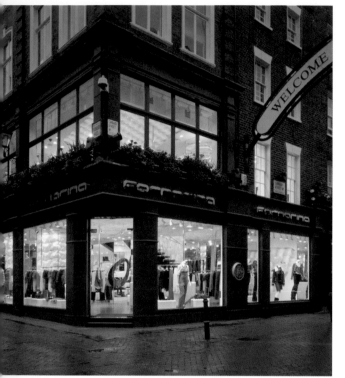

The Fornarina store on London's fabled Carnaby Street takes shoppers on a voyage, using elements like a steel and metacrylic staircase to emphasize the mystery and anticipation of a journey.

The space is icy and blue – almost as if you're traveling through a frozen cavern in the Antarctic. The few rays of color are the warm yellows and pinks from shoes dotted along a molded, liquid-like polycarbonate material that covers the entire space. It flows across the ceiling and down to the dressing rooms, creating protruding ice blocks for seats and product pedestals. Back-lit LEDs give the walls and ceiling a cool glow.

Connecting the two levels is a polished steel staircase surrounded with weaving acrylic slats. The stairs twist and echo the curves of the white cashwrap and furniture, silver hanging lights and asymmetrical mirrors.

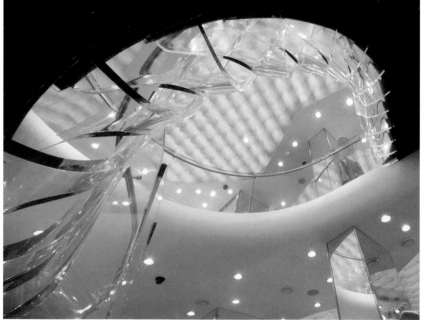

Client Fornarina, London *Design/Architecture* Giorgio Borruso Design, Marina Del Rey, Calif. – Giorgio Borruso, principal designer; Elizabeth Chang, project coordinator *General Contractor* Studio 2000, London *Outside Design Consultant* Buzzoni Srl, Rovigo, Italy (general coordination) *Millwork/Furniture/Fixtures/Flooring* Buzzoni Srl, Rovigo, Italy *Photography* Benny Chan, Los Angeles

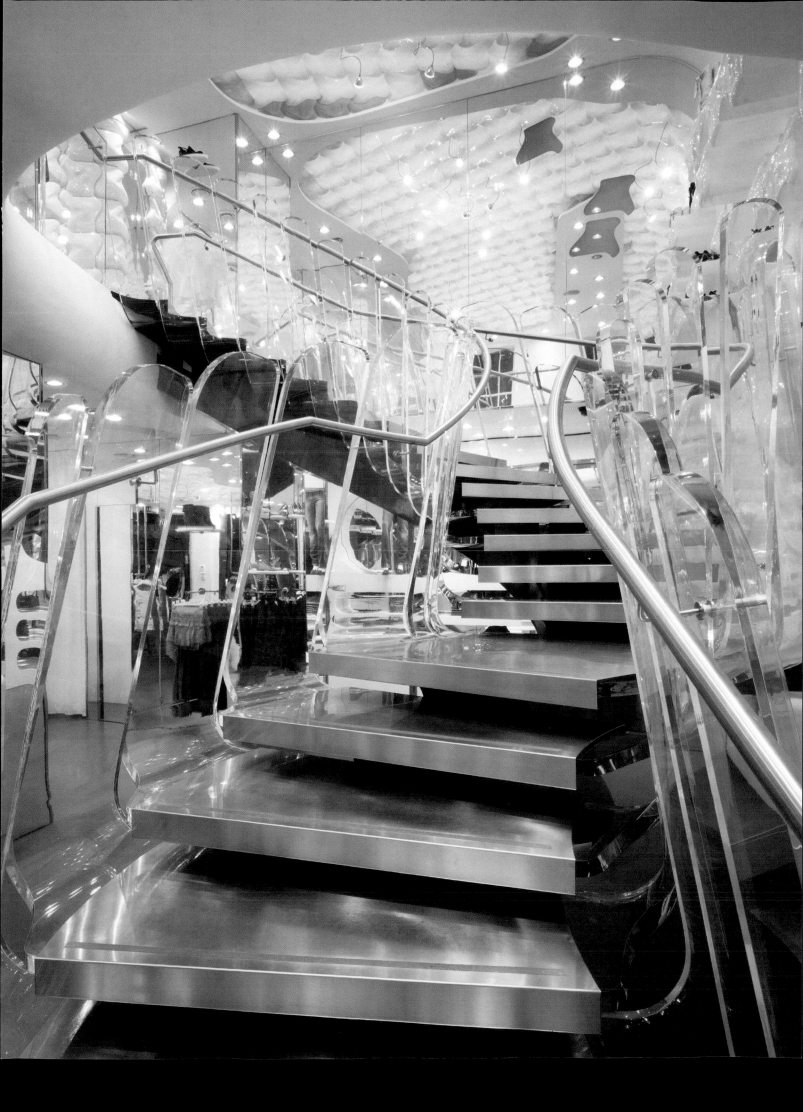

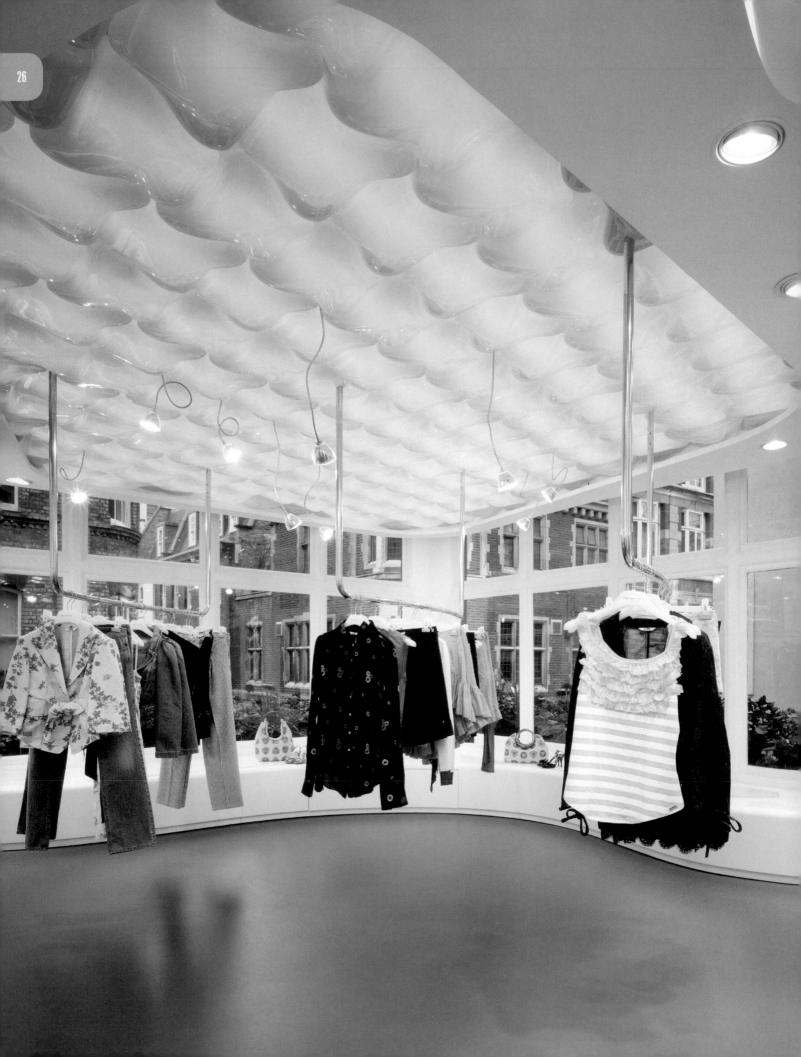

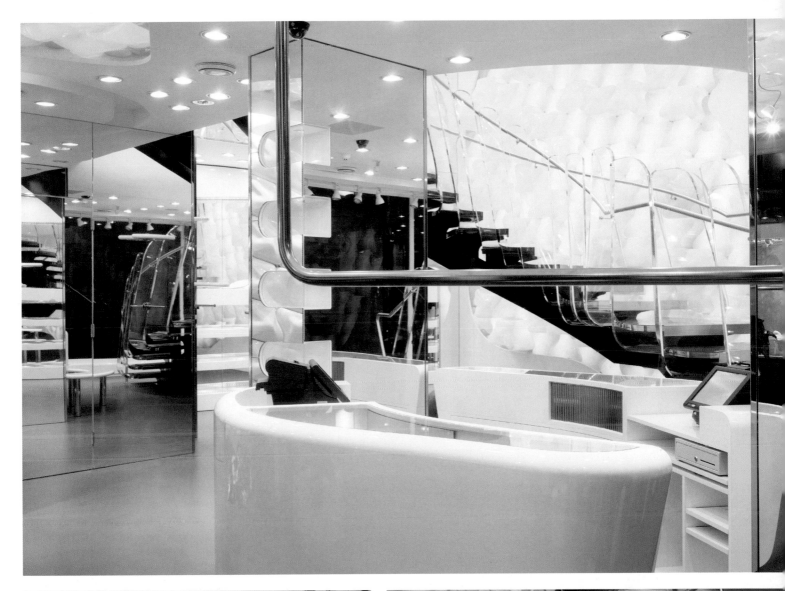

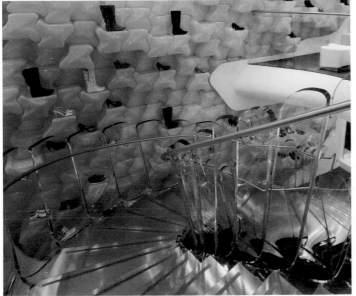

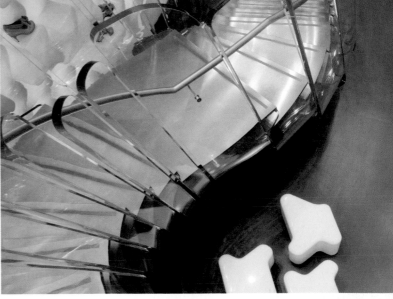

Fornarina, Rio de Janeiro, Brazil
Specialty Store, Sales Area Under 1500 square feet

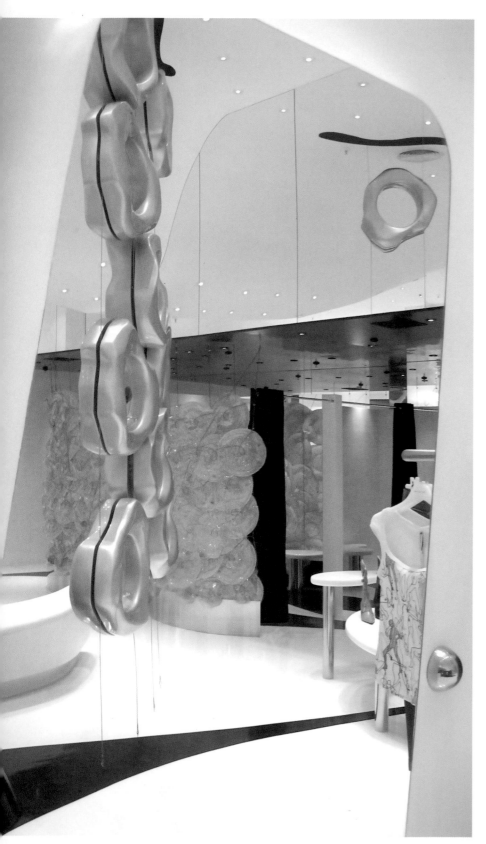

The Fornarina store in Rio de Janeiro's open-air Sao Conrado Fashion Mall is a version of the retailer's evolving design concept, by Giorgio Borruso Design (Marina del Rey, Calif.), with its organic shapes and tactile materials.

The concept for this 1450-square-foot space begins at the storefront, framed with a sleek stainless steel ribbon that morphs into a door handle to open the second of eight panels of the glass façade. A wall of eyes, visible through the façade, is set at exactly the proper angle to capture the attention of the main pedestrian traffic flow.

The Fornarina signature-styled apparel hangs from two freestanding mirrored displays, one in black the other in white. Two cascades of silver-coated fiberglass rings drop from the ceiling, suspended by cables.

A large and inviting white hill in the center of the store, and visible from outside, draws shoppers to use it as a seating area.

Hundreds of translucent, inflated, polyethylene units are loosely connected by cables to form semi-solid polyform structures that become the dressing room walls. Inside, customers' silhouettes are fragmented in a kaleidoscope manner.

Client Fornarina, Civitanova Marche, Italy *Design* Giorgio Borruso Design, Marina del Rey, Calif. – Giorgio Borruso, principal designer; Elizabeth Chang, project coordinator *General Contractor* Sauro + Kerima, Sao Paolo, Brazil *Photography* Courtesy of Giorgio Borruso Design, Marina del Rey, Calif.

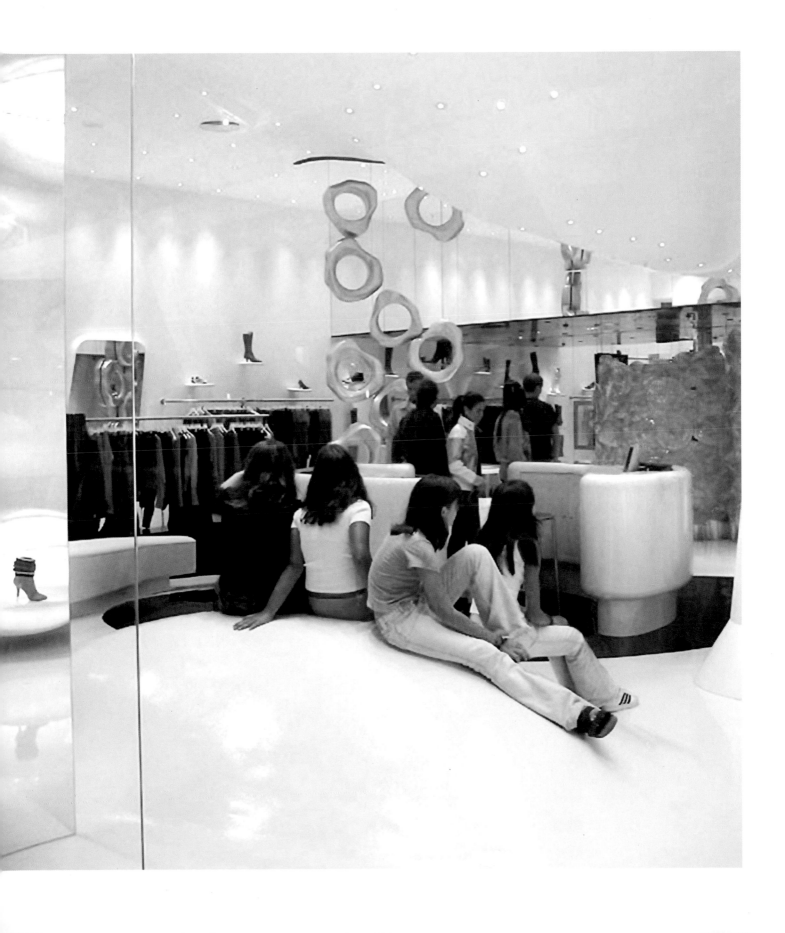

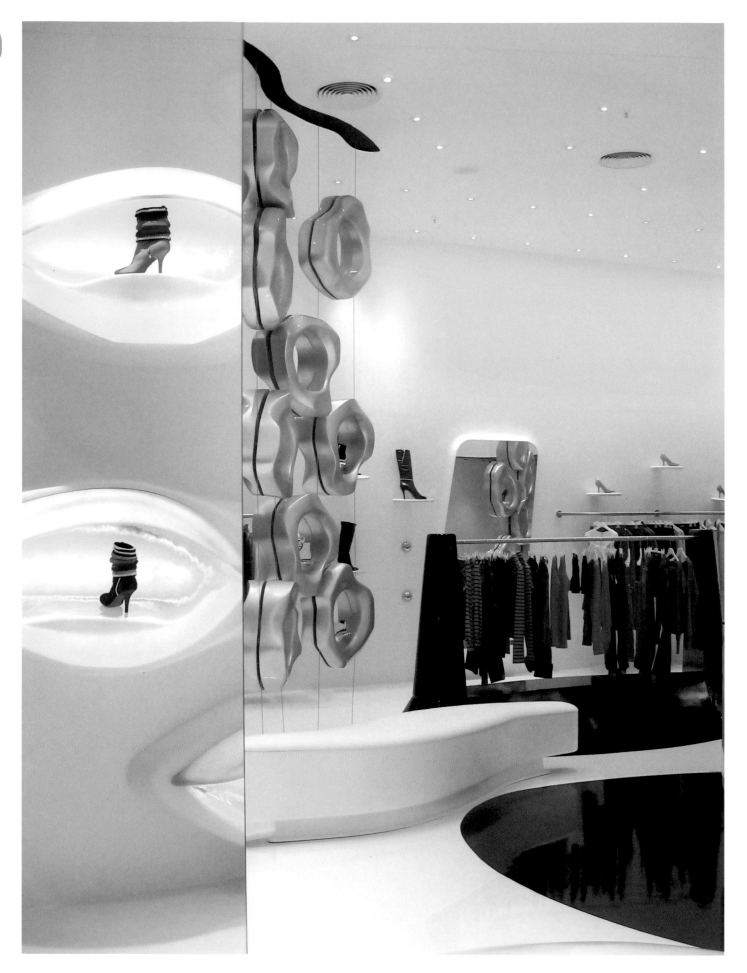

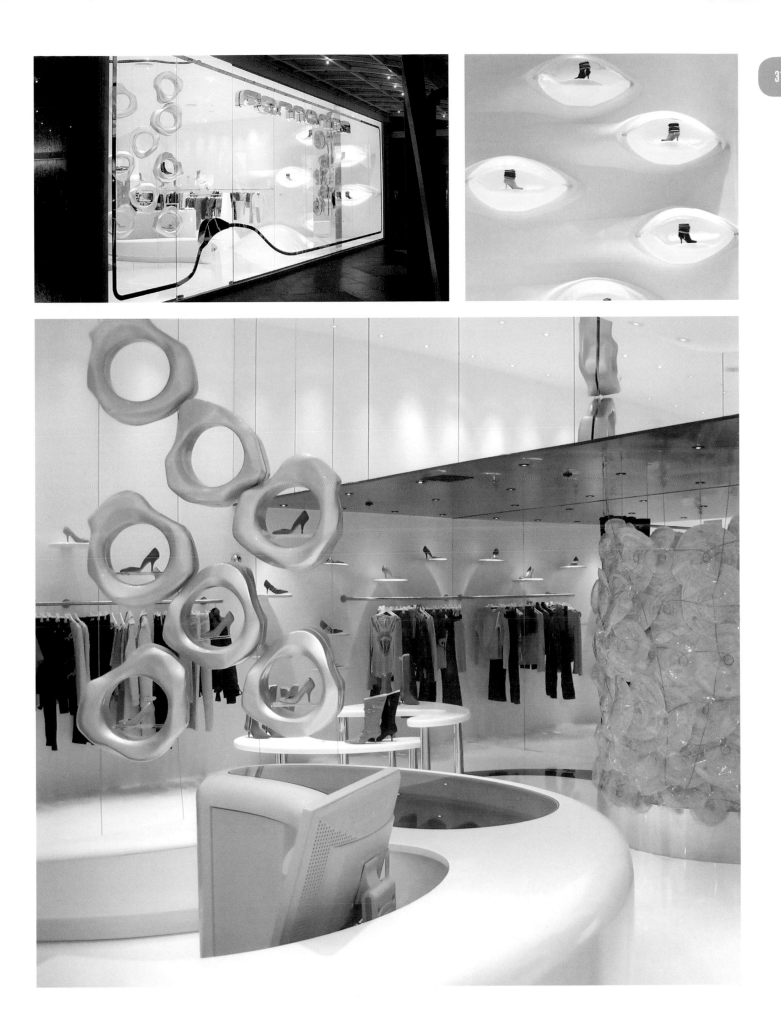

Motorola RED, Chicago
Specialty Store, Sales Area Under 1500 square feet

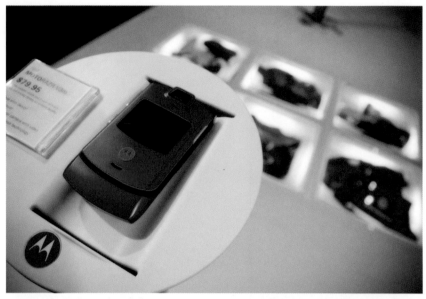

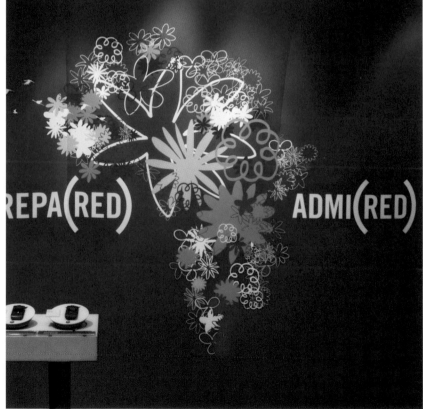

The (Product) RED campaign works to bring the fight against AIDS in Africa to mainstream America. Corporate heavyweights like Converse, Gap, Giorgio Armani, American Express and Motorola joined the global initiative and produced an array of merchandise featuring the parenthetical logo. Sales from (Product) RED benefit Global Fund-financed AIDS programs.

WalkerGroup (New York), in collaboration with the Motorola design team, created a "pop-up" store on Chicago's iconic Michigan Avenue for Motorola's (Moto)Red cell phones.

"We have created an immersive environment within a retail shell that showcases not only the stunning (Product)RED merchandise, but also the powerful message that underpins the campaign," says Randall Ng, managing director of WalkerGroup.

Mimicking the logo's brackets, designers created convex-shaped walls out of fabric. The structured fabrics draw attention to the RAZR phones and other Motorola (RED) accessories elevated on red and white pedestal displays. Signature parenthetical statements of the campaign, such as "Desi(red)" and "Inspi(red)" are screenprinted in chunky white letters along one curved wall, while the other side presents the campaign's manifesto. A crisp white floor with illuminated plexiglass showcases other (Product) RED merchandise.

Client Motorola, Libertyville, Ill. – Guto Andrade; Elena Limbert *Design/Architecture* WalkerGroup, New York – Randall Ng, principal; Julio George, project executive; Steve Kitezh, director, colors and materials; Noboru Ota, senior designer *General Contractor* Shawmut Design & Construction, New York *Outside Design Consultants* Rex Electric, Addison Ill.; Intelligent Lighting Creations Inc., Skokie, Ill.; Mike Casale, Chicago (lighting); Contract Flooring Service Inc., Tampa, Fla.; TOR Construction Co. Inc., South Elgin, Ill. (carpentry); Bobbe & Co., Burr Ridge, Ill. (painting); Impression Cleaning Services, Elmhurst, Ill. *Audio/Video* Ovation In-Store, Maspeth, N.Y. *Vinyl Graphics* Pico Chicago, Round Lake Beach, Ill. *Fabric Tension Structures* Moss, Belfast, Maine *Plexiglass Lightboxes* DNS Display Industries Inc., Concord, Ont. *Flooring* Shaw Carpets Inc., Dalton, Ga.; Architectural Systems Inc., New York *Photography* Jeffery Lau, Jamaica, N.Y.

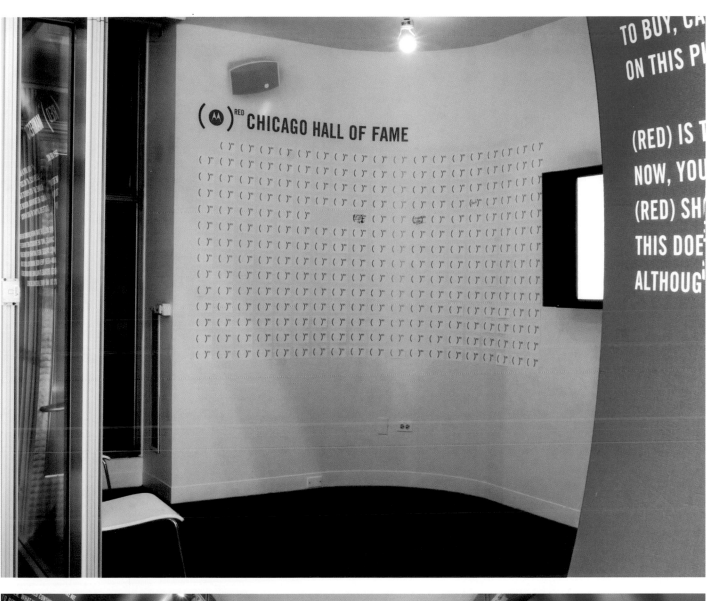

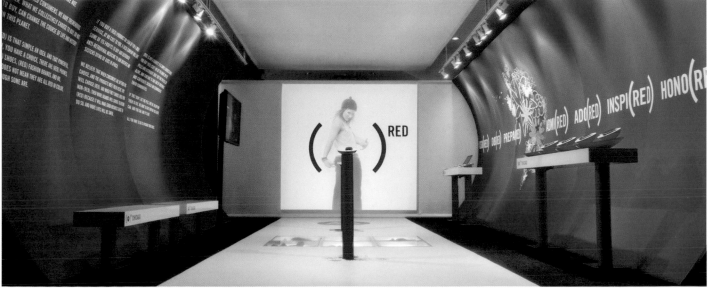

Paradies Shops at the Georgia Aquarium, Atlanta

Specialty Store, Sales Area 5000 to 10,000 square feet

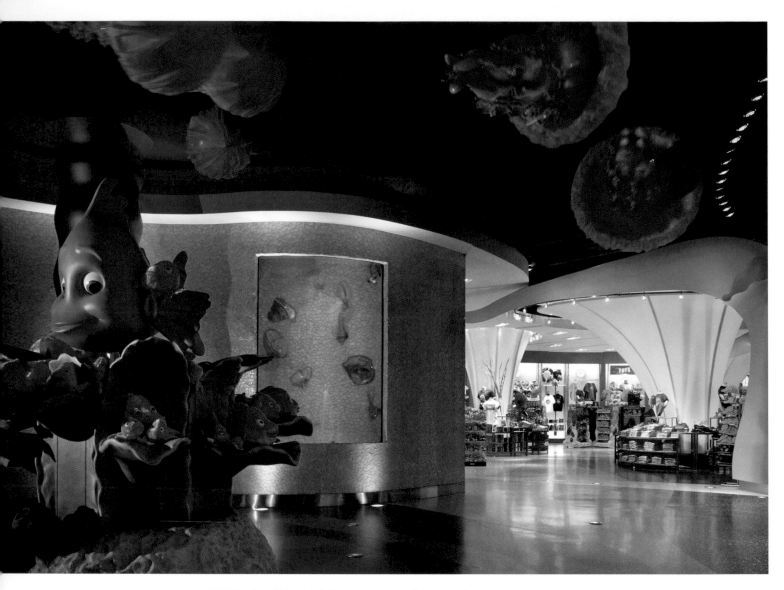

TVS Interiors (Atlanta) designed a deep-sea diving experience for the Georgia Aquarium's two retail spaces. "We wanted to entice the aquarium visitors to look around first instead of heading for the door," says TVS project designer Paula Carr.

Lighting first enchants guests at the entrance of the larger, 6000-square-foot "Beyond the Reef" store with glowing fiberglass jellyfish draped in sheer, orange organza silk. To achieve an underwater feel in the darkened cove-like opening, designers used recessed floor lights that create rippled reflections on the walls.

A second 600-square-foot children-inspired shop, the "Sand Dollar," sustains the underwater theme with tension-hung shelving displays that create the illusion of the merchandise suspended in water. Ocean life is present everywhere – in images behind and on the cashwrap and in the large sea creature seats where children can read, draw or interact with other toys.

Client The Paradies Shops, Atlanta *Design* TVS Interiors, Inc., Atlanta – Stephanie Belcher, associate principal; Steve Clem, project designer; Paula Carr, project designer; Dana Carter, project designer; Tonja Adair, project architect; Dan Sweeney, architect; Stephen Wells, project manager *Outside Design Consultants* Bliss Fasman, New York (lighting) *Architect* Thompson, Ventulett, Stainback and Associates, Atlanta *General Contractor* Brasfield & Gorrie, Kennesaw, Ga. *Fixtures* ALU, New York *Flooring* U.S. Mosaic Tile Co., Norcross, Ga. *Lighting* Juno Lighting Group, Des Plaines, Ill.; Louis Poulsen Lighting, Ft. Lauderdale, Fla.; Lithonia Lighting, Conyers, Ga.; Color Kinetics, Boston *Millwork/Fixtures* Raydeo Enterprises, Ball Ground, Ga. *Signage/Graphics* Paradies, Atlanta *Wallcoverings/ Materials* Goodman Decorating Co. Inc., Atlanta; Ceramic Technics Ltd., Atlanta; Zolatone Interior Finishes, Los Angeles *Photography* Brian Gassel, Atlanta

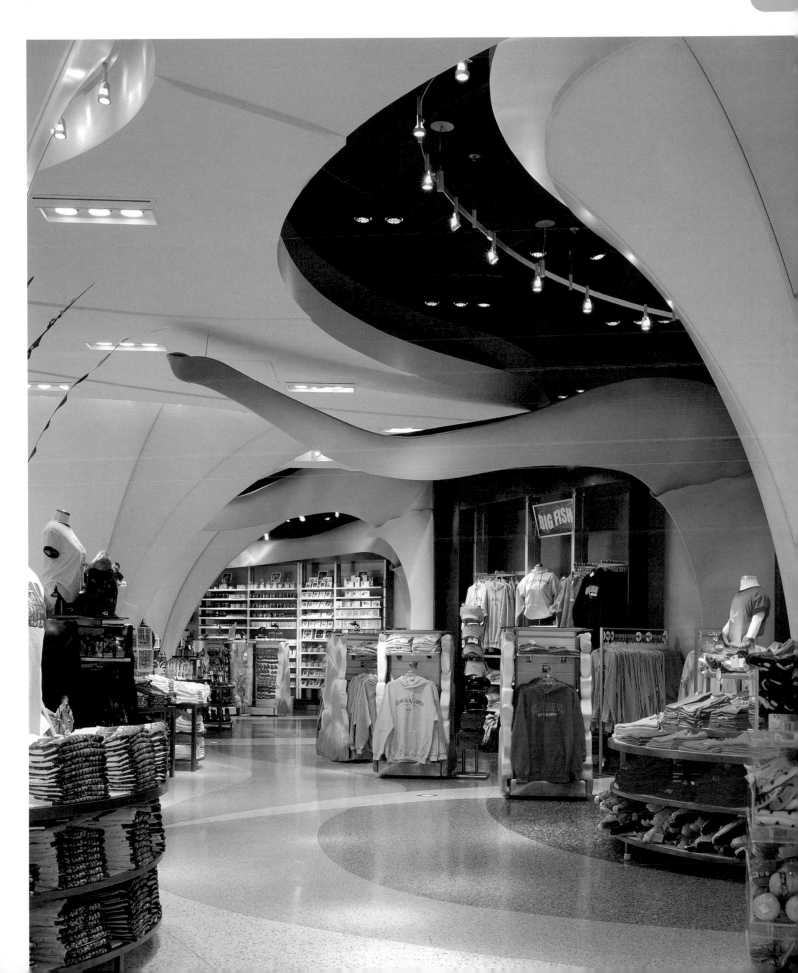

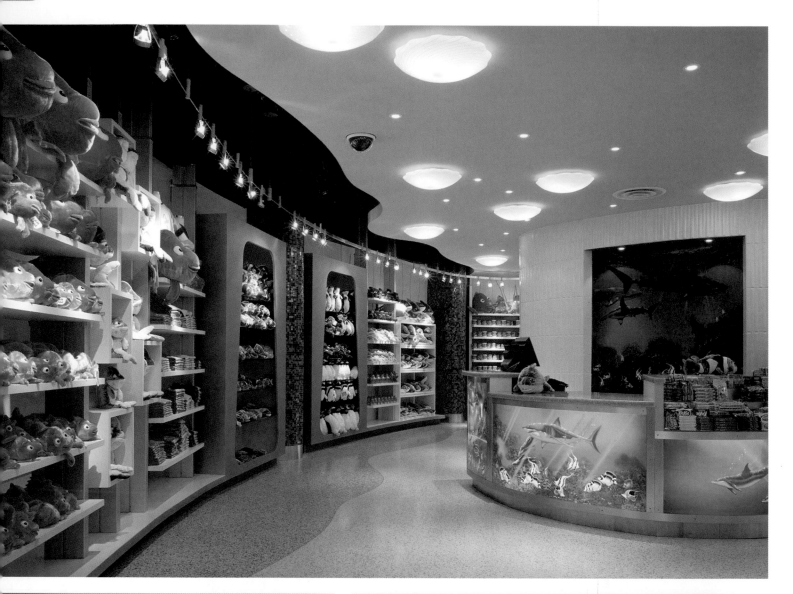

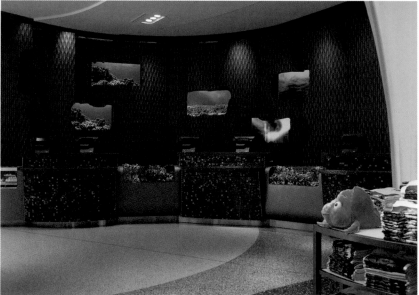

Olay Brand Experience Counter, Cincinnati
Shopping Center Kiosk

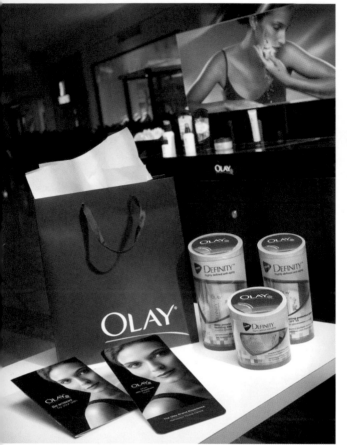

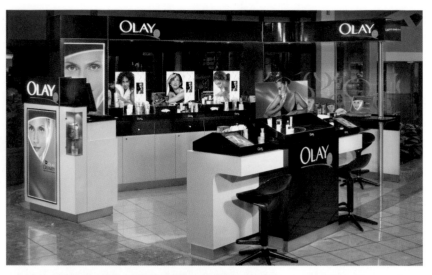

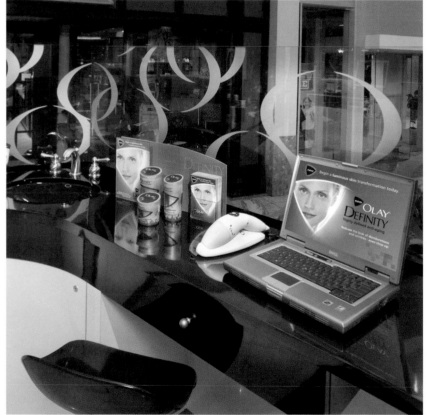

Procter & Gamble's first Olay retail environment was more about talking to consumers than about selling goods. A 130-square-foot "brand experience" counter was placed in a wing of Cincinnati's upscale Kenwood Towne Centre, part of P&G's campaign to learn more about what triggers a buy impulse, what the consumer goods giant calls "the first moment of truth."

The strategy was to feature the brand holistically, engaging shoppers through product testing, education and professional beauty advisors. Designers created a temporary experiential and brand-centric environment with high touch and high interactivity to optimize consumer engagement. The counter was invested with new and familiar Olay retail collateral, including high-quality graphics and recognizable logos. Product samples and literature was liberally available throughout the area.

The intelligence gathered from interacting with fashion-conscious, upscale mall visitors will help P&G tailor future packaging and in-store marketing strategies and provide insights to promote and market its products. It will also inform the current global development of the Olay brand, already launched in Poland, Russia, Spain and Mexico.

Client The Procter & Gamble Co., Cincinnati – Michael Kuremsky, vp, global Olay & North America skin; Lia Braaten Hager, associate design, P&G beauty; global identity director, Olay; John Brownlee, North America Olay brand manager *Design* Benchmark, Cincinnati – John Carpenter, president and chief creative officer; Beth Harlor, creative director; Camille Popplewell, vp, market leader, beauty & fashion; Maria Deacon, senior environmental designer; Wendy Hunt, director of client services; Jacque Baker, account executive *Fabricator* Array, New York *Furniture* Voltage, Cincinnati *Laminates* Arpa, Jacksonville, Fla.; Wilsonart Intl., Temple, Texas; Chemetal (a div. of The October Co. Inc.), Easthampton, Mass. *Visualizations* Harlan Graphic Arts Services Inc., Cincinnati *Photography* Mark Steele Photography Inc., Columbus, Ohio

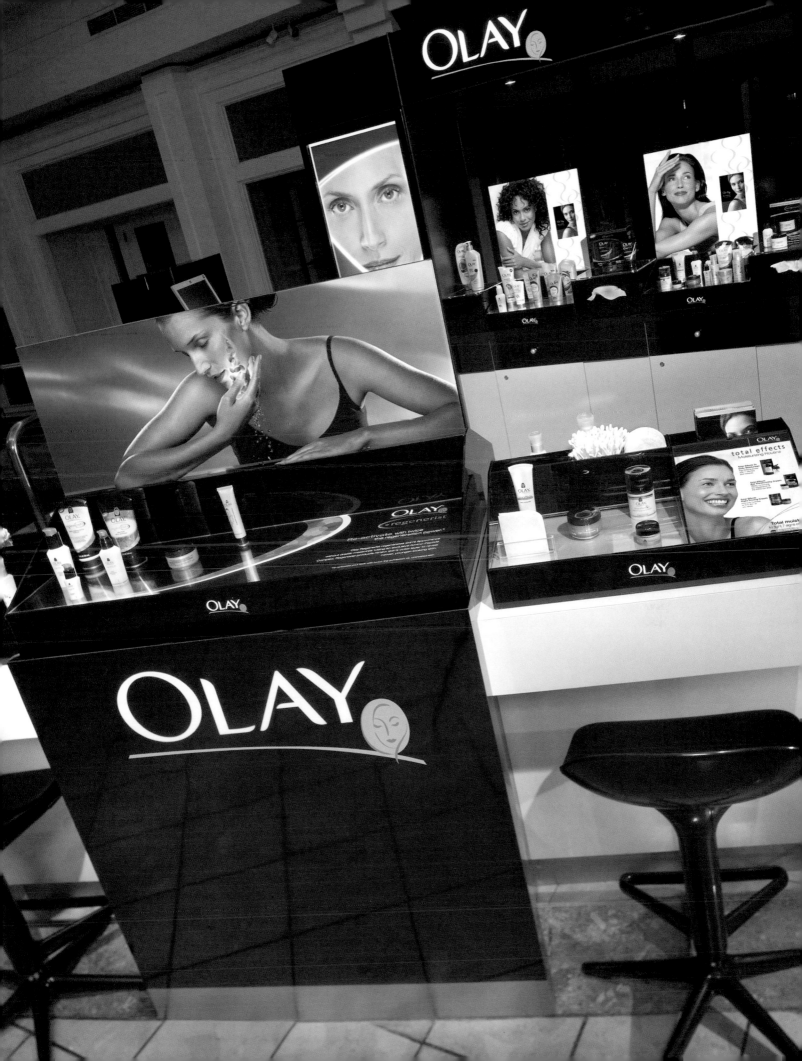

KFC, Louisville, Ky.
Specialty Food Court or Counter-Service Restaurant

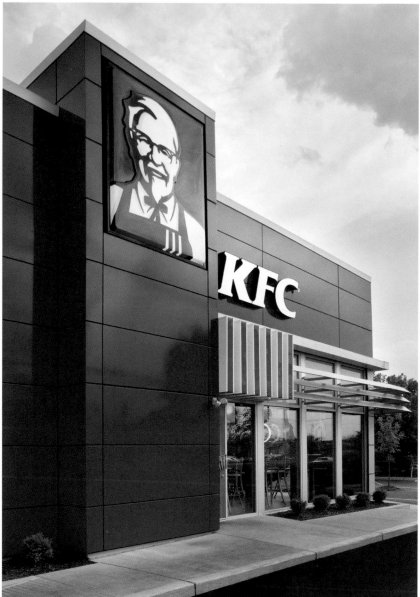

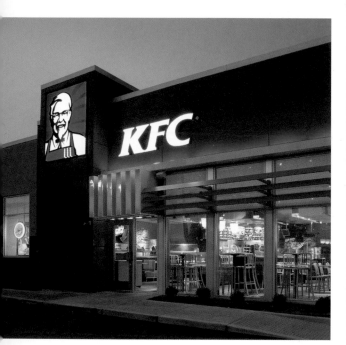

The Colonel is back. And this time he's bringing an international, contemporary flair to KFC's original store recipe, designed by FRCH Design Worldwide (Cincinnati).

The use of bold graphics, deep red colors and streamlined design made this fast-food joint's extreme makeover a big hit.

The interior is broken up into a variety of dining experiences. Conventional seating arrangements of wooden benches and standard tables have been replaced with perimeter red leather seating, picnic tables for family-sized groups and trendy metal chairs for smaller dining parties. Clean lines provide an international feel, while touches of stars and stripes near the improved buffet add elements of Americana.

Bucket-themed lights and metal bucket condiment holders emphasize KFC's famous fried-chicken holder. On the exterior facade, the Colonel greets his loyal followers from inside an illuminated bucket sign.

A solid, floor-to-ceiling glass entrance adds an urban element and attracts street traffic.

Client: Kentucky Fried Chicken, Louisville, Ky.; Terry Davenport, senior vp, concept design and multibranding; Anne Fuller, global concept design director; Sean Hagan, design architect; Scott Keadle, program manager; Michael Osborne, program manager, emerging concepts *Design/Architecture* FRCH Design Worldwide, Cincinnati; Paul Lechleiter, principal; Steve McGowan, vp, creative director; Shane Kavanagh, senior vp, specialty retail architecture; Tobias Harris, graphic design director; Jeff Waggoner, environmental graphic design director; Lori Kolthoff, resource design director; Jeff Siegel, operations manager; Denise Sharma, project coordinator; Frank Mulich, team leader; Doug Bunker, graphic designer; Greg Smith, graphic designer; Katie Stepleton, interior designer; Marty McCauley, designer; Aaron Ruef, senior environmental graphic designer; Rob Rink, director, specialty architecture *General Contractor* Derek Engineering, Louisville, Ky. *Outside Design Consultants* KLH Engineers, Fort Thomas, Ky.; Graham Obermeyer & Associates, Cincinnati (structural engineers); Lighting Management, New York (lighting) *Furniture/Millwork* Plymold, Kenyon, Maine *Signage/Graphics* Everbrite, Greenfield, Wis.; Harlan Graphics, Cincinnati *Laminate Countertops* Wilsonart Intl., Fairfield, Ohio; Formica, Cincinnati *Photography* FRCH Design Worldwide, Cincinnati

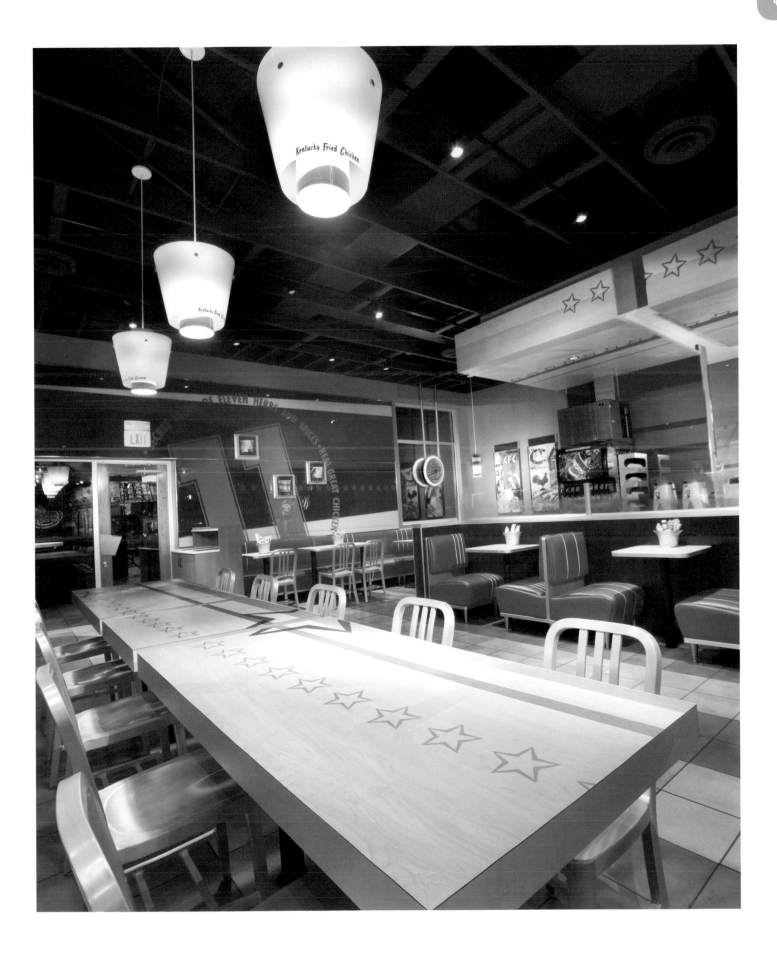

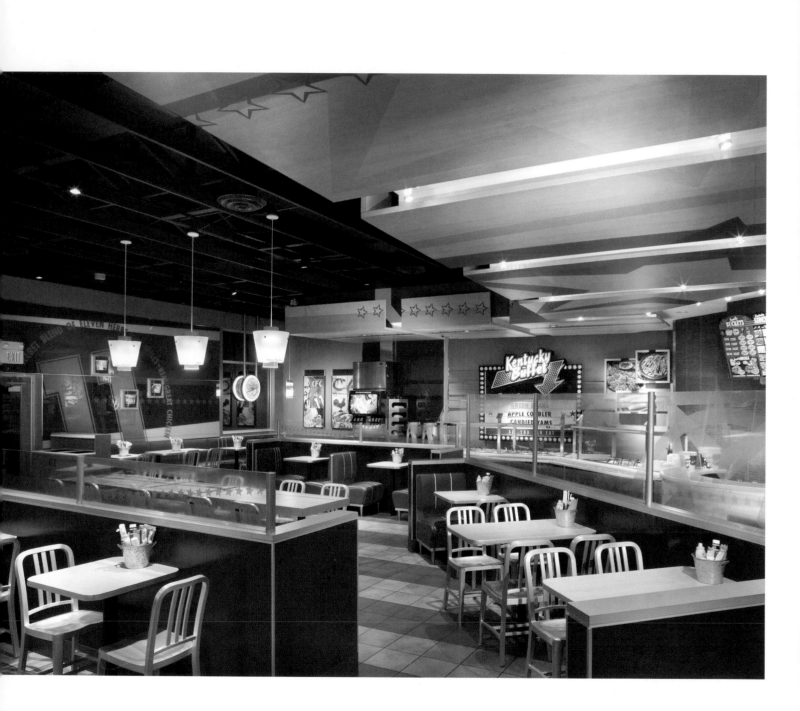

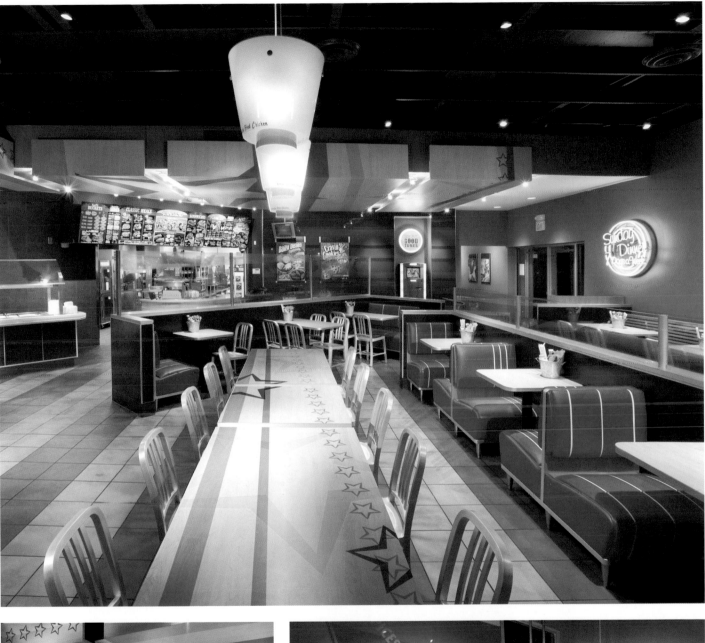

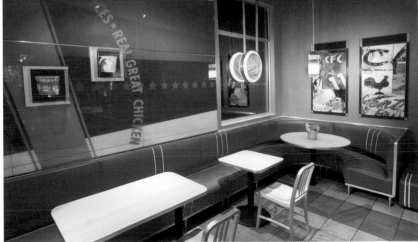

Mariposa Restaurant, Boca Raton, Fla.
Sit-Down Restaurant

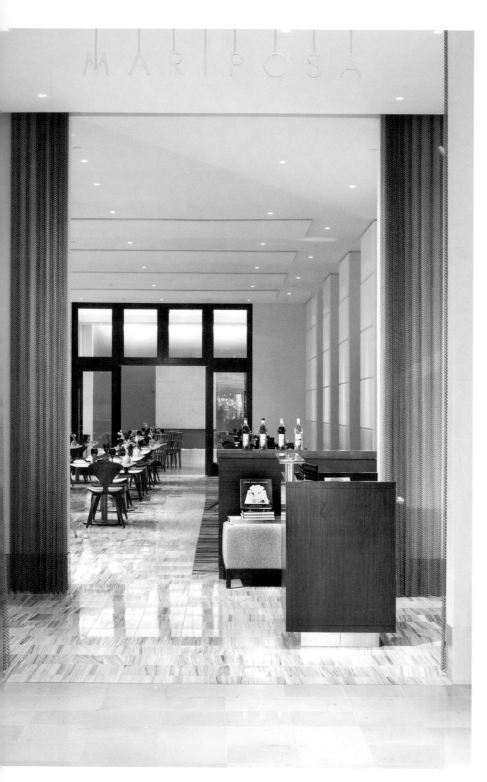

Tropical meets urban chic at the Mariposa Restaurant inside Neiman Marcus' Boca Raton, Fla., store.

Art, color and texture draw attention to the 3600-square-foot space on the department store's second floor. High ceilings and open sightlines lend a high-end gallery ambiance complemented by a variety of luxe elements, including a custom-designed runner of grasses and sticks; a long frieze of hand-blown glass designed to mimic the wind blowing through south Florida's tall grasses; and a Lanai terrace serving as a private dining room.

Floor-to-ceiling windows with copper coil abstract draperies provide ample natural light and help bring the outside in. In contrast, dark striated wood in shifted planes sets a rich, dark atmosphere for the bar area. Subtle changing LED lighting in the bar front adds to the moody environs.

Client Neiman Marcus, Dallas – Wayne Hussey, senior vp, properties and store development; Ray Gearhard, vp, property development; Ignaz Gorischek, vp, store development; Chris Lebamoff, vp, store planning; David Volosin, site representative; Paolo Antonini, manger, store planning; Megan Hermann, manager, color and materials *Design* Charles Sparks + Co., Westchester, Ill. – Charles Sparks, principal-in-charge; Donald Stone, account executive; David Koe, senior creative director; Stephen Prosser, account coordinator; Rachel Mikolajczyk, director, resource studio *Architect* Barteluce Architects & Associates, New York *General Contractor* Keene Construction, Maitland, Fla. *Outside Design Consultants* Integrated Lighting Concepts, Woodland Hills, Calif. (lighting); KLR Associates, New York (MEP); Avcon Design Group *Carpet* Della Robbia Inc., Corona, Calif. *Ceilings* Armstrong World Industries, Inc., Lancaster, Pa. *Fabric* Donghia, Chicago; Spinney Beck, Chicago; Maharam, Chicago; Nathan Chapin Ltd., Chicago *Fixtures* Goebel Fixture Co., Hutchinson, Minn.; Faubion Intl., Dallas *Flooring* Innovative Marble & Tile Inc., Hauppauge, N.Y.; Surface Group Intl., Barrington, Ill.; Coverings Etc. Inc., Miami *Furniture* The Cherner Chair Co., Westport, Conn.; Atta Inc., New York; Shelby Williams, Chicago; David Sutherland, Dallas; Callard & Associates, Chicago *Glass* Twin City Creative Mirror & Glass, Burnsville, Minn. *Lighting* Winona Lighting, Winona, Minn; Modular Intl. Inc., Pittsburgh, Pa. *Paint* Benjamin Moore Paints, Melrose Park, Ill.; Wolf Gordon/Scuffmaster, Chicago *Wall Frieze* Mickelsen Studios Inc., Melbourne, Fla. *Wall Material* Innovations, Chicago *Wood Stain Finish* R.S. Bacon Veneer, Burr Ridge, Ill. *Photography* Charlie Mayer, Oak Park, Ill.

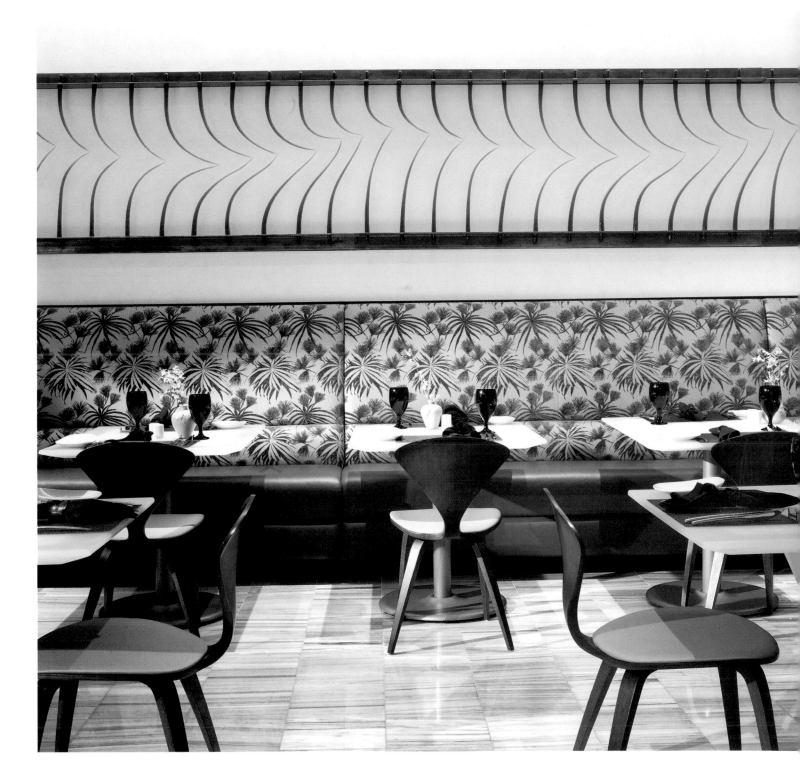

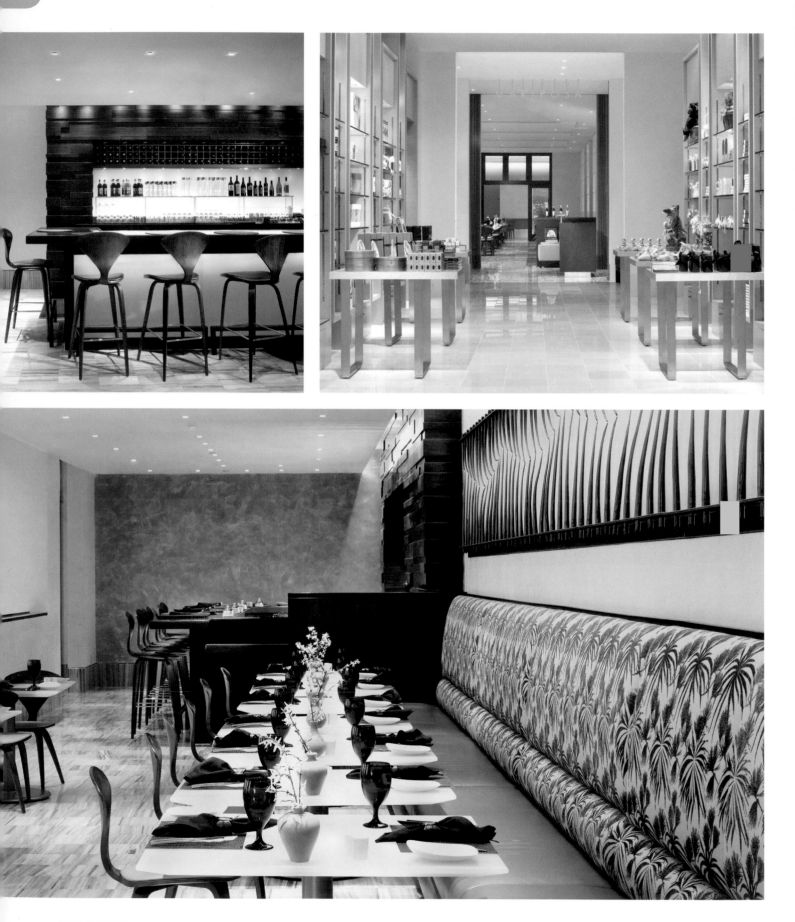

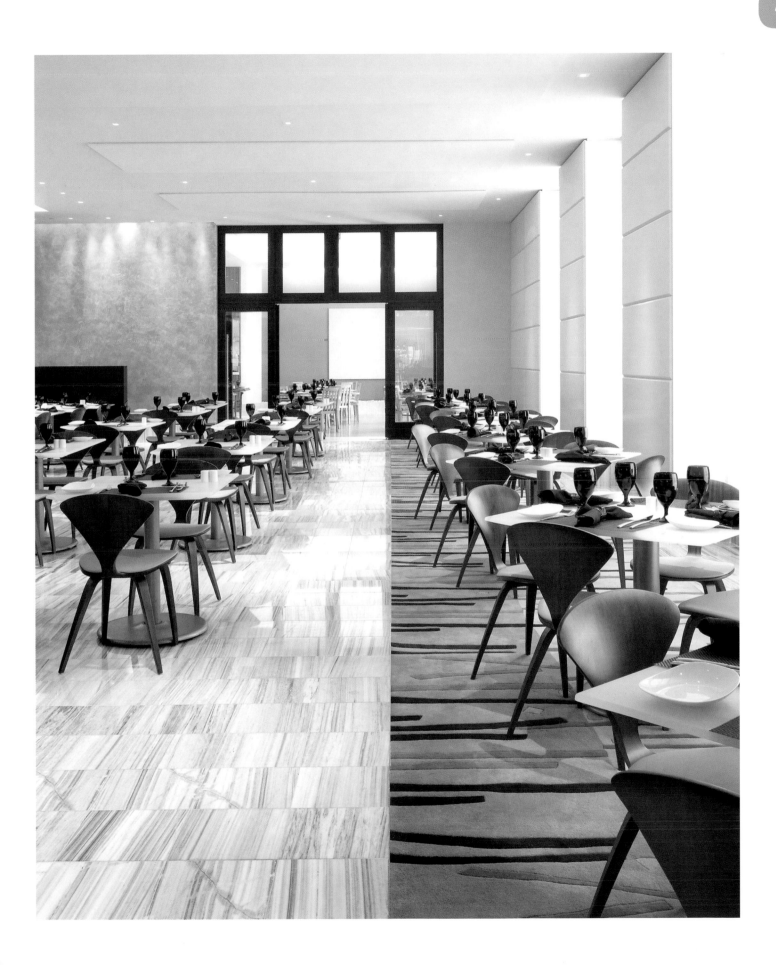

The Market by Longo's, Toronto
Specialty Food Shop

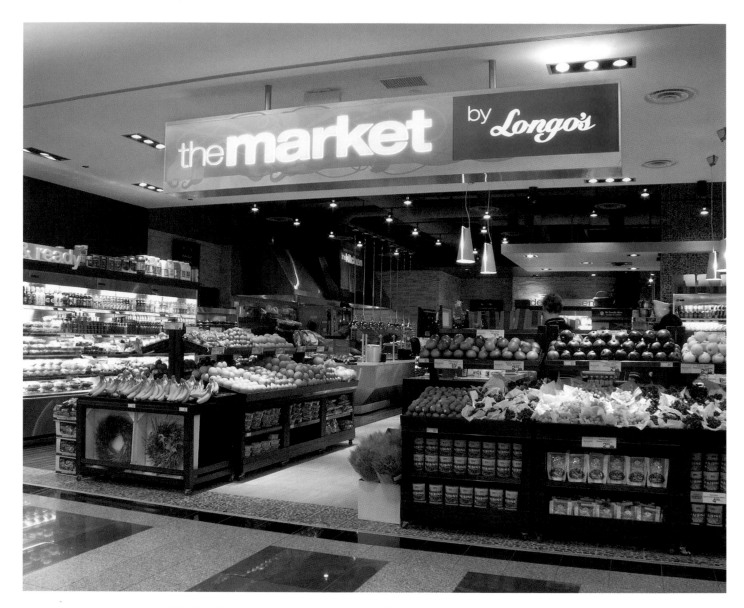

With the rising popularity of city living, many retailers are challenged to re-create their stores into formats that fit urban spaces.

When Longo Brothers Fruit Markets, known for its grocery stores offering quick, healthy and fresh foods, sought a store on the concourse of BCE Place in Toronto, it was faced with translating its reputation and store experience into a space that was 1/10th the size of a typical Longo store.

Working with Watt Intl. (Toronto), designers captured the essence of the urban grocery experience – quick and convenient – using a fixturing system that maximizes space while keeping the store easy to navigate.

Longo's new recipe is appealing to Toronto's city dwellers, too. The grocery store has already extended its hours of operation to meet growing customer needs and appetites.

Client Longo Brothers Fruit Markets, Toronto *Design* Watt Intl. Inc., Toronto – Jean Paul Morresi; Sam Chan; Kim Clark; Steve Van Rooy; Matt DeAbreu; Carla Conte *Architect* Bregman + Hamann Architects, Toronto *General Contractor* RFB Construction, Burlington, Ont. *Cultured Stone* Kurt Trierweiller, Newmarket, Ont. *Stainless-Steel Baseboards* Alumasteel, Salt Lake City *Tiles, Countertops, Surfacing Materials* Ciot Tecnica, Toronto *Vinyl Baseboard* Johnsonite, Waterloo, Ont. *Wood Ceilings* The Sullivan Source, Toronto *Wood Plastic Laminates* Tafisa Canada, Dorval, Que. *Wood Tiles, Flooring, Column Tops* Stone Tile, Toronto *Photography* Si Hoang, Toronto

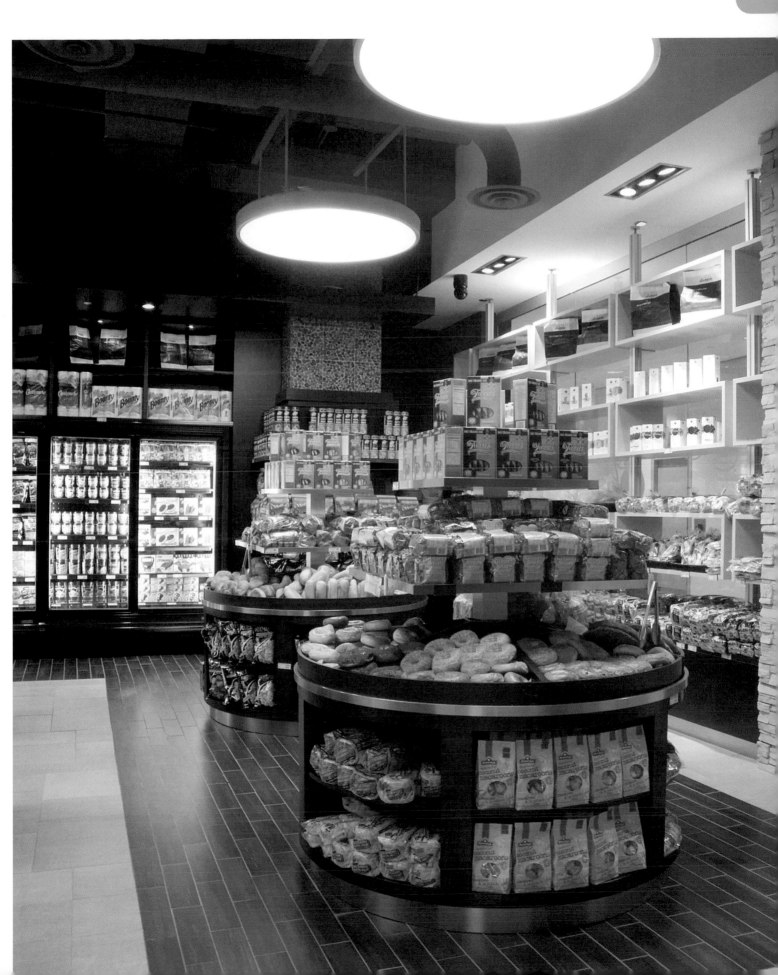

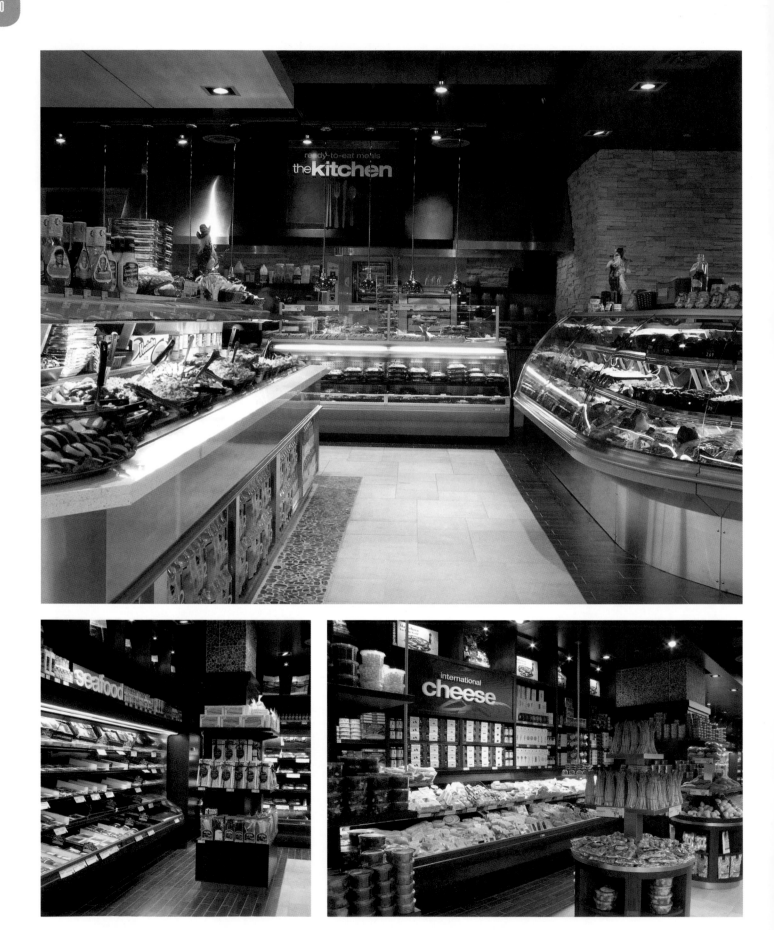

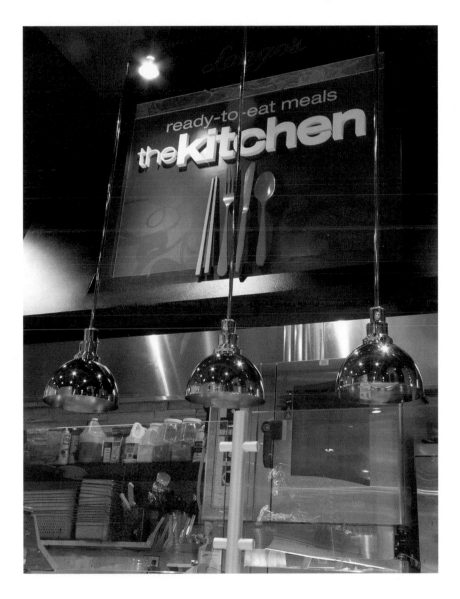

Carnival Super Market, Dallas
Supermarket

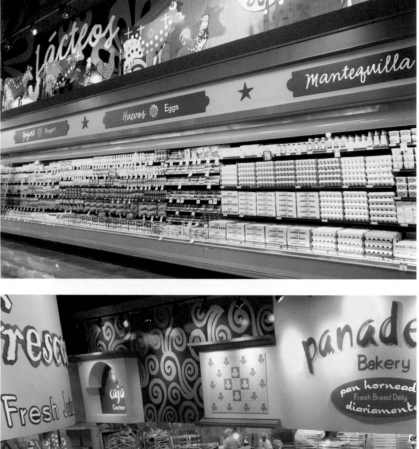

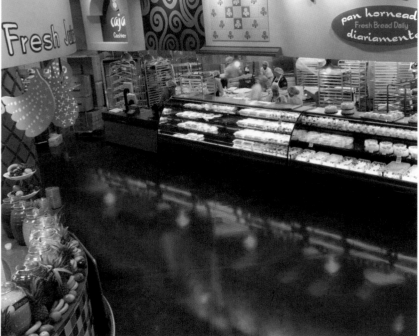

To appeal to the multicultural population surrounding Carnival's Dallas supermarket, designers from api(+) sought to remake the store's shopping experience into one that was fun, promoted freshness and abundance and was family-focused – all trademarks of the grocery experience in Hispanic cultures.

Culturally relevant colors, patterns, lighting, sound and scents were used throughout the store to create an engaging environment for the entire family. Store signage was also composed primarily in Spanish, with English translations secondary.

In La Panaderia (bakery), fresh bread aromas are vented into the store from the back bakery, seen through large showcase windows. In La Fruteria (fruit juice bar), designers re-created a plaza fountain setting where shoppers can find fresh juices, salads, sandwiches and desserts. In the La Concina (kitchen) area, nearby picnic tables offer customers a place to enjoy a quick snack or meal from the prepared foods area.

Drop ceilings and canopies delineate the common areas, while themed elements and storefronts, such as a thatched hut roof over the Pescaderia (fresh seafood department) and pineapple and palm fixtures in La Fruiteria, identify each of the food departments.

Client Minyards Food Stores Inc., Coppell, Texas *Design* api(+), Tampa, Fla. – Juan Romero, president and ceo, cultural segmentation-branding; Tom Henken, vp and director of design; John Scheffel, environmental graphics; Ryan Martin, graphics, conceptualization; Heidi Garcia, architecture; Rena Cao, graphics; Barbara Soto, public relations, signage translation *Architect* Johnson Architects Inc., Dallas *General Contractor* W.B. Kibler Construction, Dallas *Outside Design Consultants* System Associates, Dallas (MEP); Hunt & Joiner Inc., Dallas (structural) *Ceramic Tile* Dal-Tile, Dallas *Concrete Flooring* L.M. Scofield Co., St. Petersburg, Fla. *Construction Materials and Machinery* Southern Store Fixtures Inc., Bessemer, Ala. *Fixturing* Madix Store Fixtures, Terrell, Texas *Foodservice Equipment* BKI, Simpsonville, S.C. *Graphic Fabricator* Infiniti Décor, Godley, Texas *Lighting* Sesco Lighting Inc., Tampa *Refrigeration* Kysor/Warren, a subsidiary of Enodis PLC., Columbus, Ga. *Photography* Scott Hales, PBL, Carrollton, Texas

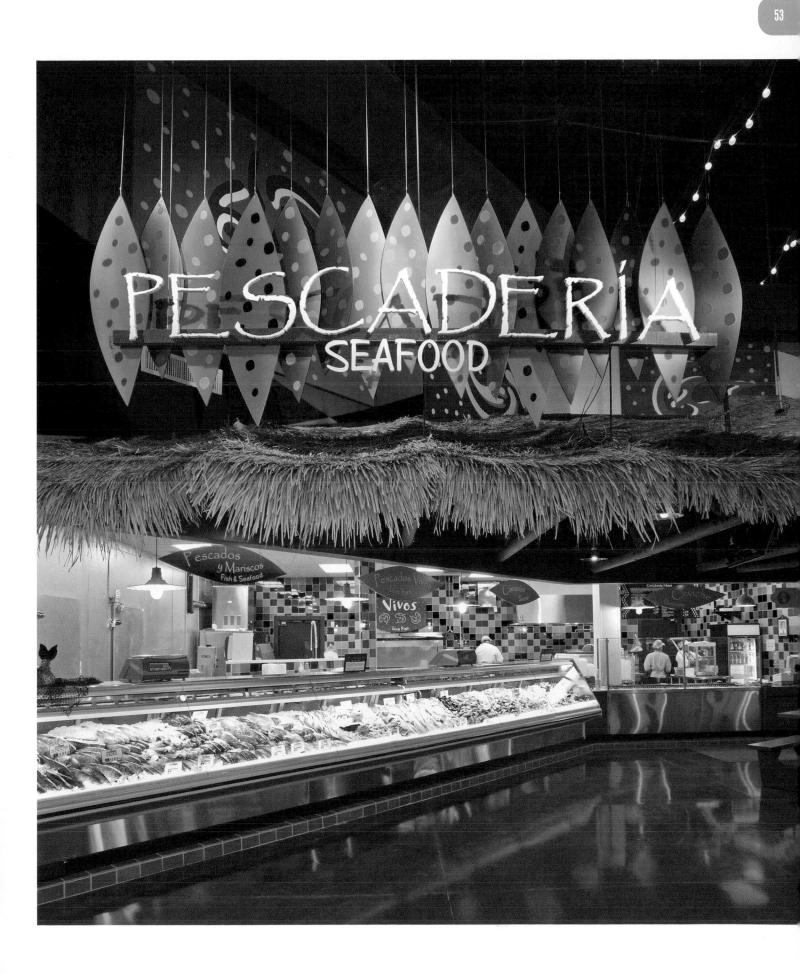

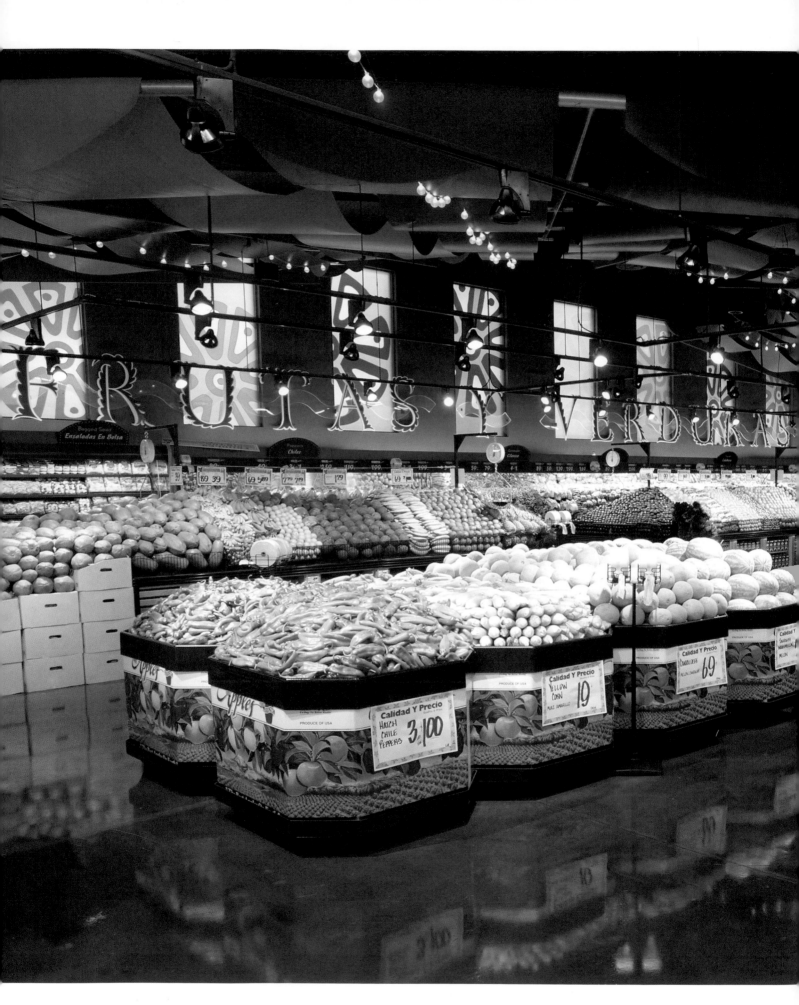

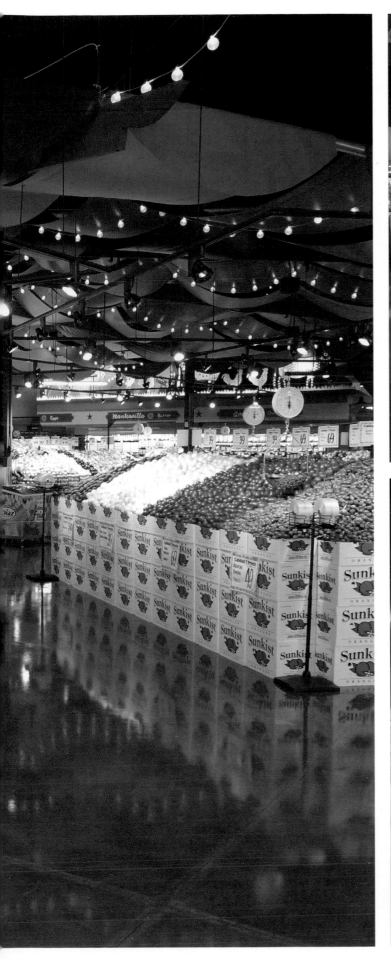

The Spa at Ponte Vedra Inn & Club, Ponte Vedra, Fla.
Service Retailer

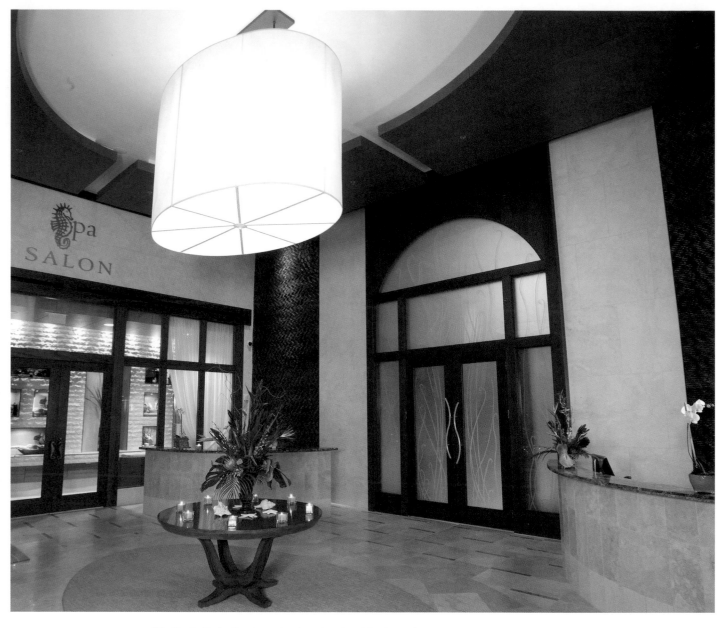

The Ponte Vedra Inn is an uber-luxurious beachfront resort. In keeping with that setting, the inn's owners commissioned Pavlik Design Team to create a spa that offers state-of-the-art treatments in a soothing, natural environment.

Pavlik infused the space with a seahorse-shaped fountain, lagoons, waterfalls, indoor/outdoor terraces and water-therapy pools. A variety of natural surfaces — including stone, marble, mahogany and bamboo — are integrated into the complex's rooms and common areas. There's also a full-service beauty salon, along with a barbershop whose oversized leather chairs offer views of the adjoining golf course.

Client The Spa at Ponte Vedra Inn & Club, Vedra Beach, Fla. – Dale Haney, general manager; Theresa Clements, spa director *Design* Pavlik Design Team, Fort Lauderdale, Fla. *Architects* Fisher/Koppenhafer Architecture Interior Design, Jacksonville, Fla.; Rink Reynolds Diamond Fisher Architects, Jacksonville, Fla. *General Contractor* Brasfield & Gorrie LLC, Lake Maury, Fla. *Flooring* Gammpar, Forest, Va.; Graniti Fiandre, St. Petersburg, Fla.; Marble of the Word, Fort Lauderdale, Fla.; Masland Carpets, Key Biscayne, Fla.; Mediterranean Designs Inc., Jacksonville Beach, Fla.; Wilsonart Flooring/Master Craft, Miami; Wolf Gordon/Bart Heikes & Associates, Fort Lauderdale, Fla. *Laminates* Interlam Inc., Fort Lauderdale, Fla. *Materials* 3 Forms/Fidler Group, Miami; Ann Sacks, Miami; Armstrong World Industries, Inc., Lancaster, Pa.; Bendheim, New York; Lumicor, Renton, Wash.; New Studio, Boca Raton, Fla.; Prodema/Artexture South, Miami; Steeltech Electroplating Inc., Hialeah, Fla.; Stylmark, Minneapolis; U.S. Terra, Boca Raton, Fla. *Paints* Benjamin Moore, Miami; Sherwin-Williams, Dallas *Wallcoverings* Coverings Etc., Miami; Bentano/Innovations, Dania, Fla.; Eykon, Memphis, Tenn.; MDC Wallcoverings, Atlanta; Wolf Gordon/Bart Heikes & Assoc., Fort Lauderdale, Fla.; Olney Wallcoverings, Toronto *Woods* Whittelsey Architectural Wood Sales, Miami *Photography* Dana Hoff Photography, N. Palm Beach, Fla.

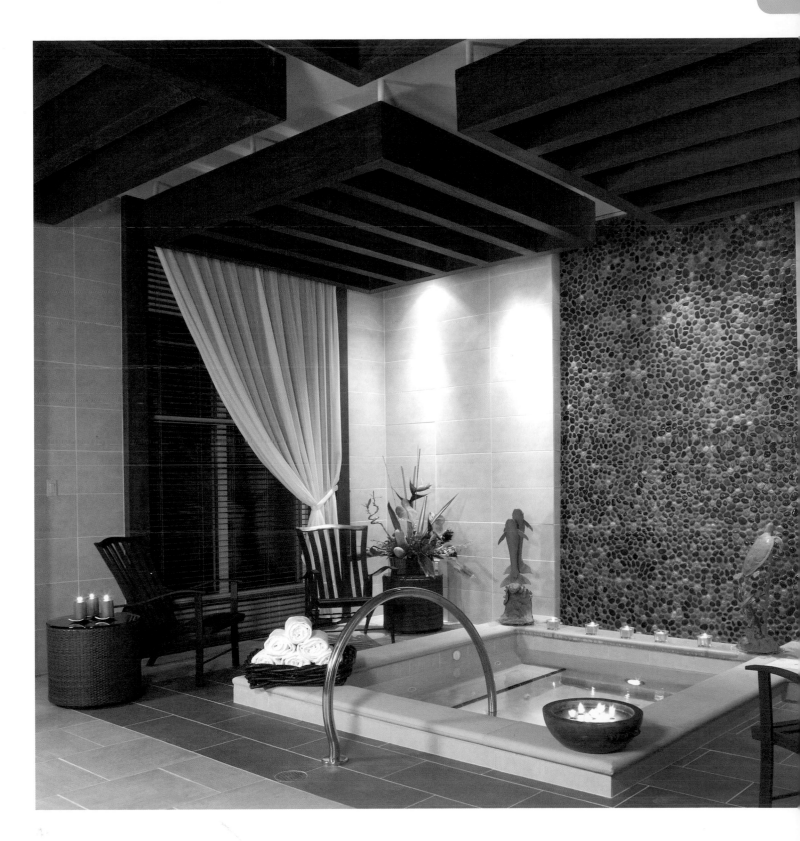

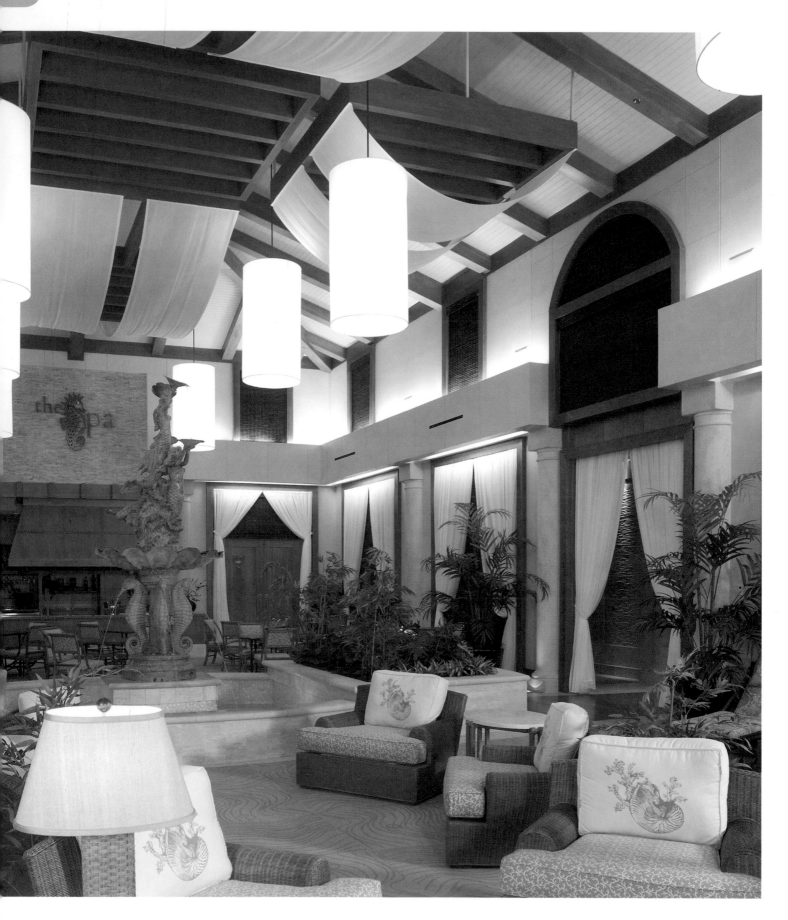

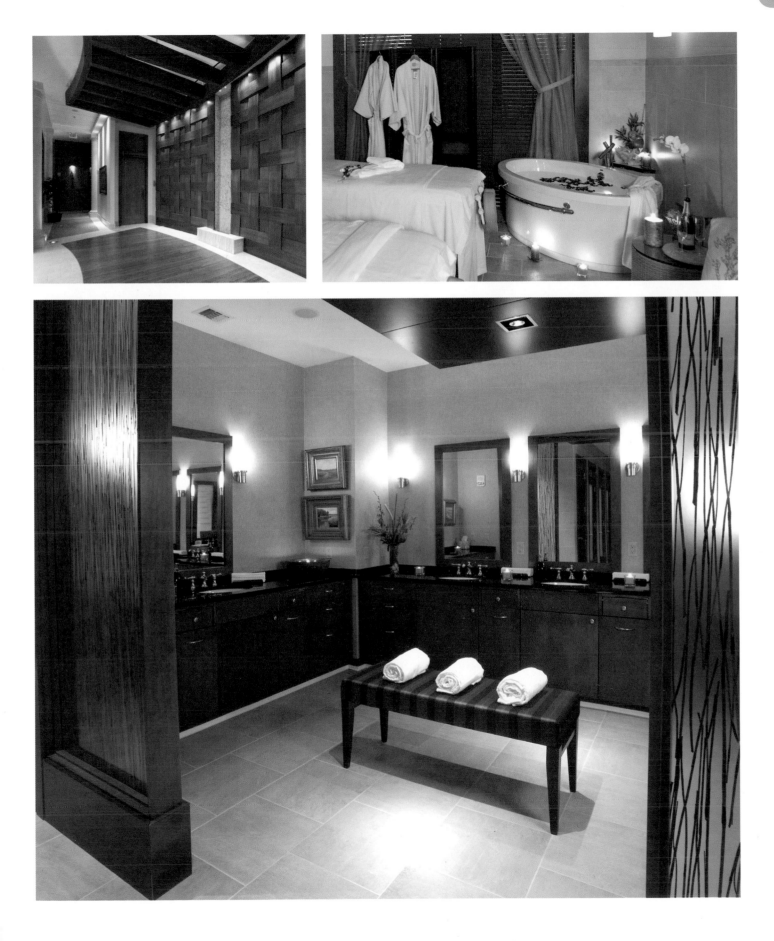

The Design Studio by Remington Homes, Markham, Ont.
Manufacturer's Showroom

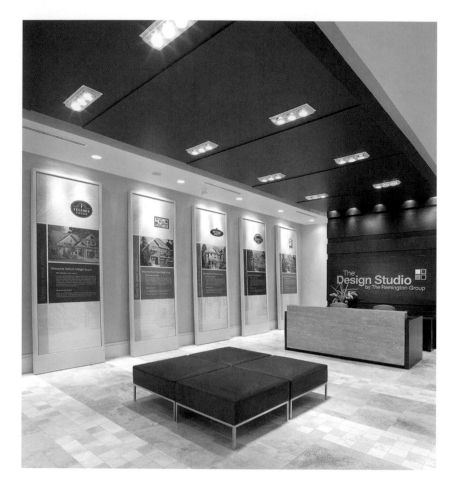

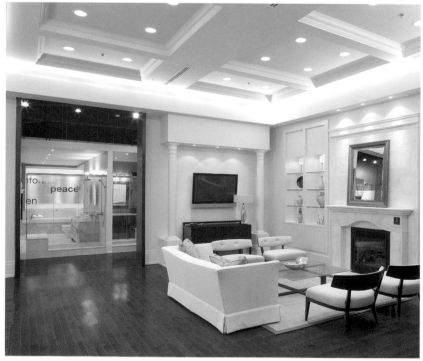

The Design Studio by Remington Homes lets visitors visualize what their custom-built home will look like by offering a range of full-scale room vignettes.

Designed by Watt Intl. (Toronto), the complex's main "Inspiration Gallery" showcases four major housing styles – classic, contemporary, urban chic and country/casual – supplemented by 12-foot-high illuminated mesh graphics. There are also separate design vignette rooms for kitchens, bathrooms and living rooms. Flooring and other décor choices are displayed in spaces with a neutral palette, to make the materials being considered the visual focus for customers.

Client The Remington Group, Vaughan, Ont. *Design* Watt Intl. Inc., Toronto *Outside Design Consultants* Lightbrigade, Toronto; Interior Images, Toronto *Corian* Commercial by Willis, Burlington, Ont. *Felt Panel Fabric* Brand Felt Ltd., Mississauga, Ont. *Flooring* The Sullivan Source, Toronto; Elite Tile, Mississauga, Ont.; Markham Flooring, Markham, Ont.; Cercan Tile, Toronto; Stone Tile, Toronto; Design Elementz, Toronto; Interface, Toronto; GE Shiner Co. Ltd., Brampton, Ont. *Furniture* Louis Interiors, Toronto *Graphic Panels* BGM Reproductions, Toronto *Lighting* Nelson & Garrett, Toronto *Metalwork* Unit 5, Toronto *Plaster Finish* Moss & Lam/Surfaces, Toronto *Wall Panel/Valence Fabric* Telio & Cie, Toronto *Photography* Richard Johnson, Toronto

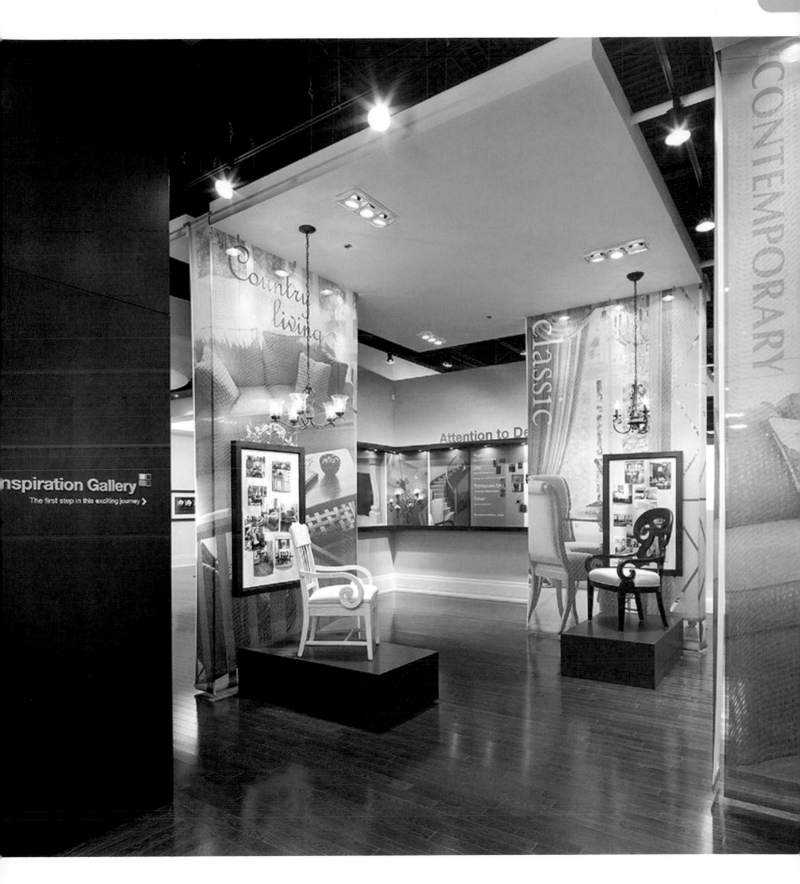

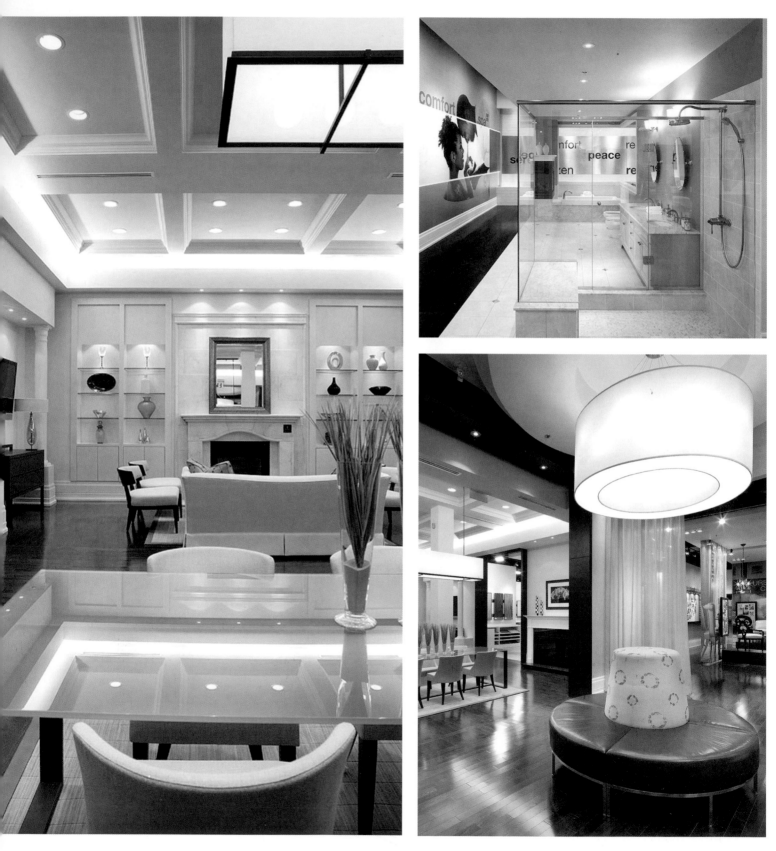

The great outdoors

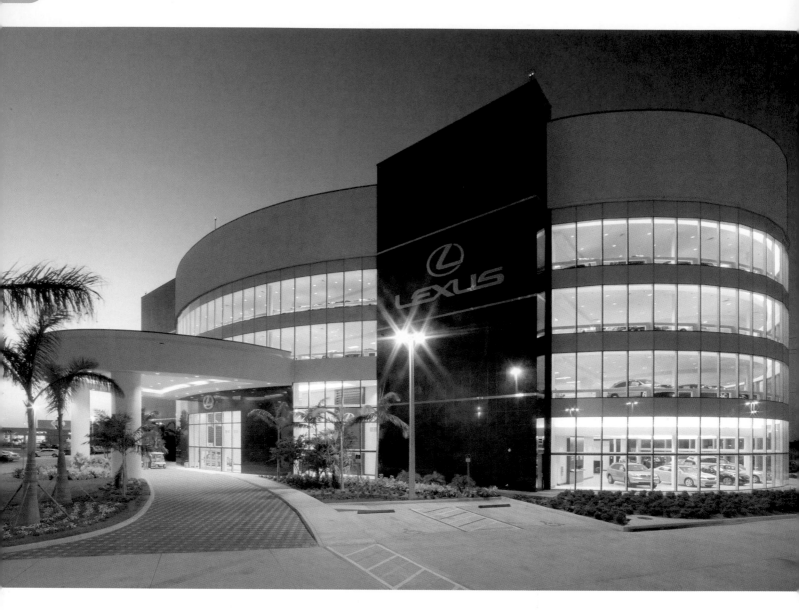

Lexus, Toyota's luxury brand, typically sells its cars in opulent dealership environments. That strategy is on spectacular display at the Lexus of West Kendal dealership in Miami. Inspired by the oval form of the Lexus logo, Pavlik Design Team created a building shape that's visually striking outside and in.

The building is set at an angle from the street, and features glass curtain walls that give passersby clear views into the space.

The inside, which houses 200,000 square feet of showroom space spread out over five floors, features a three-story entrance atrium and a curved rotunda that leads to a central "great room." The latter space is lined with a series of decorative columns and has as its focal point a Lexus set like a diamond in an elegant chrome millwork display.

Client Lexus of West Kendal, Miami – Jerry Bean, owner; Bob Harter, ceo *Design* Pavlik Design Team, Fort Lauderdale, Fla. *General Contractor* Dana B. Kenyon, Jacksonville, Fla. *Flooring* D&B Tile, Sunrise, Fla.; Keys Granite, Miami; Marble of the World; Fort Lauderdale, Fla.; Armstrong World Industries, Inc., Lancaster, Pa.; Johnsonite, Chagrin Falls, Ohio; Innovative Stone & Tile, Hauppauge, N.Y. *Finishes* Benjamin Moore, Montvale, N.J.; Wilsonart Intl., Temple, Texas; Wolf Gordon, New York; Stylmark, Minneapolis; MDC Wallcoverings, Elk Grove Village, Ill. *Photography* Dana Hoff Photography, N. Palm Beach, Fla.

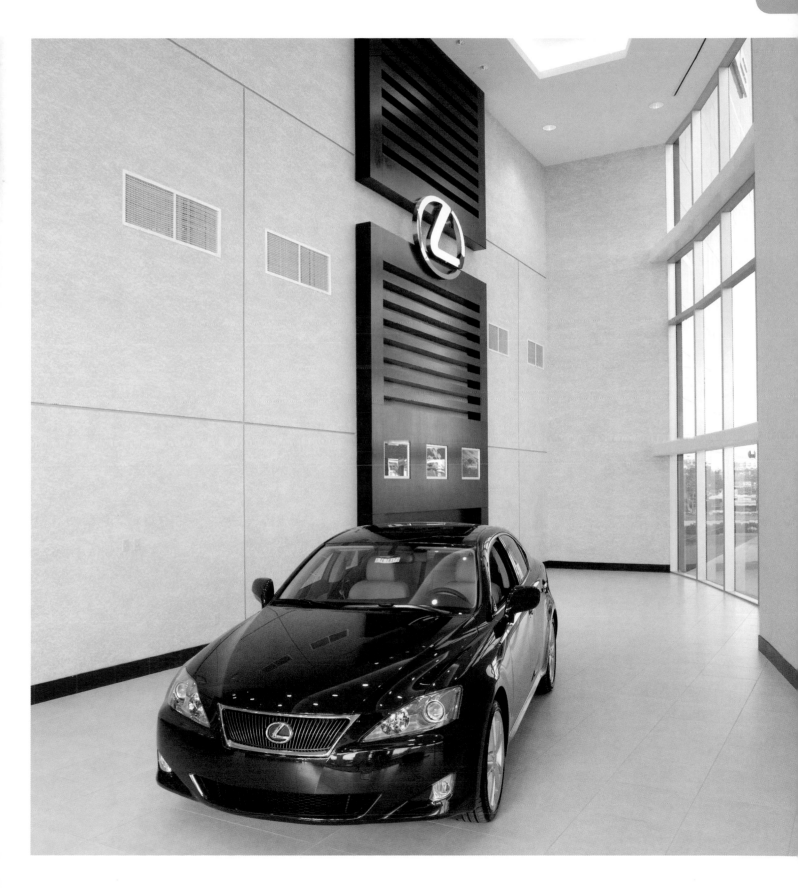

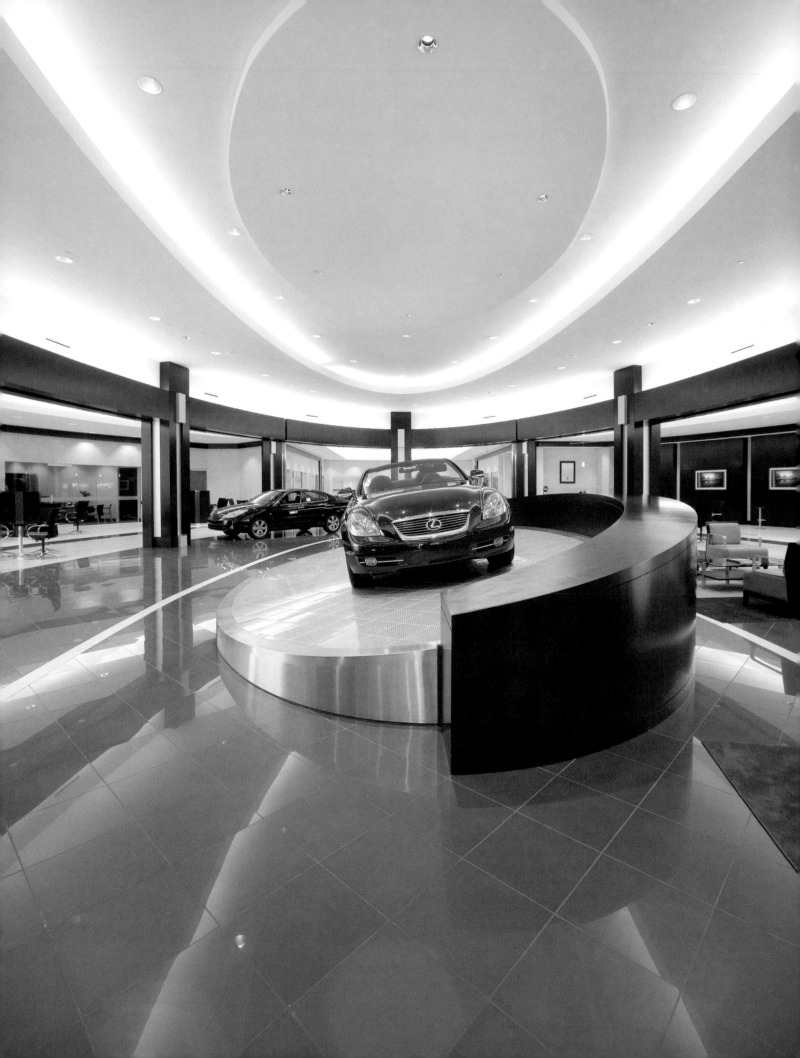

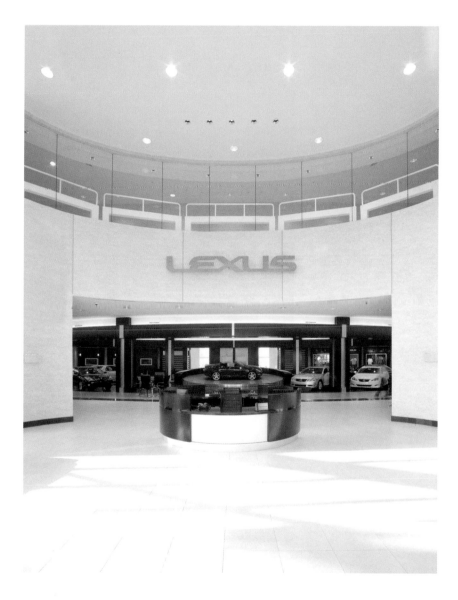

Bass Pro Shop, Denver
Big Box Retail

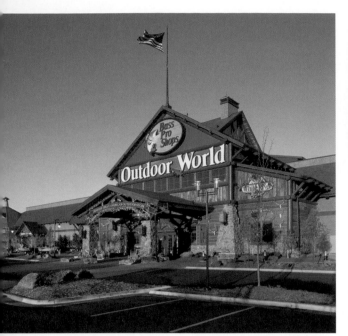

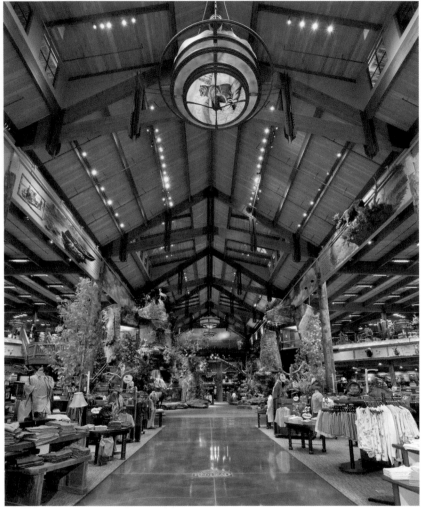

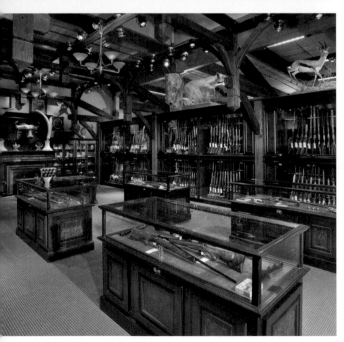

Bass Pro Shops prides itself on creating stores that bring the great outdoors indoors. The sporting goods retailer took that theme to a new level at its Outdoor World in Denver, where the Rocky Mountains serve as a spectacular backdrop to the two-level, 186,000-square-foot superstore.

Inside, store sports a "great lodge" theme, featuring a grand entrance framed with massive log and rockwork, a 63-foot-high central gabled clerestory, a series of outdoor-themed chandeliers, concrete flooring imprinted with dinosaur fossils and wildlife tracks, and a 21,000-gallon freshwater aquarium.

Design Bass Pro Shops Inc. Architect, Springfield, Mo. – Tom Jowett, vp, design and development; Tom Gammon, director, construction; Mark Tuttle, director, architecture; Allan Schomaker, director, visual imagery; George Carameros, director, visual merchandising; Lenny Clark, senior technical designer; Glennon Scheid, interior project manager; Steve Slaten and Glen Lewis, project managers; Monica Matthias, interior project manager – fixtures and signage; Rick Collins, taxidermy; Bruce Teter, director, retail planning; Jan Burch, national account manager/color coordinator *Architect/Structural Engineer* Butler Rosenbury & Partners, Springfield, Mo. *General Contractor* W.E. O'Neil Construction, Lakewood, Colo. *Outside Design Consultants* Hoss & Brown Engineers Inc., Lawrence, Kan. (MEP engineer); SWT Design, St. Louis (landscape architect); Randy Burkett Lighting, St. Louis, and Speirs and Major Associates, Edinburgh, Scotland (lighting); Cost of Wisconsin, Jackson, Wis. (aquarium contractor); Marvin Levine, Lipan, Texas (imagery); Chad Bryan, Atlanta (muralist); Brundege Studio, Rogersville, Mo. (design); Interior Planning Consultants, Springfield, Mo. (interior planning) *Aquariums* Precision Pool Inc., Pleasant Hope, Mo. *Carpentry* Duggan Contracting Corp., St. Peters, Mo. *Carpet* Bellbridge Inc., Benicia, Calif.; Mohawk Carpet & Affiliates, Calhoun, Ga.; Megerians Persian Rug Co. *Ceiling* The American Tin Ceiling Co., Bradenton, Fla. *Decorative Concrete* Colorado Hardscapes, Denver *Doors, frames and hardware* LaForce Inc., Vernon Hills, Ill. *Exterior Wall Texturing* Advanced Stucco Design Inc., Arvada, Colo. *Fireplace* Maschino's Home Express, Springfield, Mo. *Fixtures* Bass Pro Fabrication Shop, Nixa, Mo.; TJ Hale., Menomonee Falls, Wis.; Lozier, St. Peters, Mo.; Rocky Creek, Stephenville, Texas *Furniture* Country Casual, Gaithersburg, Md.; Flat Rock Furniture Inc., Waldon, Ind.; Hickory Chair, Hickory, N.C.; Vintage Veranda, Marion, Ark.; Roadside Rustics, Eureka Springs, Ark. *Imagery framing* PFI Artworks, Kansas City, Kan. *Imagery production* Luke LeTourneau, Overland Park, Kan.; Design Image, St. Louis; Bass Lithocolor Inc., Springfield, Mo. *Graphics* Garage Graphics, Springfield, Mo. *Landscaping* Schultz Industries Inc., Golden, Colo. *Lighting* City Lighting, Kansas City, Mo. *Masonry* Fischbach Masonry Inc., Lakewood, Colo. *Mechanicals* Works Ultd., Orlando *Paints* Service Painting Corp., Orlando *Roofing* D&D Roofing Inc., Commerce City, Colo. *Signage* LSI Graphics Solutions Plus, North Canton, Ohio *Software* Marilyn Systems LLC, San Antonio *Taxidermy* Nature's Design, Cody, Wyo.; Safari World, Three Lakes, Wis. *Tile* Cody Flooring & Tile, Golden, Colo.; Unique Tile Ltd., Nixa, Mo. *Photography* Douglas K. Hill, Hill Photographics, Snellville, Ga.

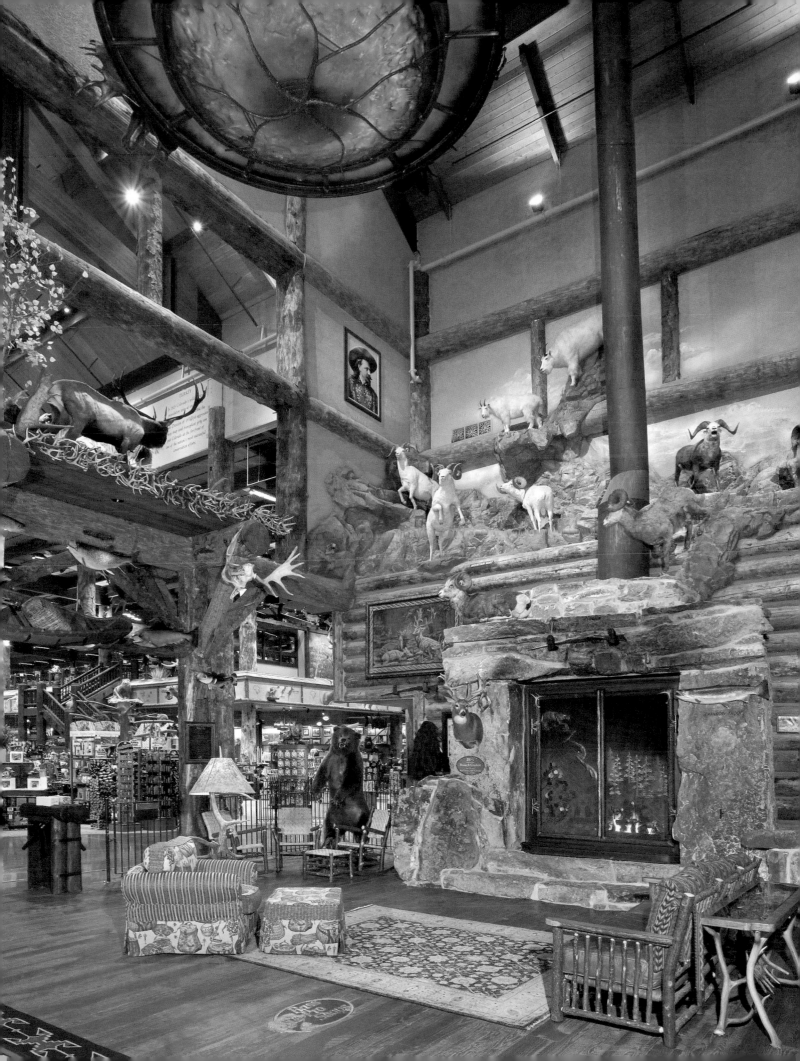

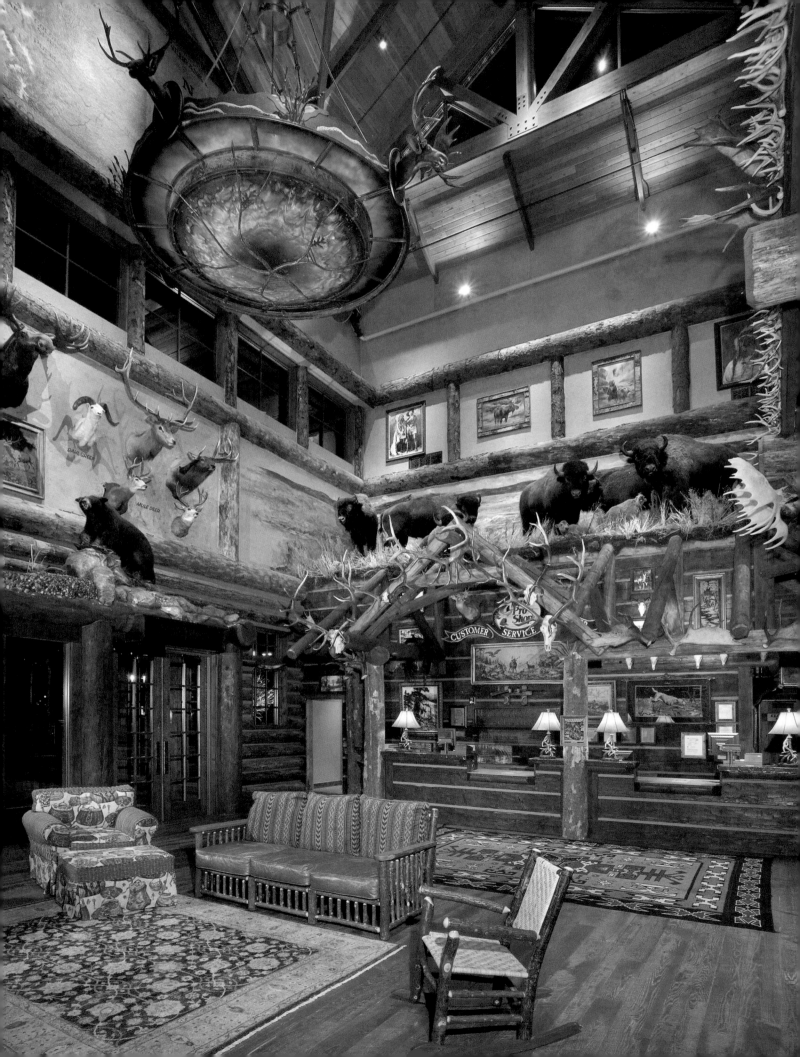

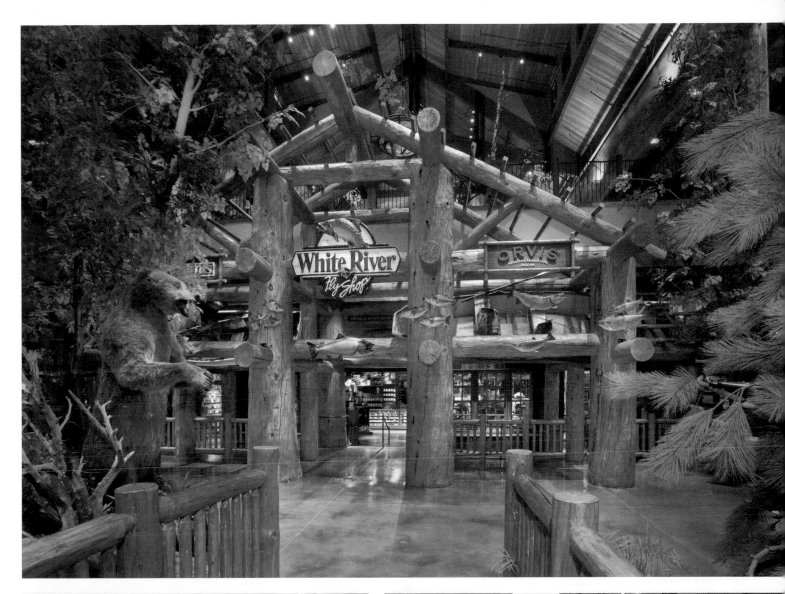

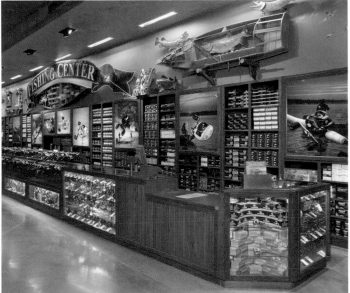

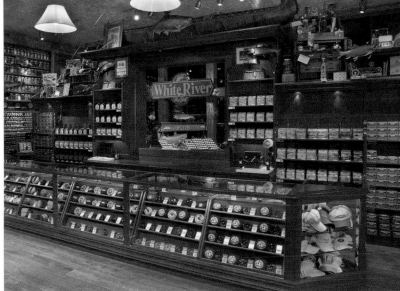

AWARD OF
MERIT

Judith Leiber, Las Vegas
Specialty Store, Sales Area Under 1500 square feet

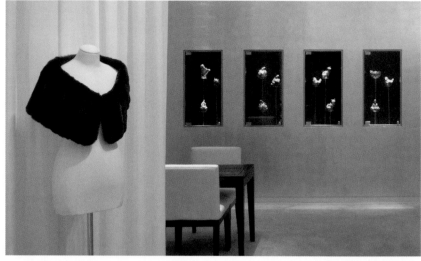

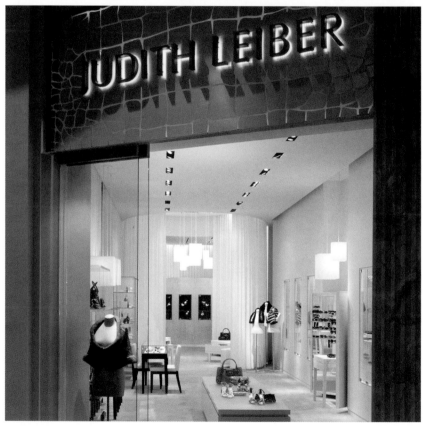

Judith Leiber's new, full-accessory Las Vegas store in The Forum Shops at Caesars was designed to set the precedent for the retailer's expansion, both invigorating the luxury brand and targeting a new audience.

The store's contemporary edge is aimed at a younger audience. Luxe materials and treatments echo the elegance of new, chic, exotic leather goods, furs and footwear, while the store more playfully showcases the brand's legacy jeweled handbags, in dramatic dioramas.

The design paces the customer experience with distinct merchandise zones and multiple ceiling heights. The store opens like a flower, revealing spaces of greater texture, color and symbolic significance for the brand. The entrance features a laser-cut alligator pattern at the shop's façade. Inside, open merchandise techniques depart from the brand's previous store designs.

Client Judith Leiber, New York *Design* Callison, Seattle – Norman Roberts, designer; Christine Nakaoka, designer; Tom Pulk, project architect; Se Hwa Yoo, project architect; Andy Thaemert, designer *Outside Design Consultants* Cooley Monato, New York (lighting); Henderson, Kansas City, Mo. (mechanical/electrical/plumbing) *Interior Millwork, Fixtures* Salzburg Interiors, Brampton, Ont. *Photography* Chris Eden, Callison, Seattle

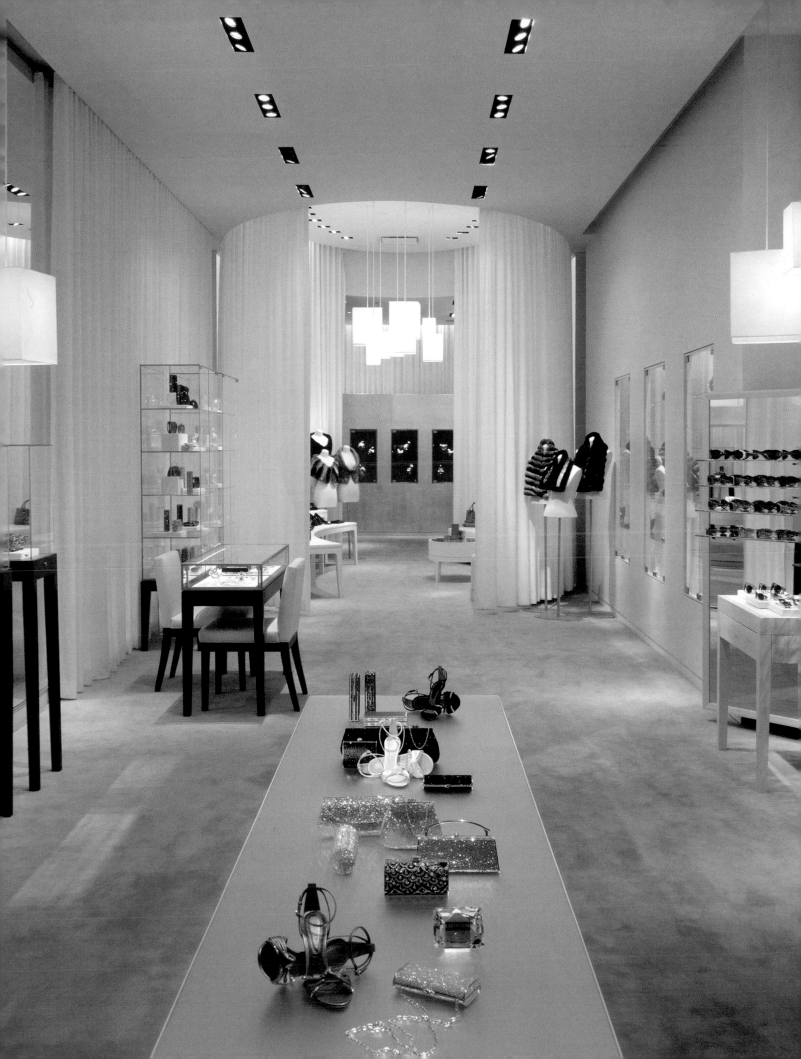

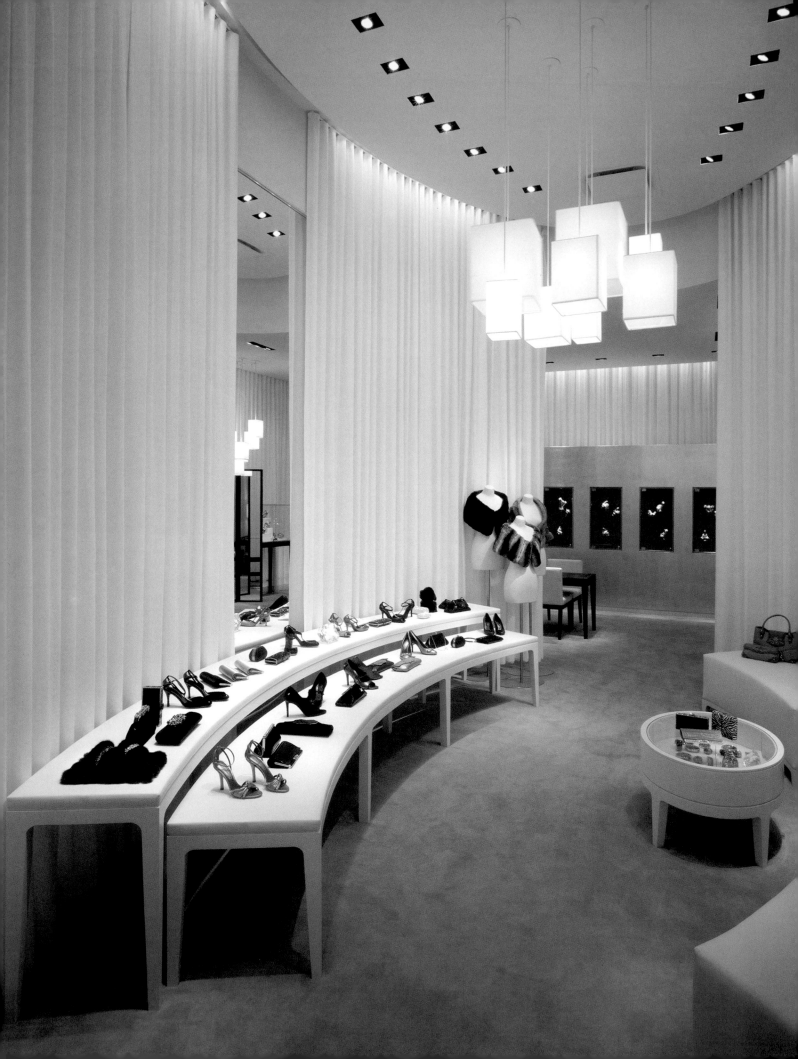

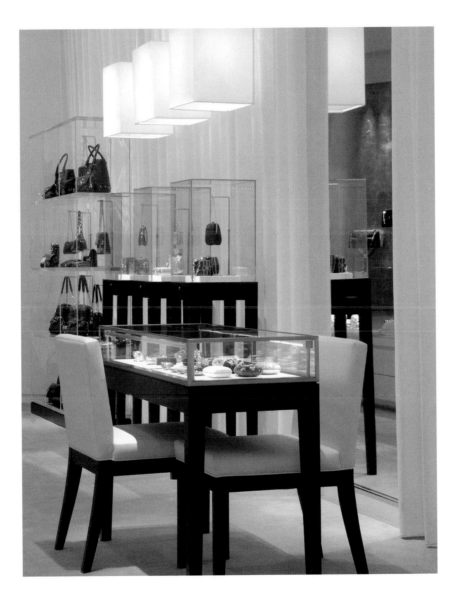

Fido, Toronto
Specialty Store, Sales Area 1500 to 3000 square feet

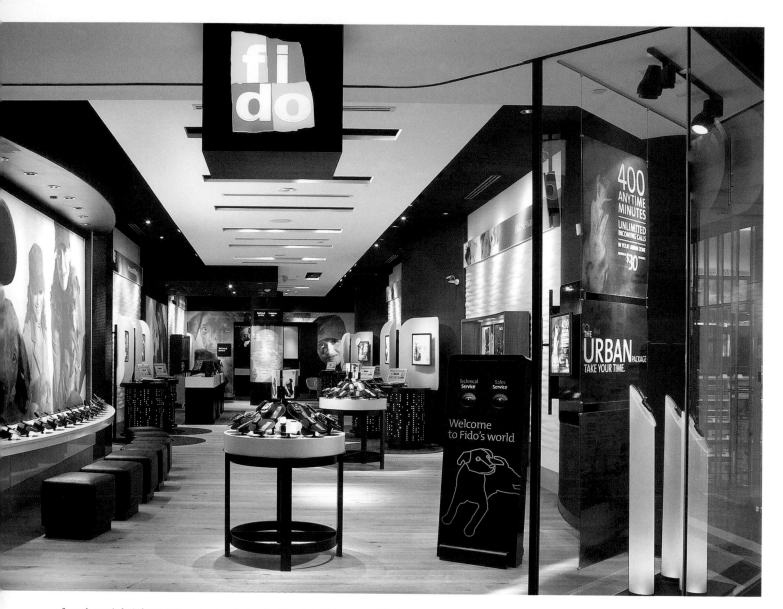

An urban-style loft was the design inspiration for Toronto's Fido store. GHA shoppingscapes (Montreal) created the concept for the Canadian electronics store to enhance the customer experience, improve operations and better define its brand image.

The layout integrates black, circular sales pods, wall accessory units as well as a Demo Bar with leather stools onto the perimeter walls, allowing for more flow within the store from the entrance to the technical service lounge at the rear. The lounge is separated by laminated glass and features dark walls with lime green chairs for customers who need assistance.

White-textured square wall panels by Artitalia (Montreal) imitate contemporary brick and draw the eye to Fido phones and services. Black-tiled walls and wide, wood plank flooring further accentuate the loft aesthetic.

Oversized muted-toned lifestyle images reinforce the Fido brand without overwhelming the merchandise.

Client Fido, Toronto – Patrice Tetrault; Tino Cosenza; Suzanne Dubuc; Caroline Le May *Design* GHA shoppingscapes, Montreal; Paola Marques, senior designer; Oxana Boriak, designer *Architect* STOA Architecture, Montreal *General Contractor* Dama Construction, Dorval, Que. *Outside Design Consultants* ModulTech, Montreal (fixturing); Dallaire Consultants, Montreal (mechanical and electrical engineers); BOS Communications, Montreal (branding and graphics) *Flooring* KAHRS, Montreal; Interface, Montreal *Lighting* NRG Management, Montreal; Lighting Engineering Intl. Group (LEIG), Montreal *Signage* Vision Dek-Or, Laval, Montreal *Millwork/Fixtures* Nemus Ebenisterie, Montreal *Wall Panels* Artitalia Group, Montreal *Photography* Yves Lefebvre, Montreal

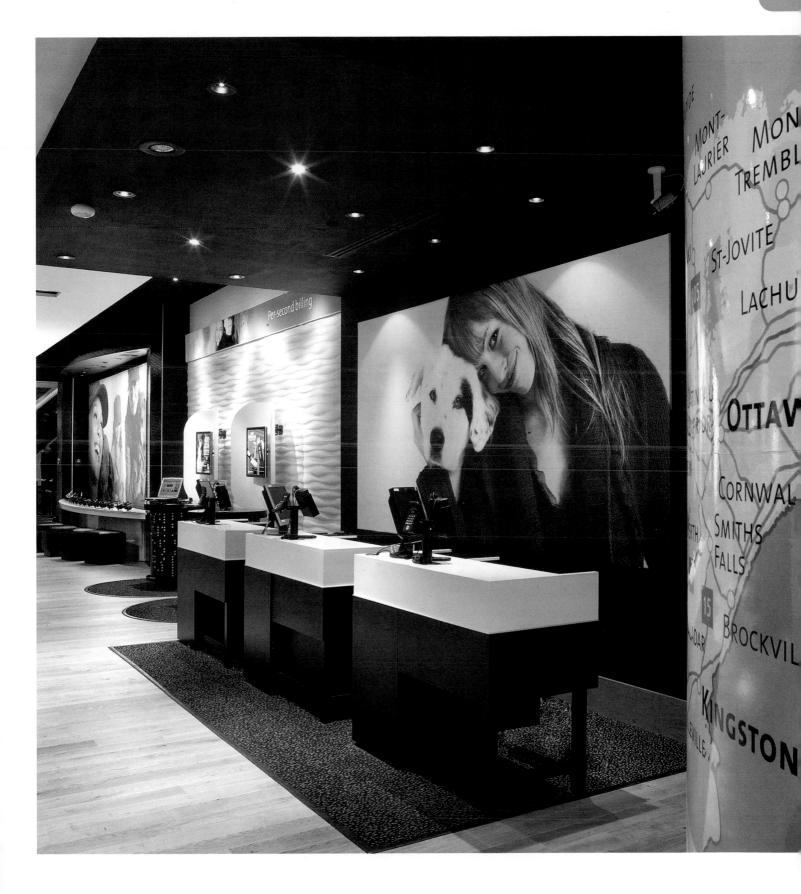

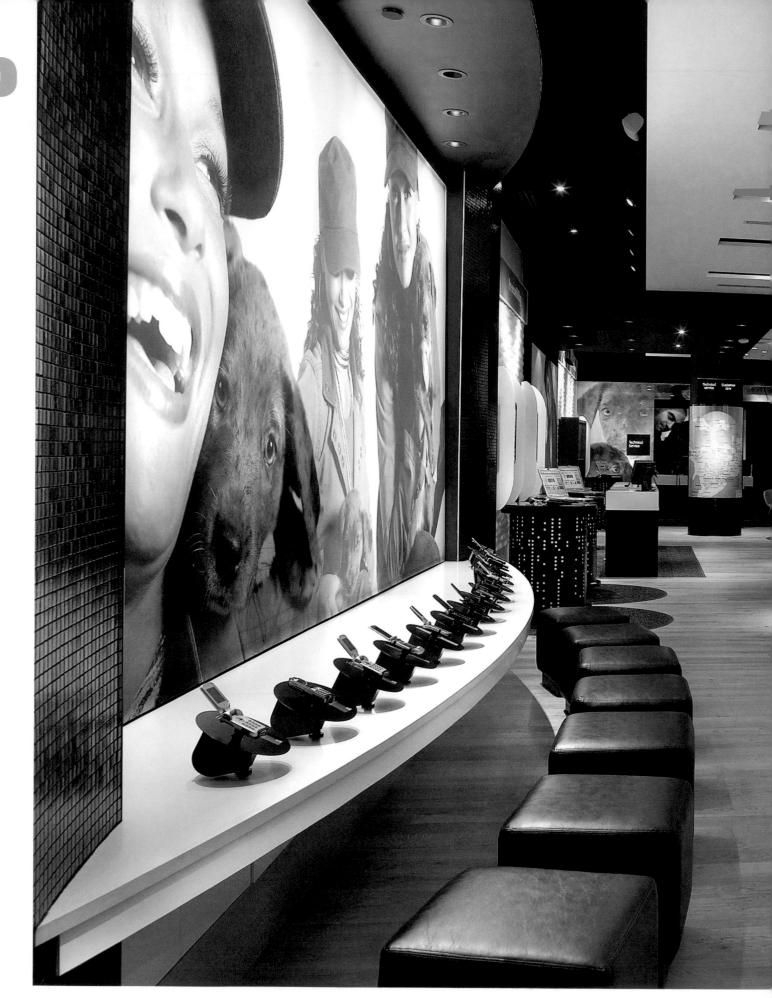

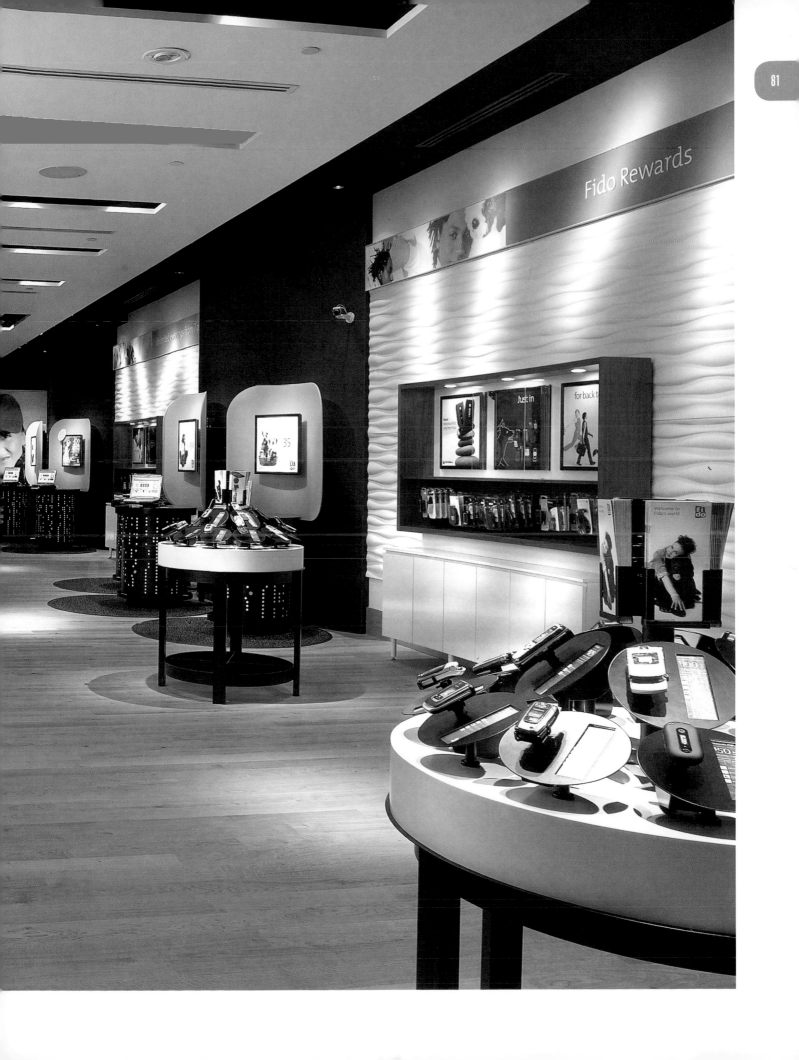

Victoria's Secret, Chicago
Specialty Store, Sales Area 5000 to 10,000 square feet

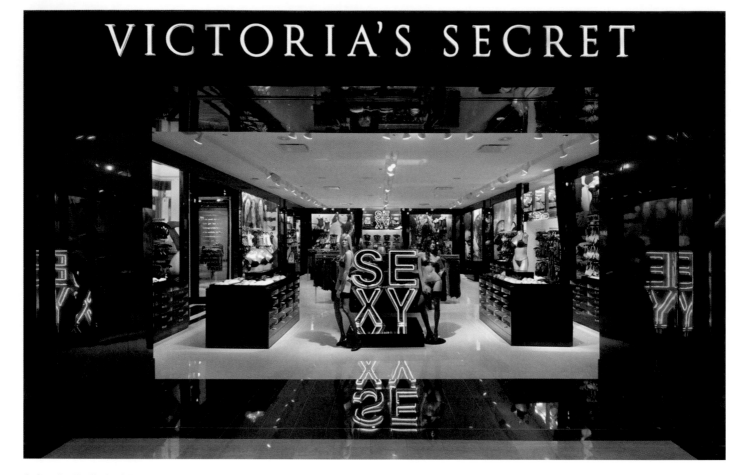

Before Justin Timberlake brought "SexyBack" in song, Victoria's Secret was toying with its own version of a sexy comeback. The provocative purveyor of unmentionables that prides itself on over-the-top fashion shows and an overwhelming amount of pink, introduced its new "sexy environments" concept at Water Tower Place in Chicago – a sort of divide-and-conquer plan that shows the sum of its parts might just be greater than the whole.

Glossy, almost liquid-black walls flank the entryway. A hot pink neon sign squeezed between two supermodel mannequins beckons to passersby, practically daring them to avert their eyes. Inside, the layout has changed. Each sub-brand (Pink, Sexy Little Things, Beauty) has its own room – something designers believe will create a powerful drive within the individual brands to bring the overall dynamic "mega-brand" of Victoria's Secret to life.

The sub-brand room environments are made up of proprietary wallcoverings and color schemes that tell individual stories, yet still manage to flow together with consistent sexed-up, super-sized graphics and cutesy neon pink signs with maxims like, "Life is Pink Life" and "I Love Victoria's."

Client Victoria's Secret, Columbus, Ohio; Shirley Schmitter, vp, store design and construction; Kathleen Baldwin, vp, prototype design; Chris Brown, director, design; Ed Hofmann, director, prototype design; Ed Kunzelman, director, construction; Matt Bosserman, designer; Kerry Weber, project manager; Van Shuff, purchasing agent; Michelle January, purchasing brand manager; Nikki Early, purchasing agent; Liz Elert, senior vp, visual merchandising; Jon Johnson, vp, visual merchandising; Anthony Battaglia, vp, visual merchandising; Kevin Houlihan, art director; James Jones, visual project manager; Traci Bentine, director, visual merchandising *Architect* McCall Design Group, San Francisco *General Contractor* Shrader Martinez Construction, Sedona, Ariz. *Outside Design Consultants* Grenald Waldron Associates, Narberth, Pa. (lighting) *Fixtures* SAJO, Montreal; Pinehurst, Mississauga, Ont.; L.T. Custom Finishing, Vaughan, Ont. *Flooring* Innovative Marble & Tile Inc., Happauge, N.Y. *Furniture/Drapery* Retail Solution Center, Freeport, N.Y.; Martin Albert Interior, New York *Lighting* Capitol Lighting, Hartford, Conn. *Mannequins/Forms* Patina-V, City of Industry, Calif.; Adel Rootstein USA Inc., New York; Manniques Sempere, New York *Props/Decorations/Graphics* PhotobitionColor Edge, Versailles, Ky.; Martin Albert, New York *Signage* Ruggles Sign Company, Versailles, Ky. *Audio* DMX Inc., Seattle *Wallcoverings/Materials* Maya Romanoff Corp., Chicago; Circle Fabrics, New York *Photography* © Peter Aaron, Esto, Mamaroneck, N.Y.

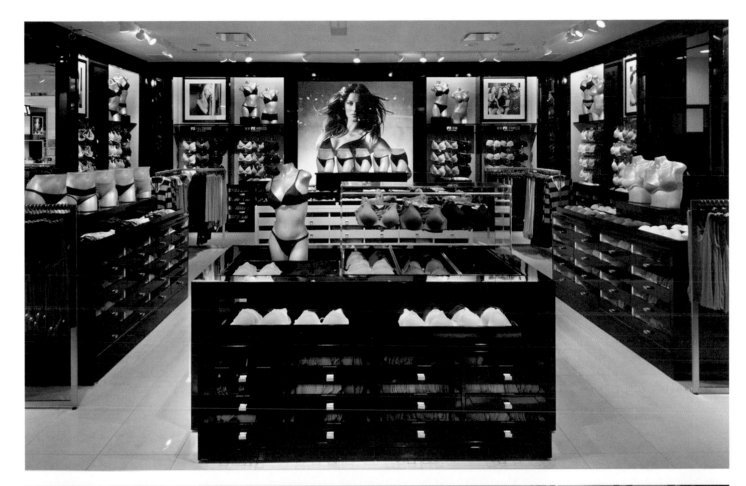

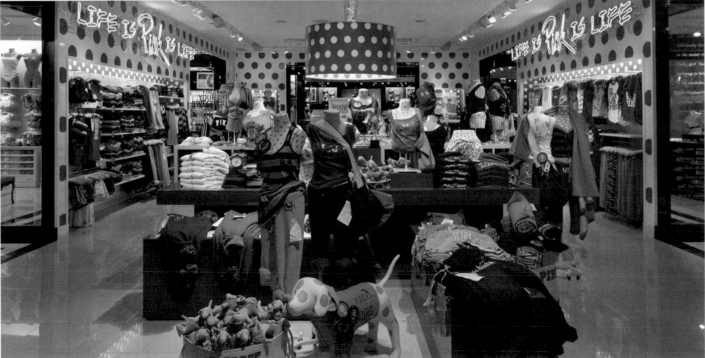

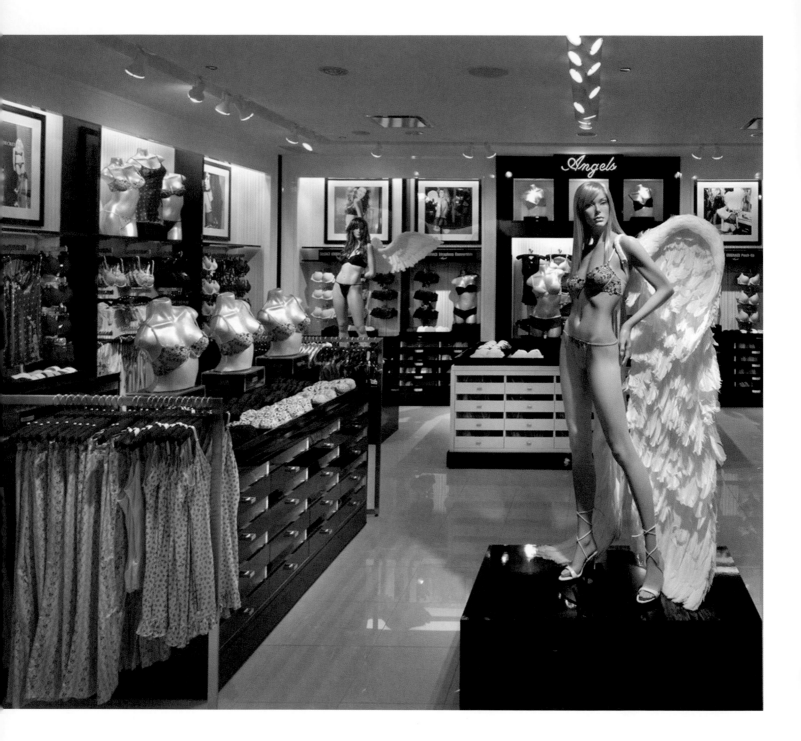

Jinsei Restaurant, Birmingham, Ala.

Sit-Down Restaurant (tie)

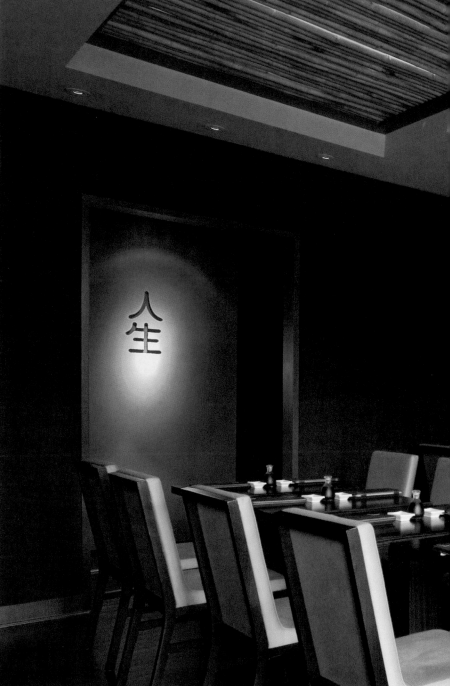

The artistry of sushi making is almost as mouthwatering and beautiful as the delectable cuisine itself. Designers from Chute Gerdeman sought to capitalize on that artistry when creating a hip, modern environment for Jinsei (meaning "life" in Japanese), a sushi restaurant in Birmingham, Ala.

To redefine diners' impression of a sushi restaurant, and to echo the deliberate presentation of finely prepared sushi, designers turned to modern materials, clean lines and splashes of color.

Taking cues from traditional sushi ingredients, designers chose a wasabi green color to stand out on the walls, chairs, and lounge stools and in the restaurant's new logo. A transparent beaded wallpaper, referencing tiny fish eggs, covers the curved soffit. And a black booth wraps around most of the restaurant, from the lounge area through the dining room, like seaweed wrapping a roll.

Rich chocolate and reddish tiger woods were used for the flooring, tables, bar and walls. Bamboo, a common element in sushi restaurant decor, was given a modern twist by as a transparent screen separating the restaurant dining area from the sushi bar and as an illuminated mat above the dining area.

Client Zoe's Kitchen U.S.A., Birmingham, Ala. – John Cassimus, president and ceo *Design* Chute Gerdeman, Columbus, Ohio – Elle Chute, principal; Lori Mukoyama, creative director environments; Glennon Schaffner, program director design development; Jodi Backes, project manager; Carmen Costinescu, colors and materials; Asako Maruyama, graphic designer; Kyle Barker, floor planning and presentation *Architect* CG Architecture, Columbus, Ohio *General Contractor* Bradford Building Co., Birmingham, Ala. *Outside Design Consultant and Engineer* M-Retail Engineering Inc., Westerville, Ohio *Audio/Visual* Audio Video Excellence Inc., Homewood, Ala. *Ceilings* Safari Thatch, Fort Lauderdale, Fla. *Fabrics* Donghia Inc., Mount Vernon, N.Y.; Rosul & Associates, Lakewood, Ohio; Unika Vaev, Powell, Ohio *Flooring* Junckers Hardwood Inc., Anaheim, Calif. *Furniture* Hall Weir & Associates, Atlanta *Glass* 3Form, Salt Lake City *Lighting* Lighting Management Inc., Harriman, N.Y.; Design Lighting Group, Chicago *Millwork* S&G Manufacturing Group, Columbus, Ohio *Paint* ICI Design & Construction, Toronto *Special Finishes* Brookside Veneers Ltd., Cranbury, N.J. *Tile* Waterworks, Danbury, Conn. *Photography* Jason Wallis, Birmingham, Ala.

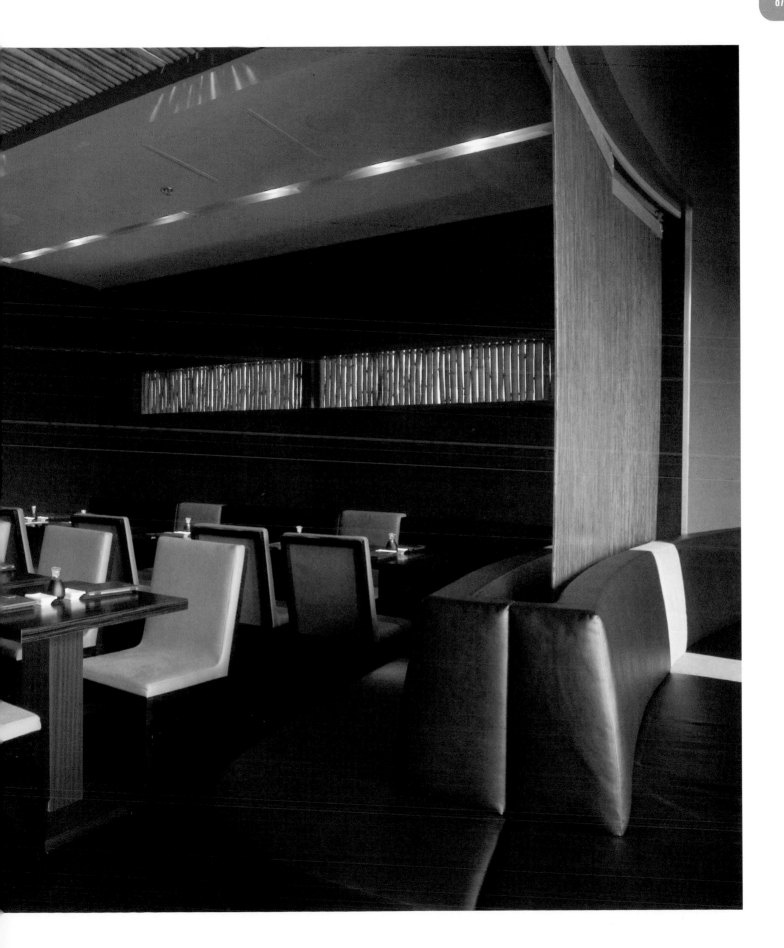

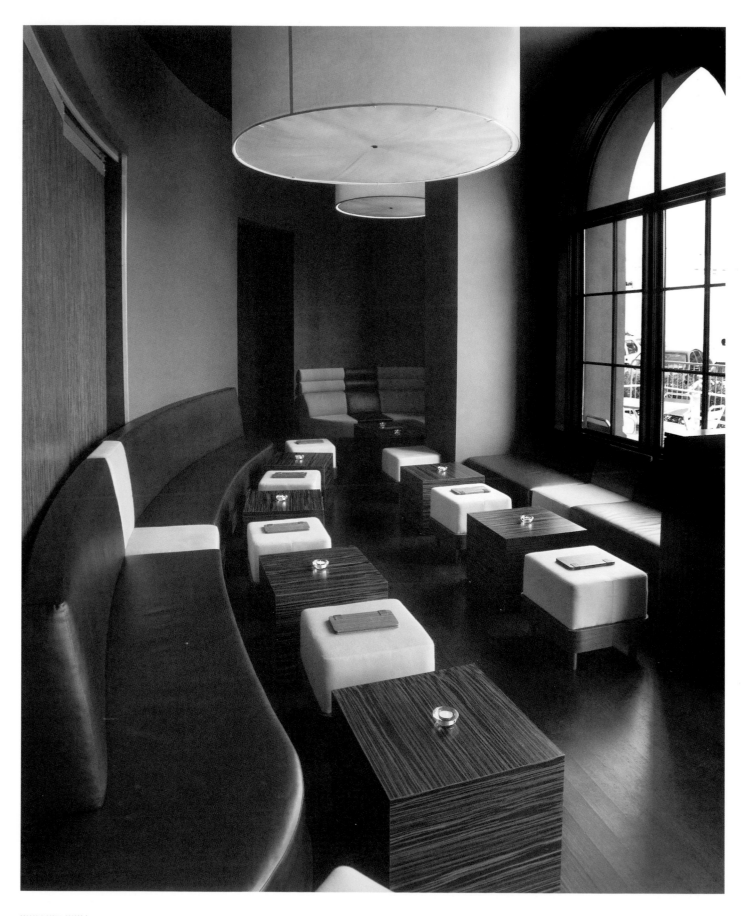

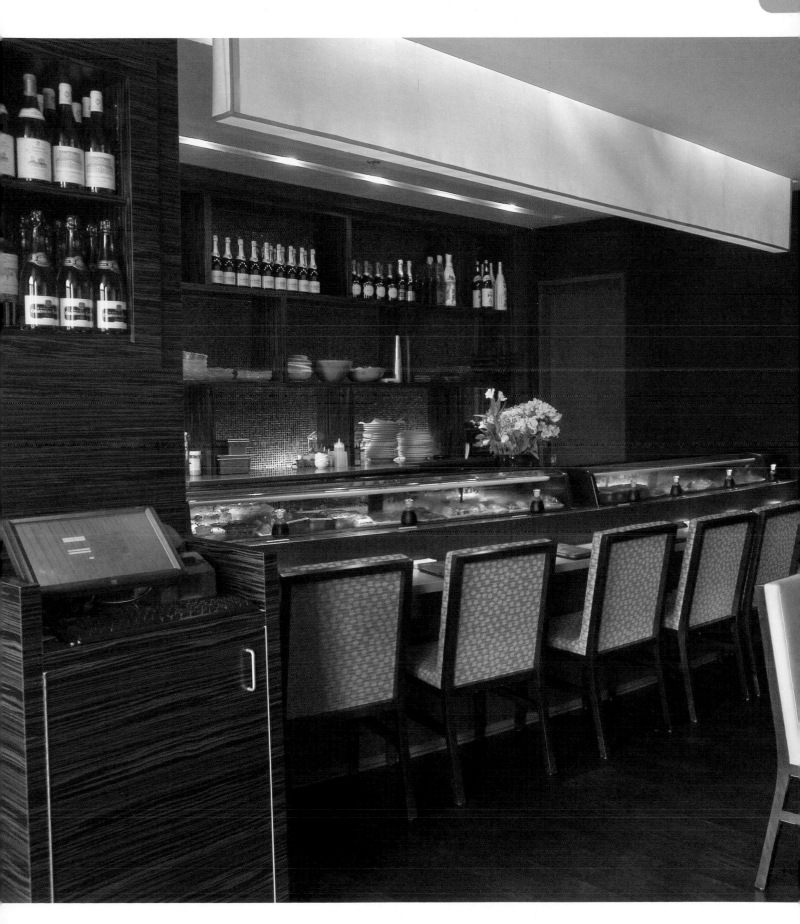

Table Restaurant and Bar, Charlotte, N.C.
Sit-Down Restaurant (tie)

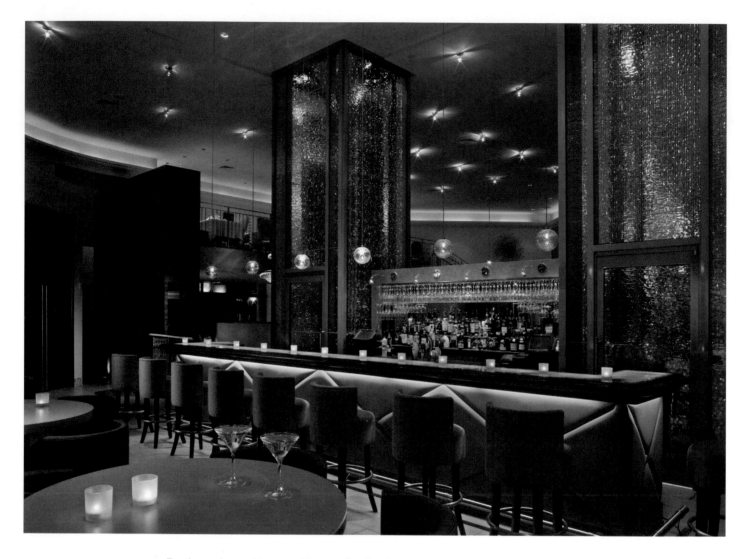

For those who want to see and be seen, the place to get a table is at Table Restaurant and Bar in Charlotte, N.C. Designers transformed this "new American cuisine" restaurant, located in a suburban lifestyle center, into a space where Old Hollywood glamour and contemporized Art Deco come together in comfortable sophistication.

The restaurant is divided into two spaces with floor-to-ceiling draperies framing the private dining area, while 18-foot tall towers inset with sparkling fiberoptics separate the lounge and dining areas.

A warm palette of pink, light blue, cantaloupe and brown references a time when tailcoats and flapper dresses were in fashion. Lighting sets the stage for a dramatic environment with sparkling spotlights inset into the 20-foot high ceilings.

A band of pink cove lighting runs the length of the perimeter, further emphasizing the glamour within. Chandeliers hanging above tables and a large walnut-framed wall graphic of the owner's grandparents offer touches of the past.

Client Alex Myrick, AM Restaurant Group, Charlotte, N.C. *Design and Architecture* Little Diversified Architectural Consulting, Charlotte, N.C. – Steve Starr, studio principal; Todd Rowland, design director; Paige Brice, senior designer; Chris Finn, project manager; Darby Tucker, designer *General Contractor:* The McAllister Group, Charlotte, N.C. *Outside Design Consultants:* Lighting Management Inc., Harriman, N.Y. (lighting); Saber Engineering, Auburn, Calif. (PM&E Engineering); WGPM Inc., Charlotte, N.C. (structural) *Carpet* Durkan, Raleigh, N.C. *Fabrics* Knoll Textiles, Charlotte, N.C. *Furniture* Holder Restaurant Furniture, Lenoir, N.C. *Light Cove* Casting Designs Inc., Fort Worth, Texas *Lighting* Times Square Lighting, Stony Point, N.Y.; Con-Tech Lighting, Northbrook, Ill.; Jesco Lighting Group, Glendale, N.Y. *Stone* Pinnacle Marble & Granite, Baltimore *Tile* Dal-Tile, Dallas; Walker Zanger, Charlotte, N.C. *Photography* Paul Warchol Photography Inc., New York

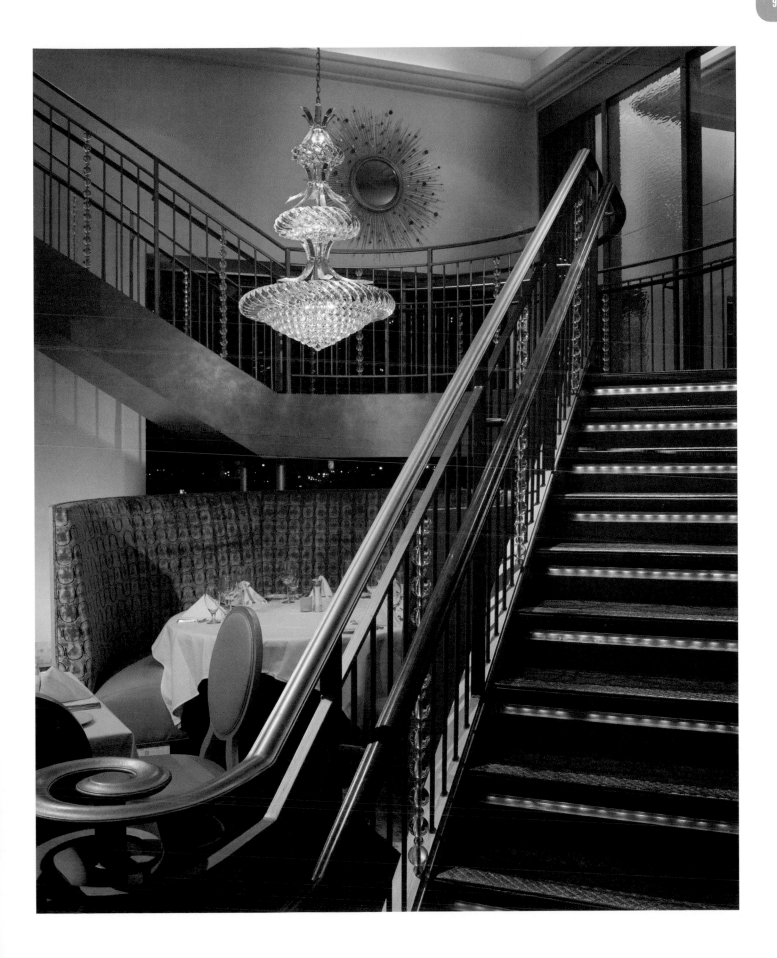

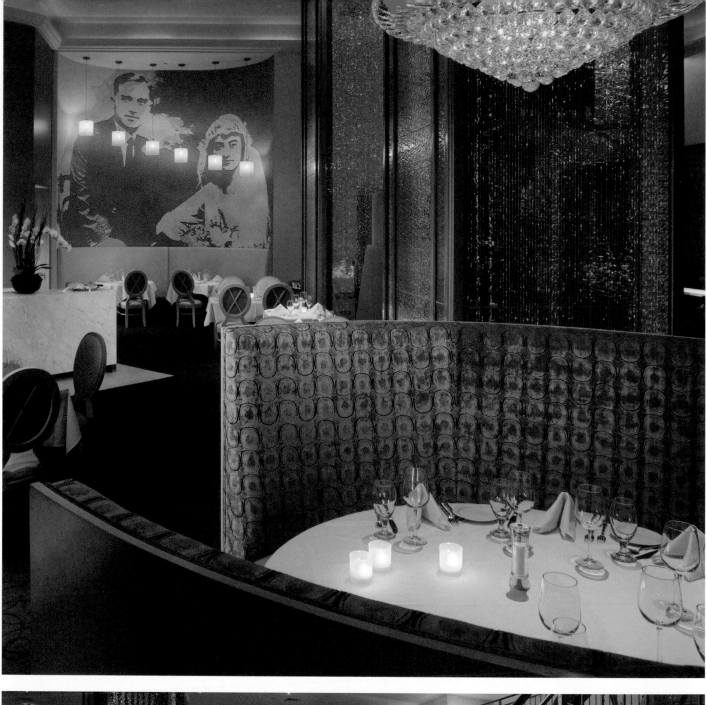

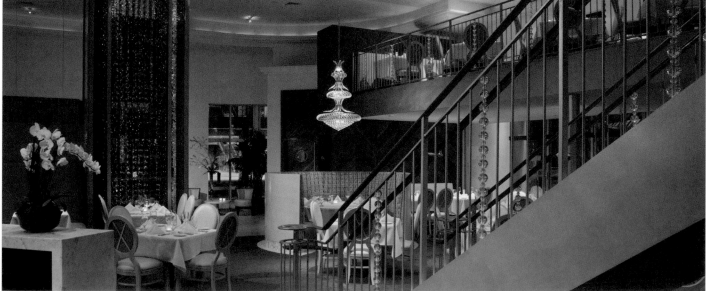

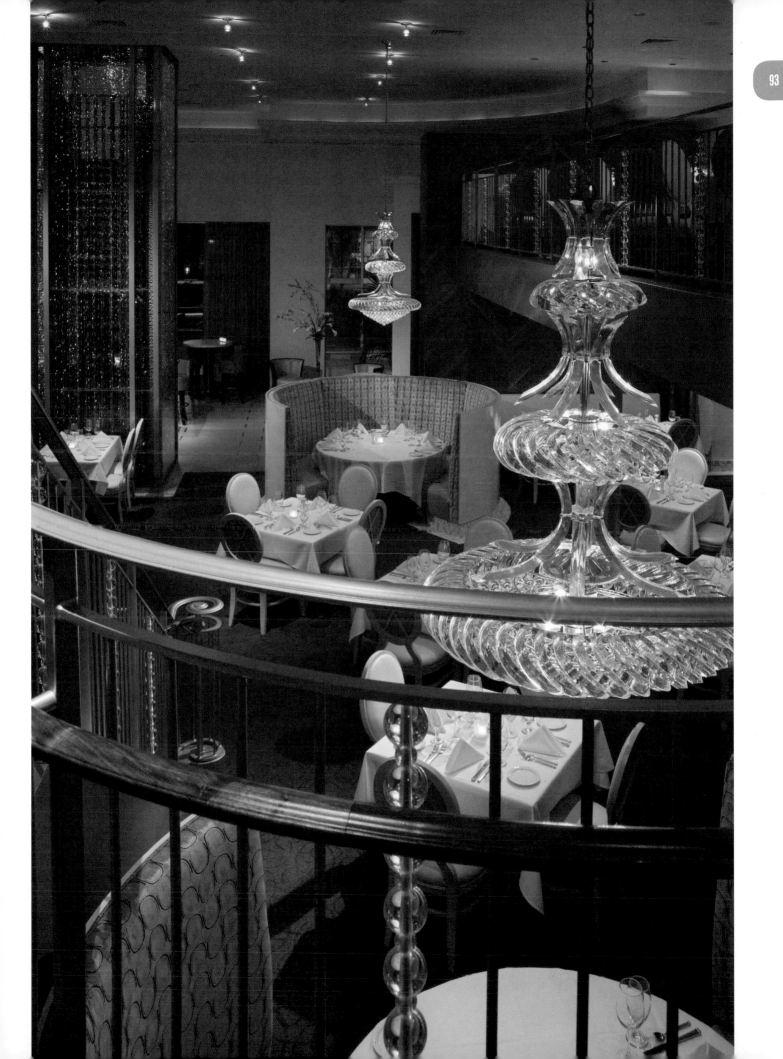

Benihana, Miramar, Fla.
Sit-Down Restaurant (tie)

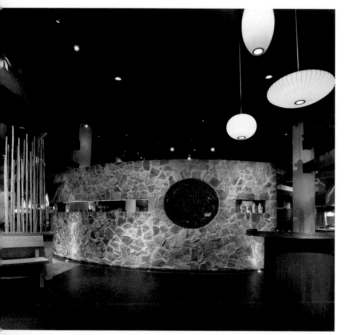

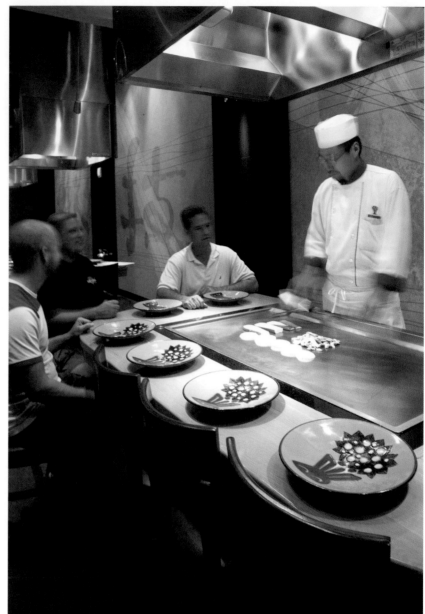

Japanese culture and architecture were given a modern-day twist using organic elements and natural materials at the new Benihana restaurant in Miramar, Fla. Designers sought to redefine the Benihana brand and its Japanese heritage using contemporary materials that elevated the image of the Japanese steakhouse.

The 6500-square-foot restaurant houses a central circular bar and sushi bar. A curving stone wall with a banded window offers a glimpse from the bar area into the restaurant's two dining rooms, each themed under the concepts "Energy" and "Spirit." A warm color and graphics, including a red Benihana flower, demark the "Spirit" area, while the "Energy" side is noted by a blue wave graphic and rich green textured concrete.

Stages were also created in the dining area using backdrops relating to each dining area's theme to create a proper setting for the theatrical dining experience. Nearby, two teppanyaki tables provide space for smaller dining parties.

Client Benihana, Miami – Joel Schwartz, ceo; Taka Yoshimoto, executive vp, operations; Juan Garcia, senior vp and chief administrative officer; Joseph Abbruzese, senior director, construction and facilities; Tom Bergen, director, real estate *Design/Architecture* WD Partners, Dublin, Ohio – Lee Peterson; Mark Godward; Juan Martinez; Bob Welty; Carline Mia; Clayton Smith; Mahbuba Hatem; Robin Gibson; Eric Mayle; Yoshiko Shimono, Christopher Michaels; Michelle Isroff; Randy Moore; Rob Turner; Chris Carr; Chris Martin *Outside Design Consultant* Optic Nerve Art Corp., Columbus, Ohio (Benihana family crest, metal work) *Ceiling* Celotex, Tampa; Gypsum Board Ceiling, Kent, Wash. *Concrete* L.M. Scofield, Rutherford, N.J.; Ohio Cemtech, Wyoming, Ohio; EFS: Dryvit, Columbus, Ohio *Fixtures/Woodwork* Mock Woodworking, Zanesville, Ohio *Lighting* Western Extralite, Kansas City, Mo. *Metal Graphics* P&R Group, Chicago *Paint* Pittsburgh Paints, Pittsburgh; Sherwin Williams, Minneapolis *Plastic Laminate* Arborite Surface Materials, Solon, Ohio *Shades with custom graphics* Sun or Shade, Dublin, Ohio; Inside Outfitters Inc., Dublin, Ohio *Signage* North American Signs Inc., South Bend, Ind. *Tile* Hamilton Parker, Columbus, Ohio; Wall, Worthington, Ohio *Vinyl* Johnsonite, Chagrin Falls, Ohio *Wood Panel* Architectural Systems Inc., New York *Photography* Mark Steele Photography Inc., Columbus, Ohio

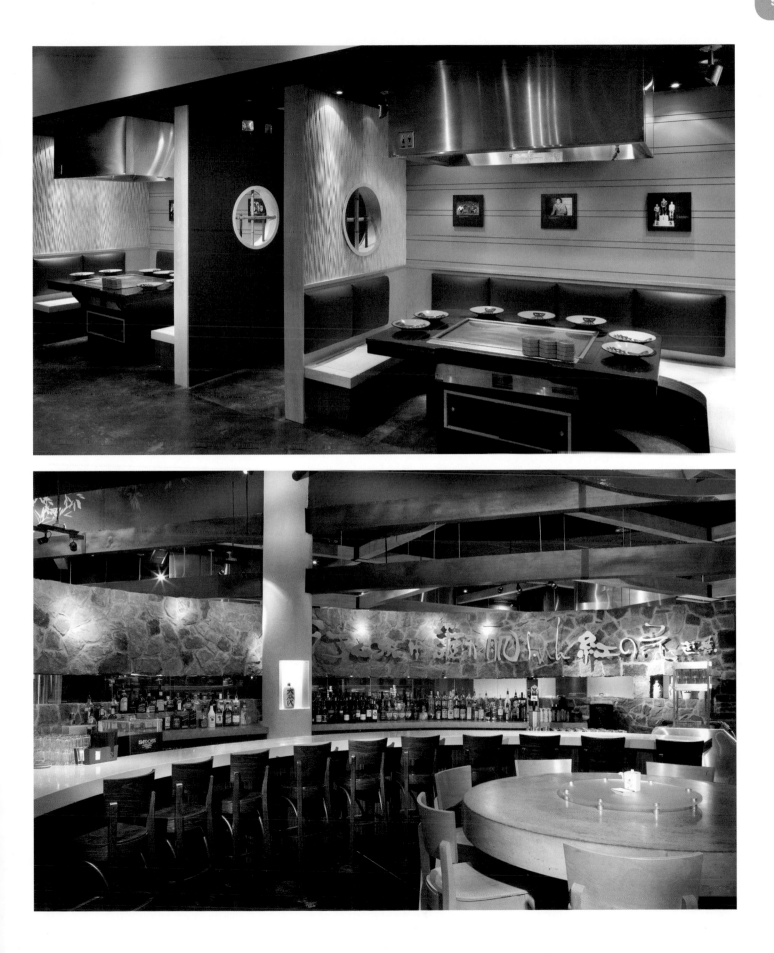

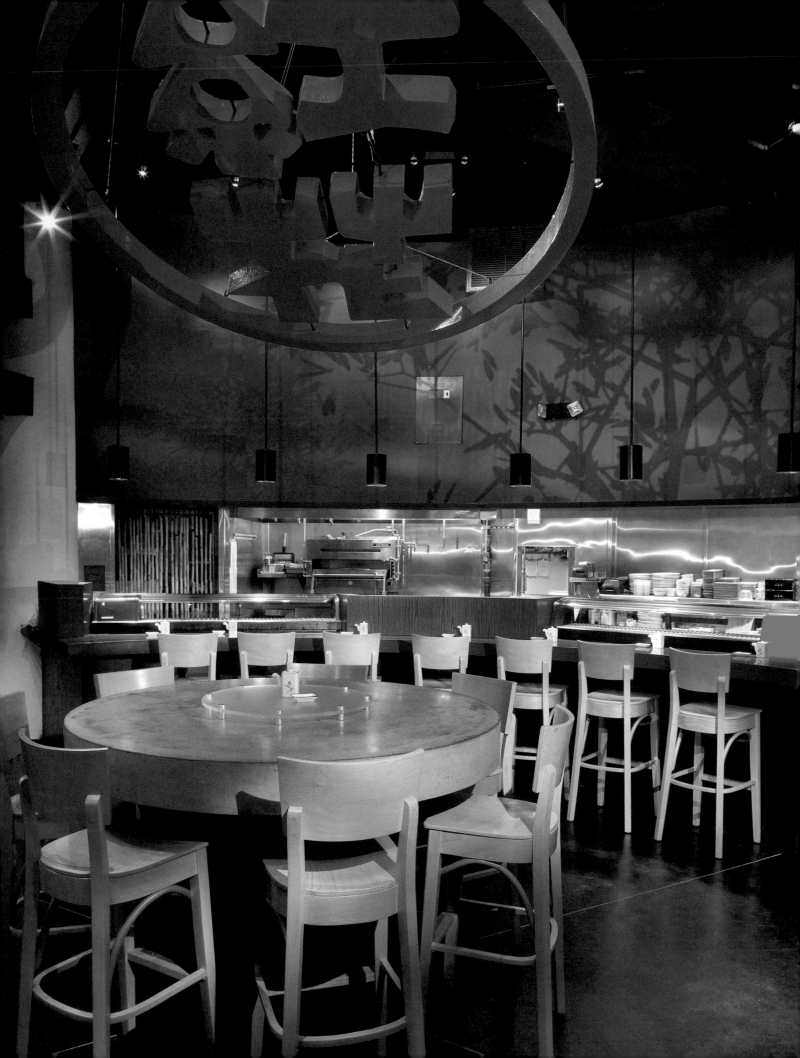

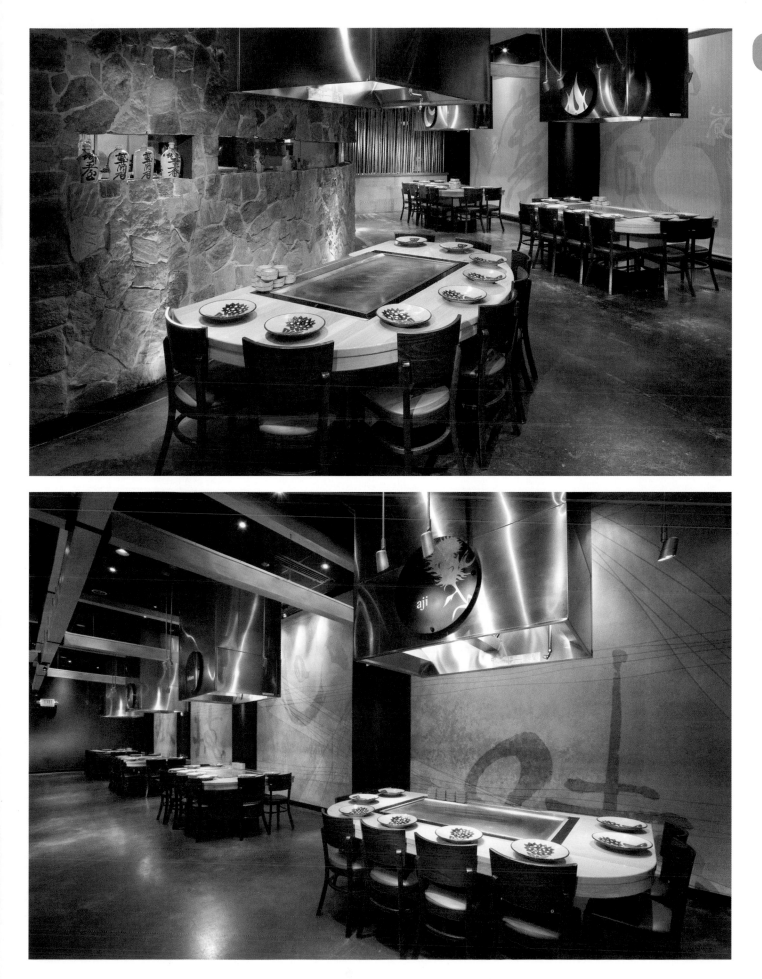

Hypercity, Mumbai, India
Big Box Retail

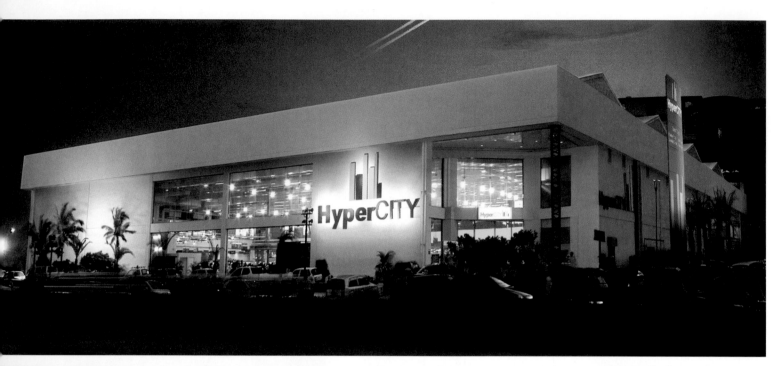

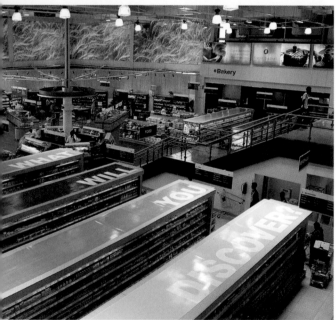

Designers of the Hypercity market in Mumbai describe it as "a glimpse into the future of retailing in India." The two-level, 120,000-square-foot store houses apparel, appliances, books, electronics, food, health and beauty, housewares, sporting goods, stationery and toys.

Whitewashed walls and exposed ceilings give the space an uncomplicated feel. To help make the shopping experience enjoyable and interactive, a variety of "experience builders," including demo kitchens and a gaming zone, were incorporated into the store.

Client Hypercity, Mumbai *Design* JHP, London – Raj Wilkinson, David Rook, Heike Brandt, Darren Scott *Architect* Anil Salian & Associates, Mumbai *General Contractor* Narsi & Associates, Mumbai *Air curtains* Aircon Engineering Pvt. Ltd., Mumbai *Electrical Systems* SNS Electricals, Thane, India *Fixtures* Hub's Engineering Pvt. Ltd., Singapore; Disha Retail Fixture Ltd., Bangalore, India *Lighting* Shri Sagar Traders, Mumbai *Refrigeration* Carrier Refrigeration Pvt. Ltd., Mumbai *Photography* Sanjay Marathe Photography, Mumbai

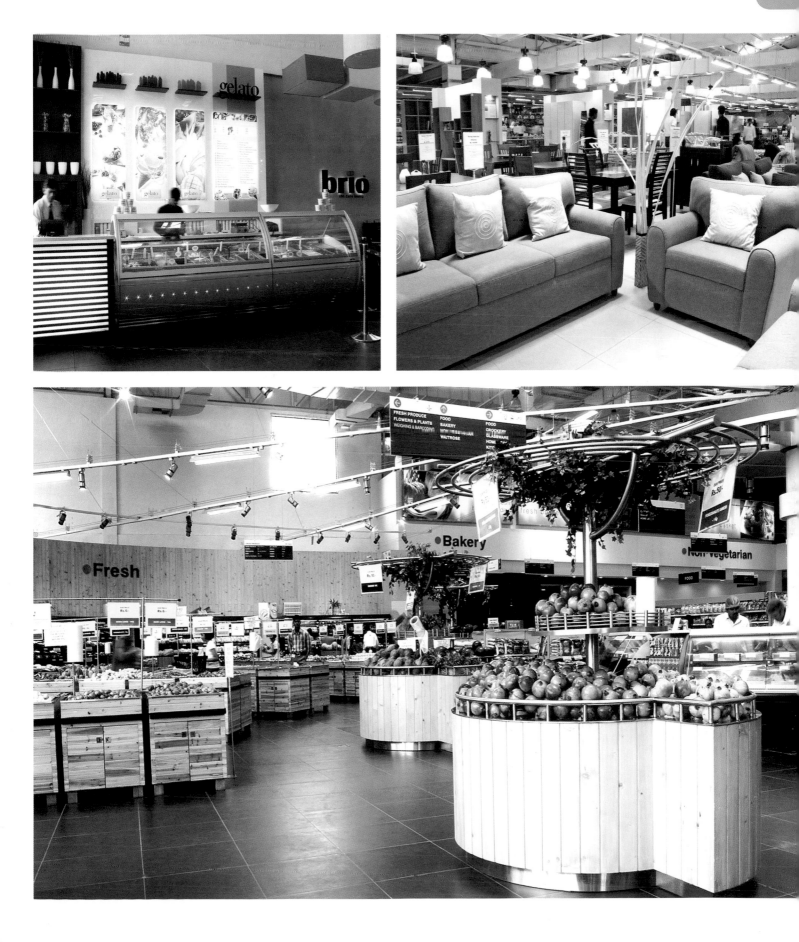

Tool Depot, The Home Depot Canada, Toronto
Special Award – Signage and Graphics

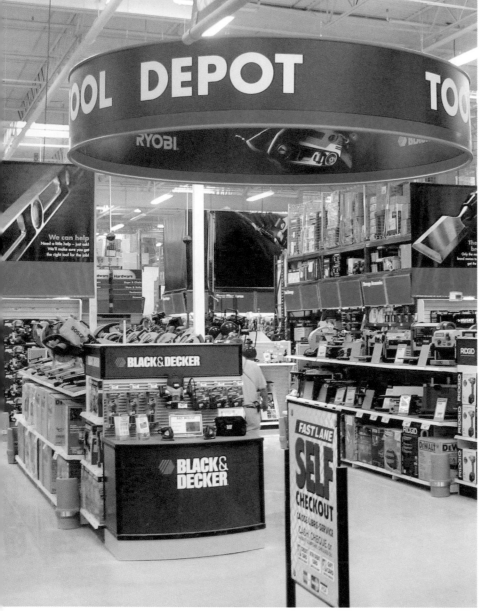

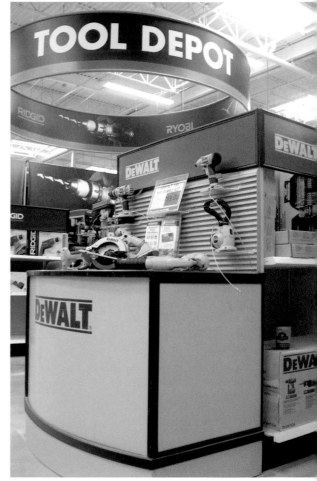

The Home Depot of Canada has undertaken a major push to remake its tool departments into the destination of choice for professional contractors and do-it-yourself consumers. Signage plays a central role in that upgrade.

A hanging central rotunda, with "Tool Depot" emblazoned in white letters on a black background edged with Home Depot's signature orange around its bottom, serves as a wayfinding element for the department. Further demarcating the department are high-wall graphics around the periphery bearing large black-and-white images of individual tools.

In addition, product within the department has been re-merchandised by category, brand name and price, with category headers displayed on a continuous orange band. Brand towers at the front of the space offer promoted items in a high-visibility setting.

Client Home Depot of Canada, Toronto *Contractors* Icon, Vaughn, Ont.; DG Ltd., Vaughn, Ont.; McMurray Interiors, Edmonton, Alberta *Fixturing* The Store Fixture Group Inc., Waterloo, Ont. *Graphics* Perennial Inc., Toronto *Photography* Richard Patmore, Toronto

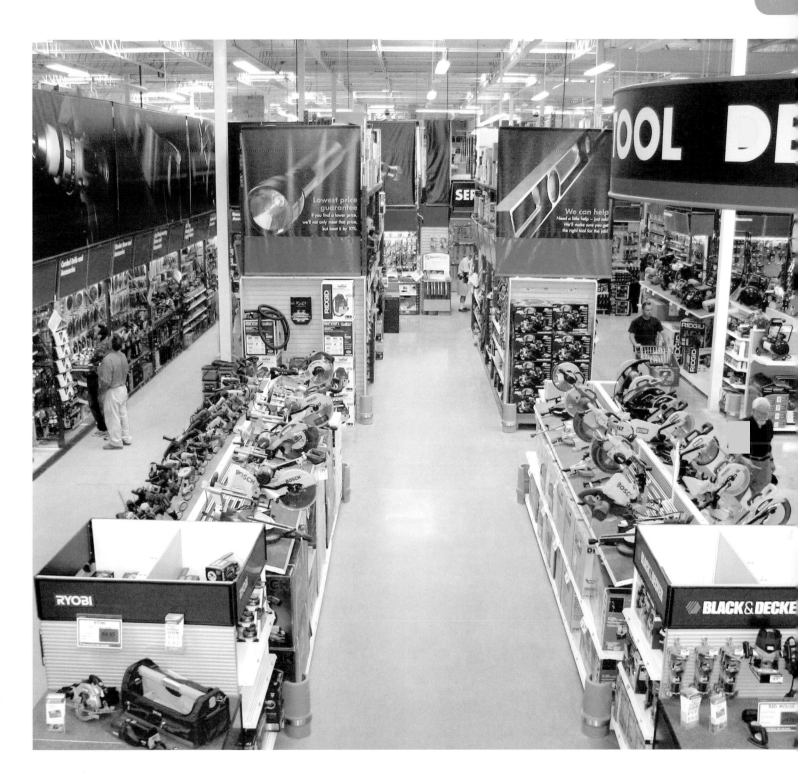

ADDITIONAL ENTRANTS

Bloomingdale's 4ᵗʰ Floor, New York

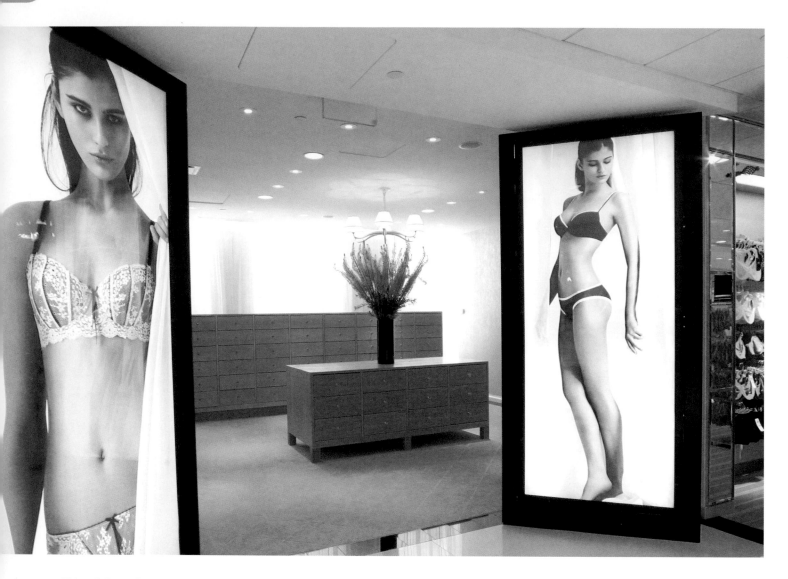

This 59ᵗʰ Street flagship had undergone grand-scale renovations of its first, second and third floors. Each is distinctively Bloomingdale's — luxurious materials, dramatic colors, black accents that call to the retailer's emblematic black-and-white checkerboard marble on the ground level.

The fourth floor, which houses the intimate apparel (much of it designer intimates), was slated to undergo a renovation of its own — one that would architecturally unify it with the finished floors.

Mancini • Duffy (New York) created a glamorous and feminine environment that showcases each designer collection among elegant swathes of crème, ivory, silver and sexy black. Drawings of female silhouettes flank an ebony-colored entry, while mannequins wearing the latest designer intimates lounge on black sofas with ivory piping. Merchandise is presented along the walls in alcoves with a crown of back-lit, patterned panels.

Noting that the Bloomingdale's shopper is rather brand-conscious, the design team used drapery to segment each intimate collection.

The fitting room resembles a grand sitting area, complete with furnishings inspired by French cabinetmaker Andre Arbus.

Clients Bloomingdale's, New York – Jack Hruska, sr. vp, visual merchandising & store design; Shan DiNapoli, vp, store design; Joe D'Antonio, sr. project manager; Bob Mankowski, building manager; Jeff O'Hearn, purchaser interiors; Elizabeth Grossman, purchaser; Federated Department Stores, Cincinnati – Rudy Javosky, sr. vp, design and construction; Bruce Quisno, operations vp; Randy Fiala, sr. project manager; Lance Woodward, project manager *Design* Mancini•Duffy, New York – Evangelo Dascal, principal & account director; Ed Calabrese, creative director; Lisa Contreras, resource director *Architects* James Harb Architects, New York; Highland Associates, New York (architect/engineer) *General Contractors* Tucci Construction, Bayside, N.Y.; Builder's Furniture, Winnipeg, Man. (perimeters) *Stock Shelving* A & D Steel Equipment, Long Island City, N.Y. *Flooring* Innovative Marble, Hauppauge, N.Y. *Lighting Consultant* HLB Lighting, New York *Photography* Robert Mitra, New York

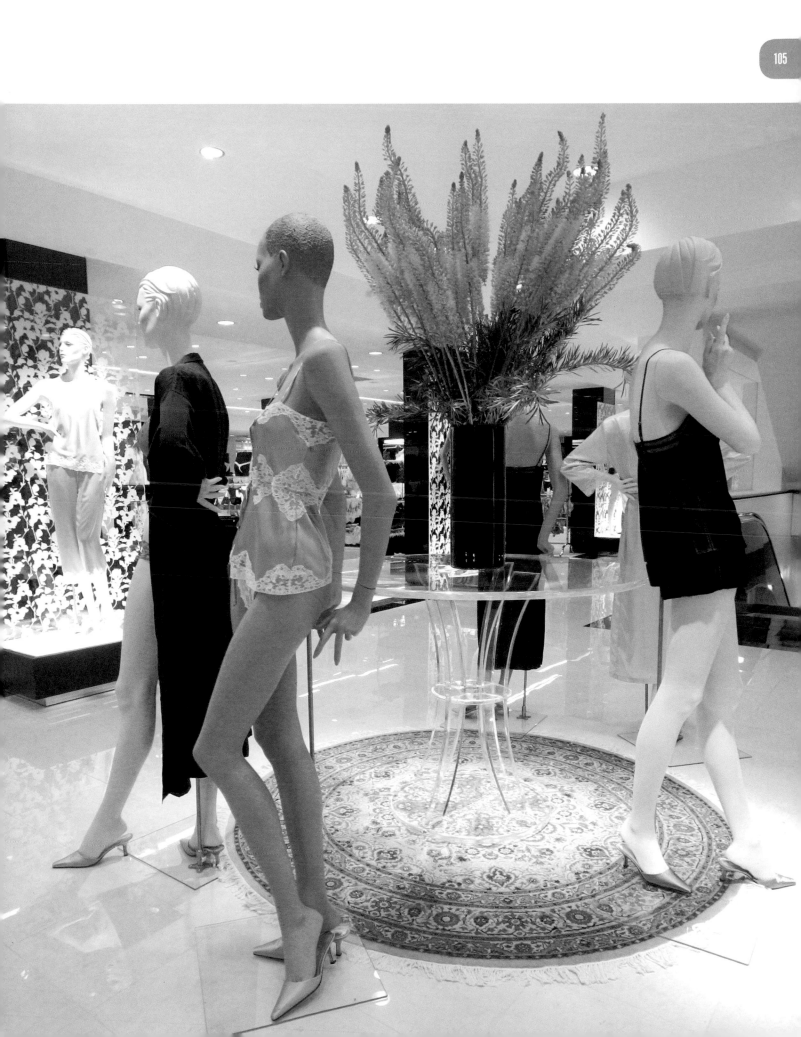

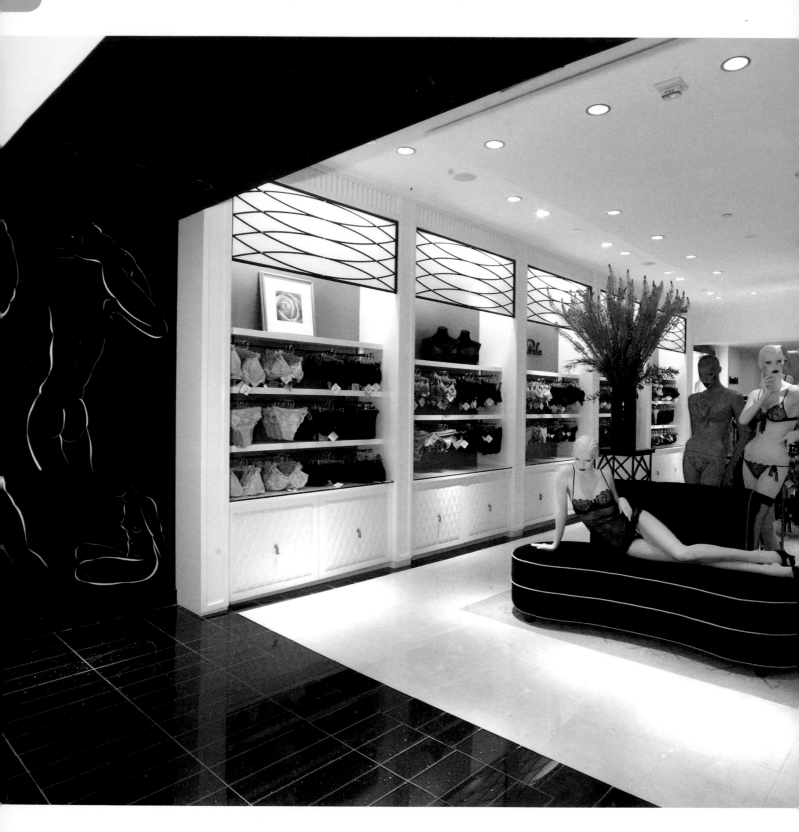

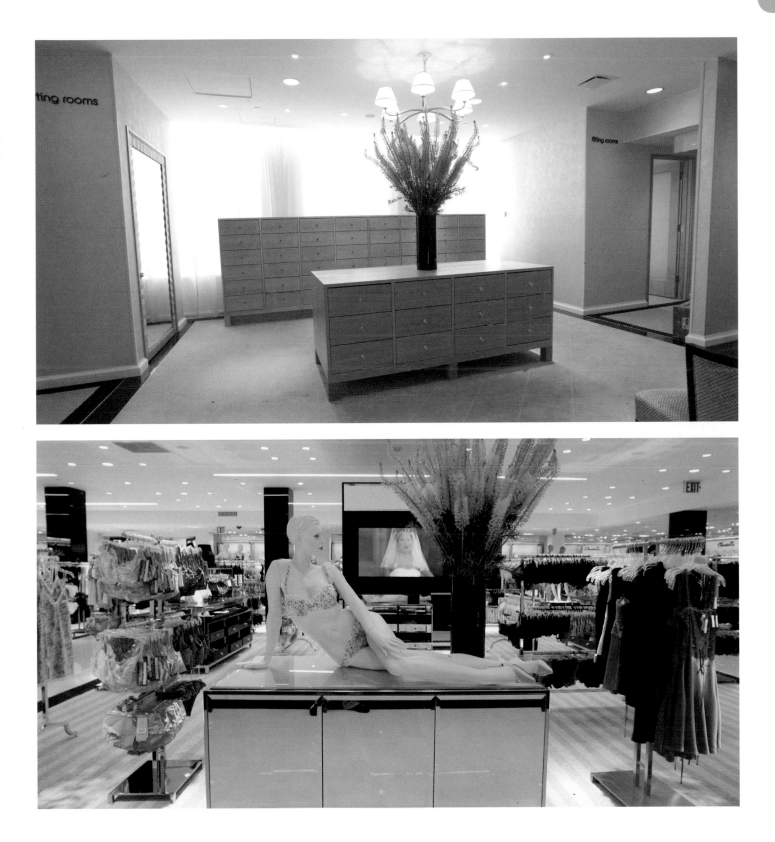

La Senza Express, Burlington, Ont.

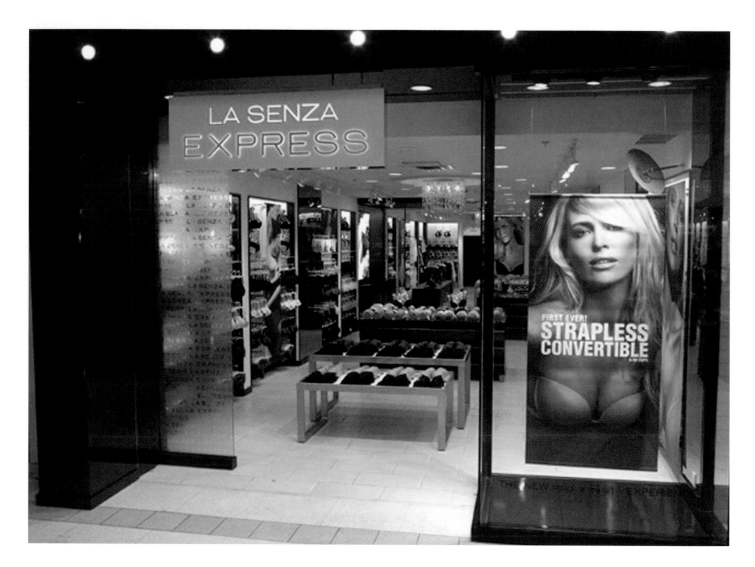

Intimate apparel retailer Since opening its first store in 1990 in Ottawa's Place D'Orleans Shopping Centre, the purveyor of unmentionables has expanded its brand to include La Senza Spirit, La Senza Girl and La Senza Express, the division dedicated solely to bras and panties.

To give the Express space a sleek, intimate look, Loda Design (Montreal) created an environment with illuminated wall niches for product and elegant chandeliers. Black and pink team up for sexy color accents.

At the entrance, art deco-style lighting crowns a glossy black archway. A frosted glass panel features the La Senza Express logo in a pattern design.

Using a puck system in illuminated alcoves, designers kept most of the floor clear of merchandise. Garments are presented on chrome busts and torso forms that rest on shelves above the pucks. Rectangular tables in a liquidy-black finish hold additional product.

The cashwrap features a pink-mirrored front and stands out with a black lacquer background stretching up the behind wall and onto the ceiling. A large graphic emphasizes the pink-and-white La Senza name.

Client La Senza Inc., Dorval, Que. – Laurence Lewin, president; Caroline Sacchetti, executive vp buyer's La Senza; Annie Tremblay, director of construction; Karine Washer, La Senza senior vp marketing & visual; Kim McLaughlin, La Senza visual director; Cara Silvestri, La Senza visual manager; Kathy Tsoulakos, marketing director; Carine LaSalle, marketing manager *Design* Loda Design, Montreal – Roman Iwanycki, president; Mario Fasciano, design director; Anastasia Prahalis, assistant design director; Larissa Mulvihill, project coordinator *Architect* Rene Tringali O.A.Q., O.A.A., Montreal *General Contractor* Modern Wood Fabricators, Montreal *Outside Design Consultant* Dallaire Consultants, Saint-Lambert, Que. (mechanical and electrical engineer) *Lighting* Franklin Empire, Montreal *Hardware* Algar Plastics Ltd., Montreal *Photography* Chris Nicholls, Toronto

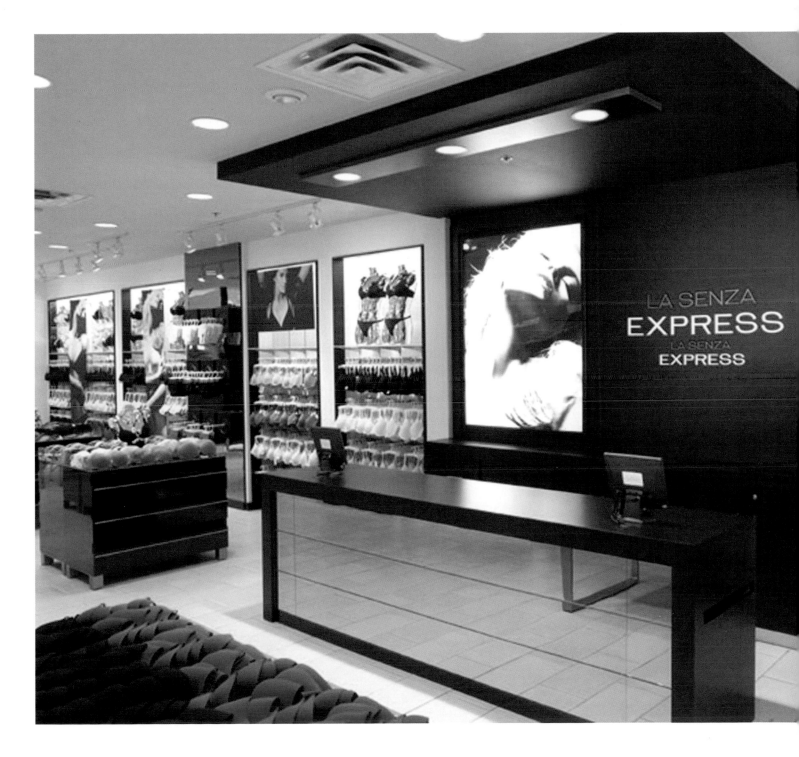

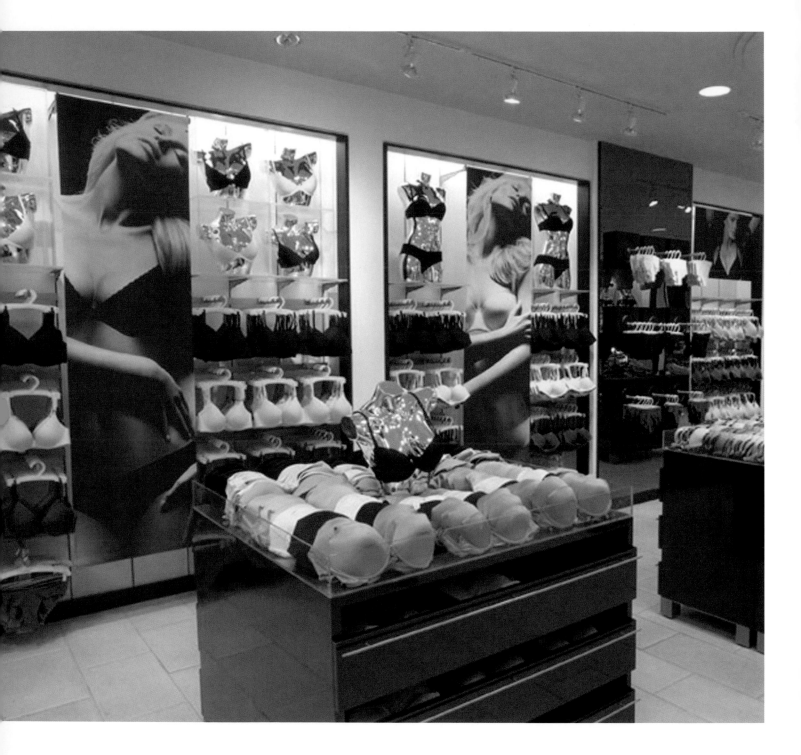

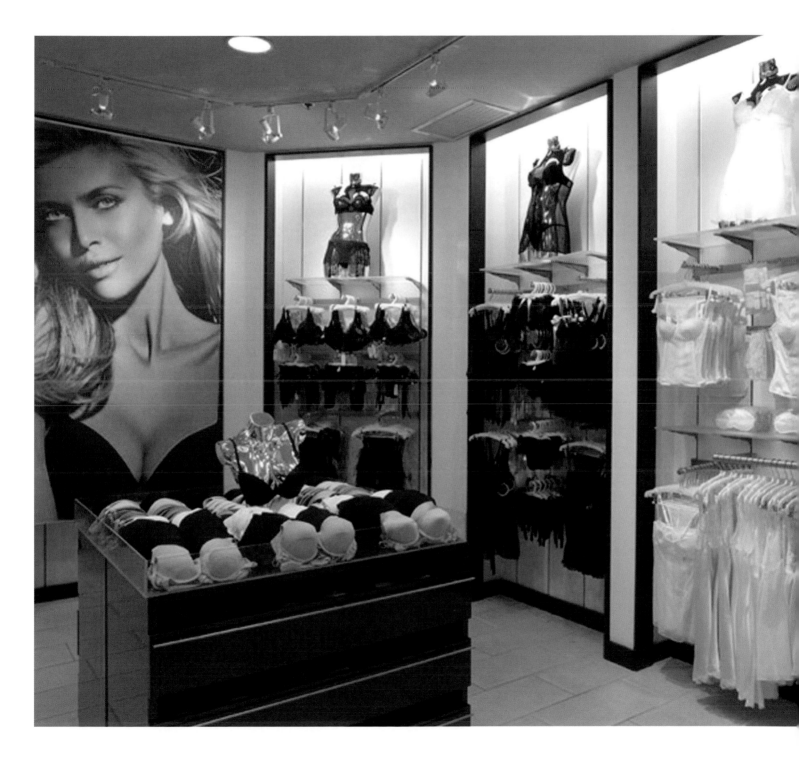

Calvin Klein Underwear, New York

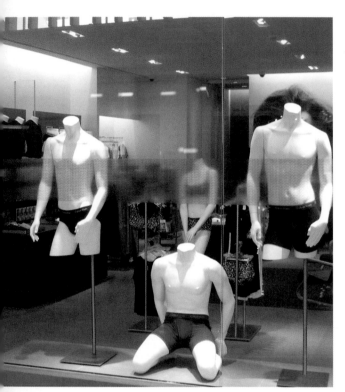

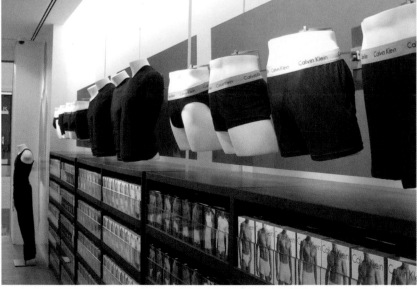

Calvin Klein may sit in the same corporate underwear drawer with Nautica, Polo and JLo, since the Warnaco Group purchased the iconic underwear business 10 years ago. But only Calvins have their own stores.

To help reinvent the 1800-square-foot Calvin Klein underwear store in Dallas' NorthPark Center, RYA Design Consultancy (Dallas) immersed itself in the CK culture and identified key strategies to better define the brand's store environment. Strategies included a user-friendly fixture system that would enable customers to shop without sales assistance and a more dedicated graphics program.

Women's merchandise is presented on a custom low-profile puck system surrounding the store's perimeter. Oversized graphics of underwear-clad models are integrated with the fixtures.

Men's merchandise was a tougher challenge, given that most of the unmentionables are boxed. So units along the wall were designed to take advantage of the product photography on the front of each box. Panels of acid-etched smoked glass float 15 inches off of the back wall, supporting torso and butt forms presenting product.

Client Warnaco, Inc., New York – Rosa D'Onofrio, director of store planning *Design* RYA Design Consultancy Inc., Dallas – Kevin Roche, partner-in-charge; Steven Derwoed, creative director and lead designer; Eric Pate, project manager; Mac Allen, architect, Pam Kennedy, resource design director; Doug Russell and Steven Espinoza, lighting *General Contractor* McGovern & Co., New York *Outside Consultants* Don Penn Consulting, Grapevine, Tex., (MEP engineer); The Structural Alliance, Inc., Dallas (structural engineer) *Flooring* Stone Source, New York *Fixtures* idx Corp., St. Louis *Mannequins* Goldsmith, New York *Wall Covering* Xorel by Carnegie, Rockville Centre, N.Y. *Acid-etched Smoked Glass* Bendheim, New York *Photography* Courtesy of RYA Design Consultancy, Dallas

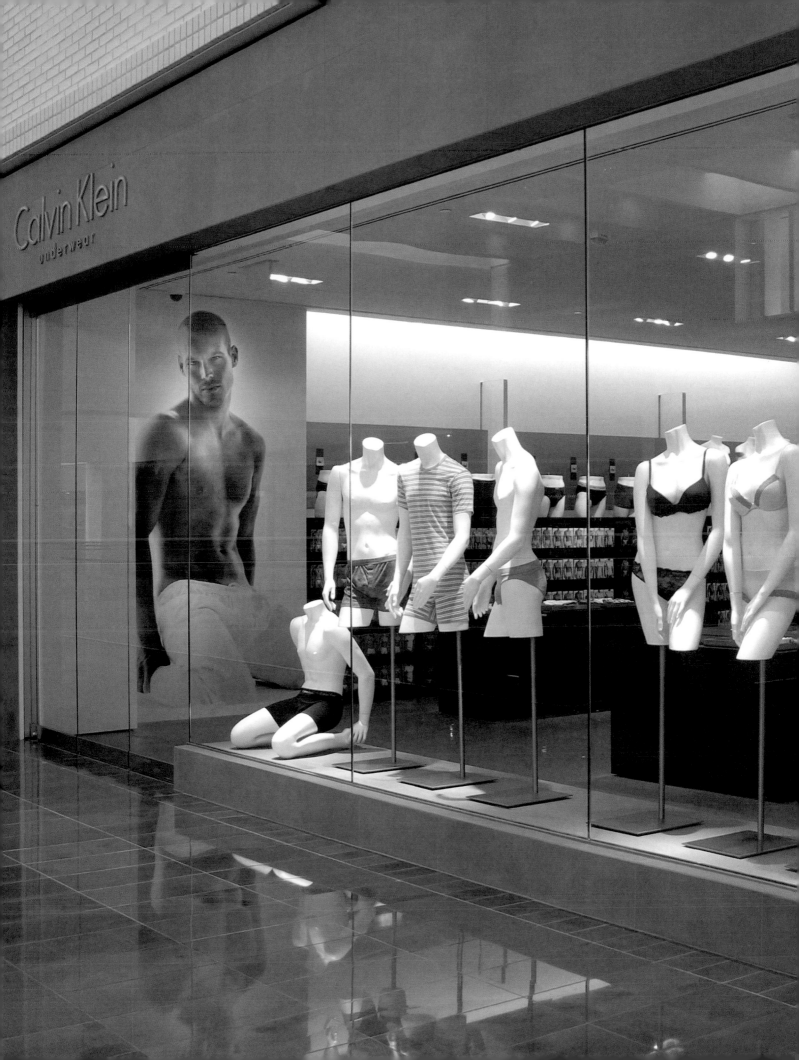

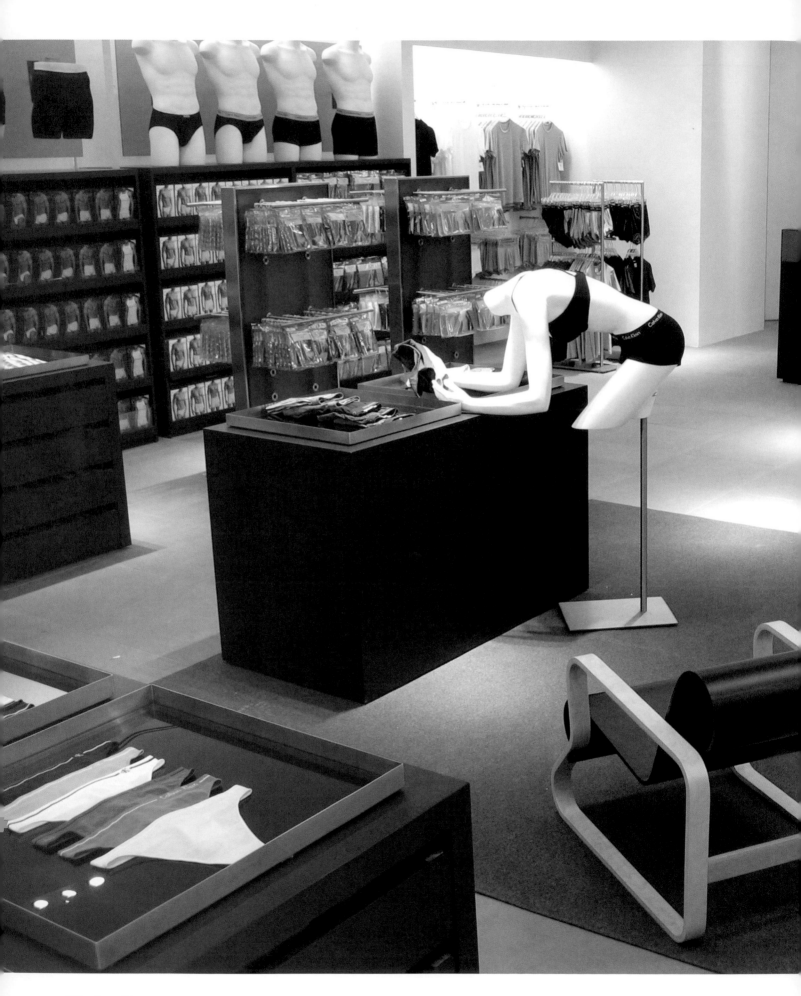

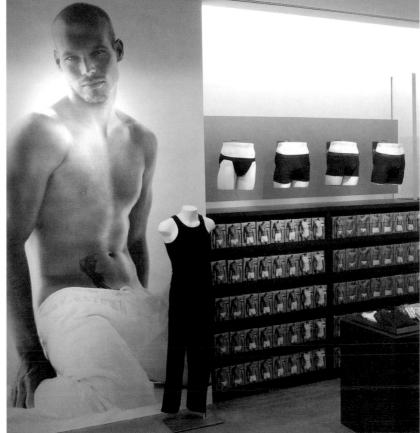

Calvin Klein
365

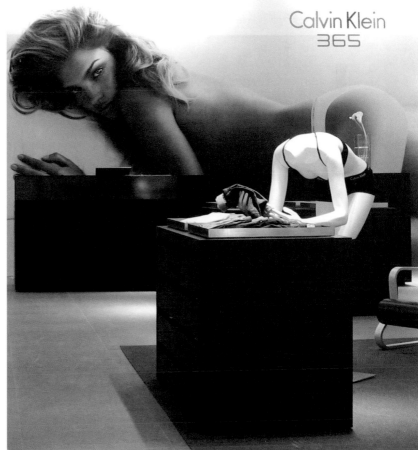

Payless ShoeSource, Topeka, Kan.

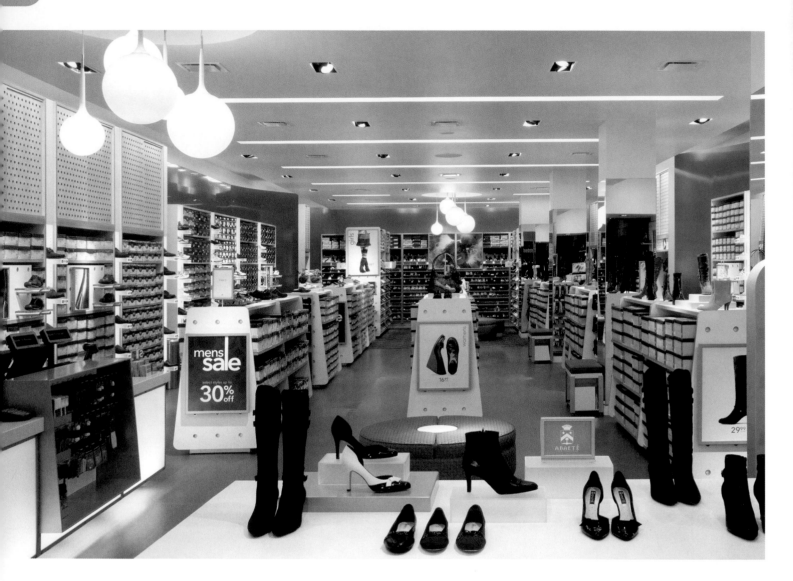

After 50 years in the discount, self-service shoe industry, the Topeka, Kan.-based retailer is now turning its focus on fashion. "We want to democratize fashion and design in footwear and accessories to inspire fun fashion possibilities for the family," says Paylesspresident and ceo Matt Rubel.

That evolution, a collaboration between an in-house team at Payless and designers at Callison (Seattle), is a multi-pronged effort, including a new stylized logo; the launch of its first-ever designer footwear collection Abaete; and two new store designs – the fashion lab, a radical renovation of the entire store, and the smaller-scale renovation called hot-zone, which features a new front-of-store layout.

The fashion lab stores made their debut in several high-profile locales, including its 2000-square-foot space on New York's Fifth Avenue.

The new format fits how women – the retailer's primary target – shop for shoes. Merchandise is out of the boxes and off the racks in full view. The women's collection was given prominent placement at the front of the store and features large lab tables and other custom display fixtures. The environment is warm and inviting, yet clean and contemporary.

"Payless stores used to be canyons of racks," says Callison design director Ron Singler. "The fashion lab layout makes heavy use of lower fixtures and lots of horizontal surfaces to feature seasonal trends and product stories."

Client Payless ShoeSource, Topeka, Kan. *Design* Callison, Seattle – Paula Stafford, executive vp/principal; Cynthia Kato, client and project manager/director; Ron Singler, sr. designer/director; Christian Jochman, designer/fellow; Jan Gaylord, interior designer/associate; Clayton Whitman, interior designer/associate; Denise Howitt, graphic designer/associate; Tom Rasnack, project manager/associate principal; Jason Morford, project architect/associate; Nicole Price, architect/associate; Ryan Luthman, architect/associate; Kelsey Blommer, architect/associate *Outside Design Consultant* Lighting Design Alliance, Los Angeles (lighting) *Audio/Visual* Muzak, Seattle *Ceilings* Schimenti Construction Co., Mt. Kisco, N.Y. *Fixtures/VM Display Elements/Furniture* Design Fabricators, Thornton, Colo. *Plastic Laminate Flooring* Abet, Inc., Englewood, N.J. *Carpet* Atlas Carpet, Los Angeles CS Group, Lebanon, N.J. (walk-off mat) *Custom Fabrics* Valley Forge, Pompano Beach, Fla. *Lighting* Villa Lighting, St. Louis *Signage/Logo Design* Descripps Gobé, New York *Fabrication/Installation* Federal Heath Signs, Euless, Tex. *Interior Graphics* Payless ShoeSource, Topeka, Kan. *Paint Finishes* Sherwin Williams, Cleveland *Fixture Finishes* Formica, Cincinnati; Corian, Wilmington, Del. *Mobile Shelving* Pipp Mobile Storage Systems Inc., Walker, Mich. *Lighted Graphic Image Display* Duratrans, Spring Lake, Mich. *Photography* Chris Eden, Callison, Seattle

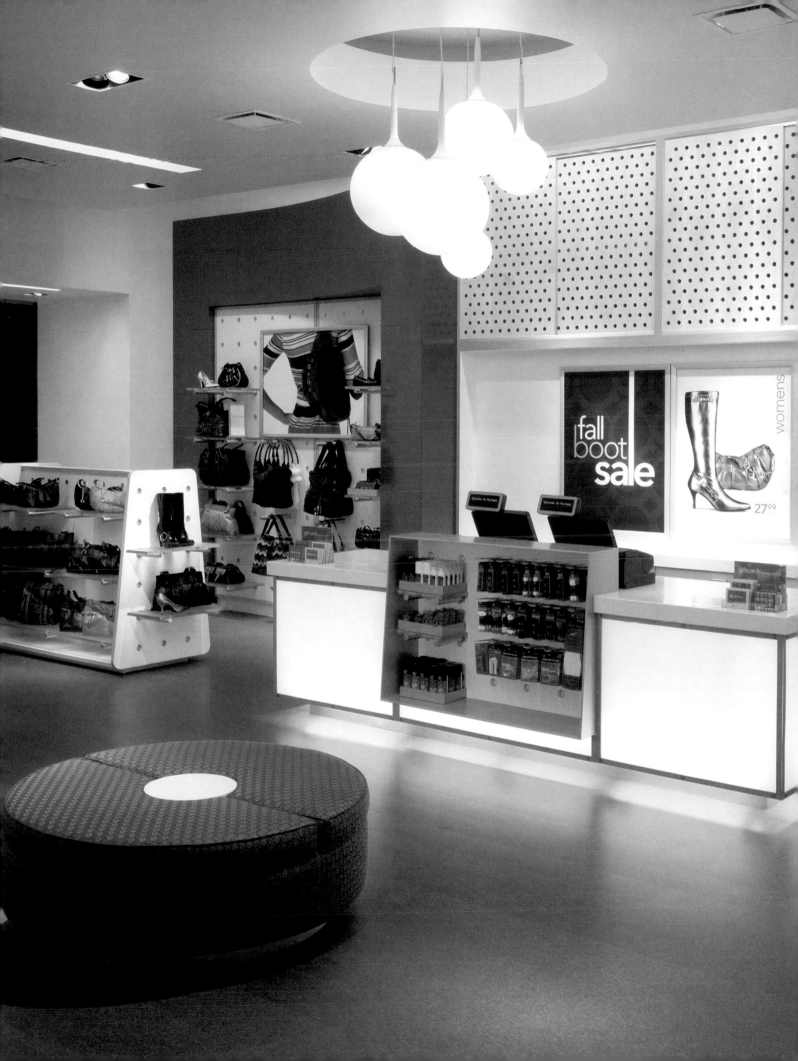

fall
boot
sale

womens

27.99

giftcards

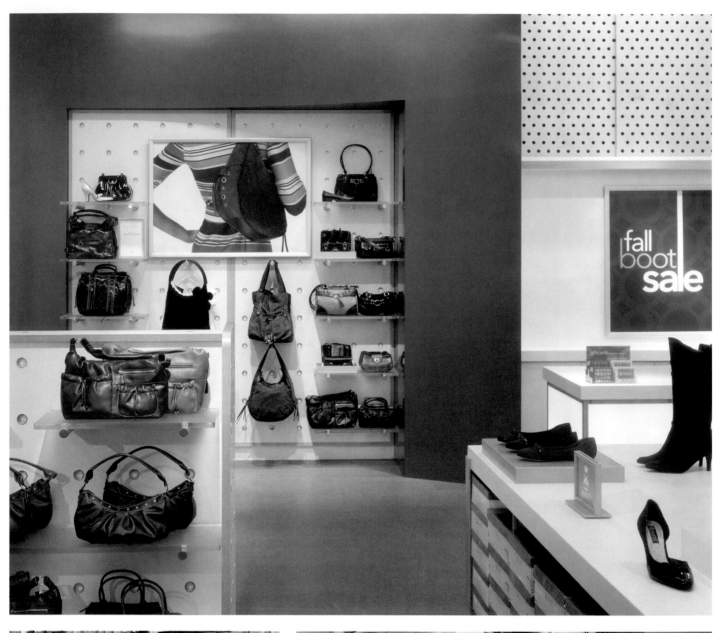

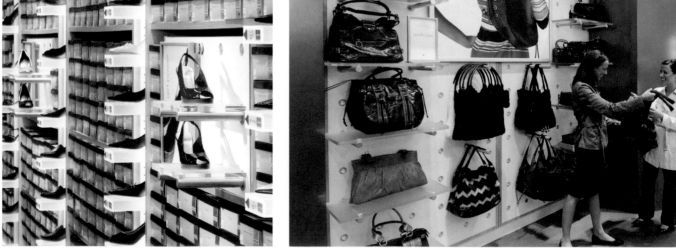

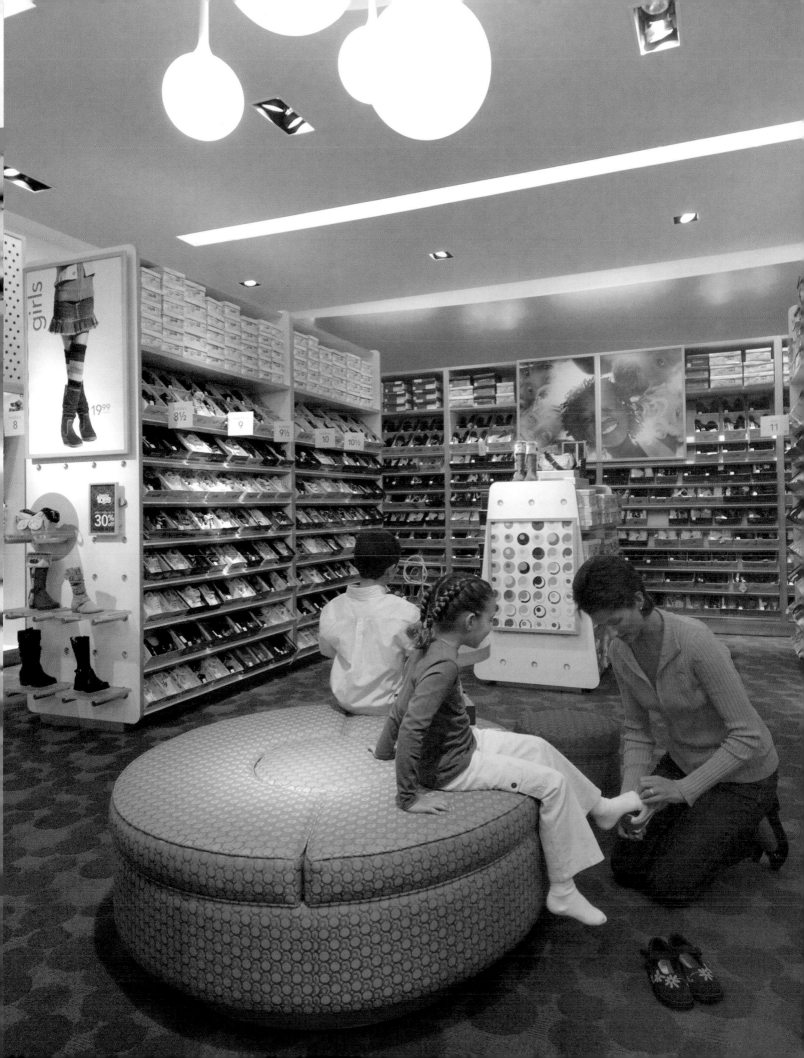

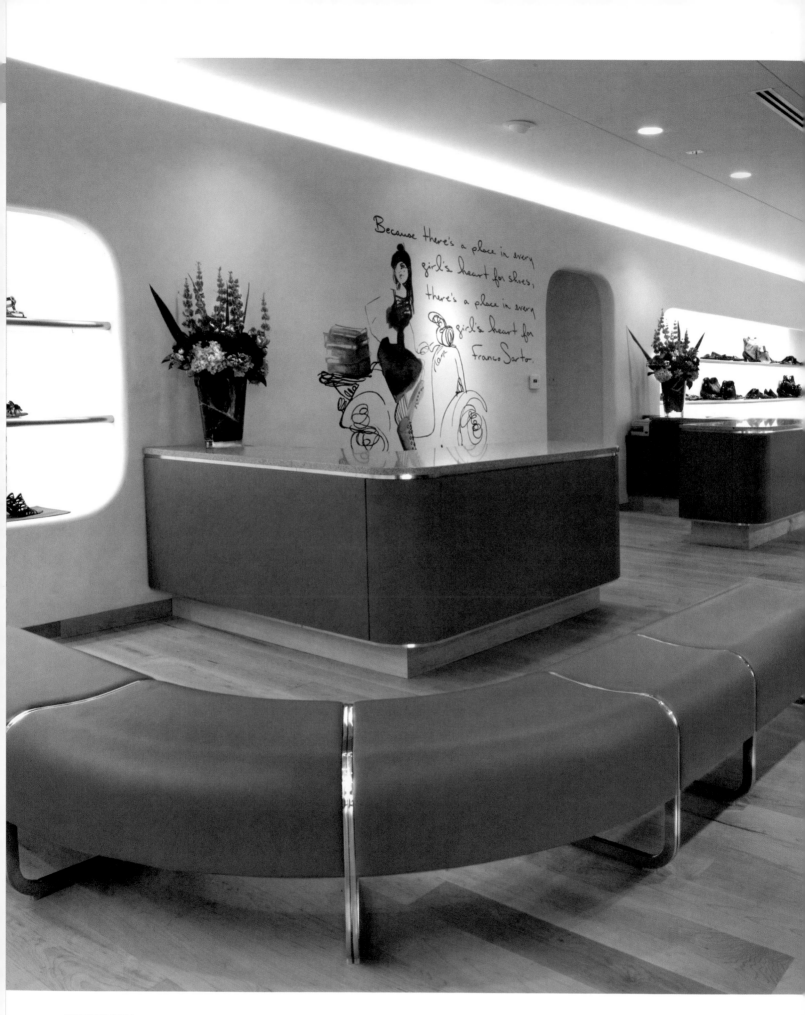

The text visible in the image reads: "Because there's a place in every girl's heart for shoes, there's a place in every girl's heart for Franco Sarto."

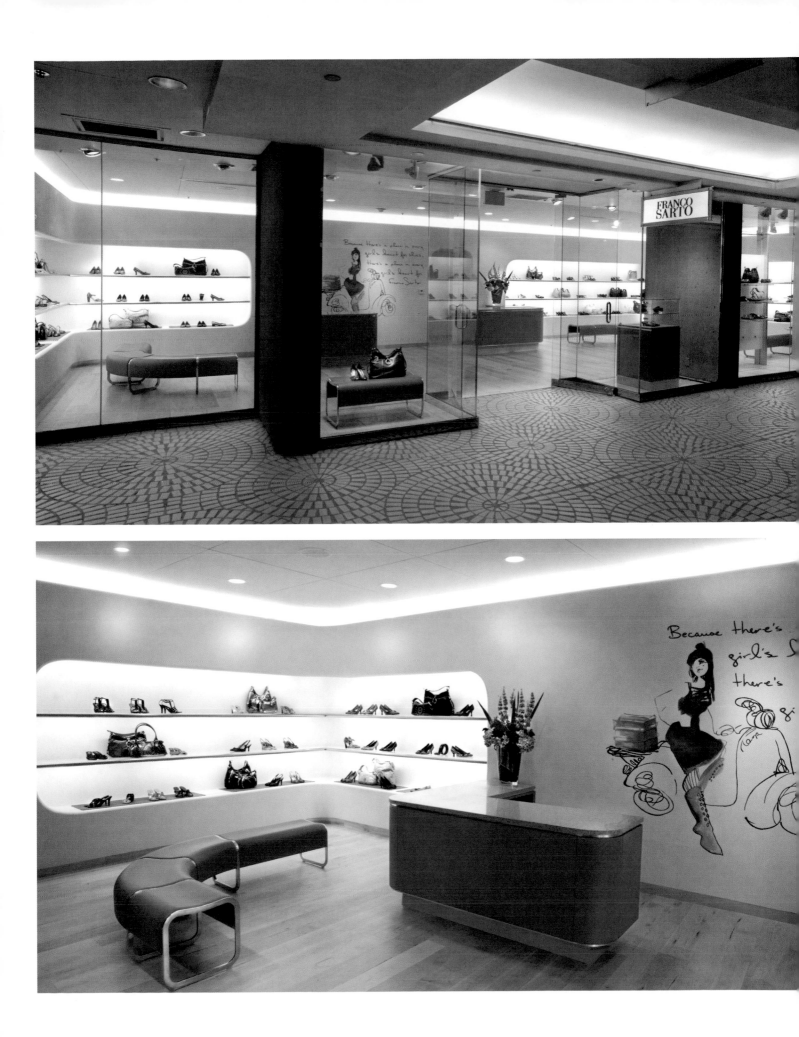

Merrell, Huntington, N.Y.

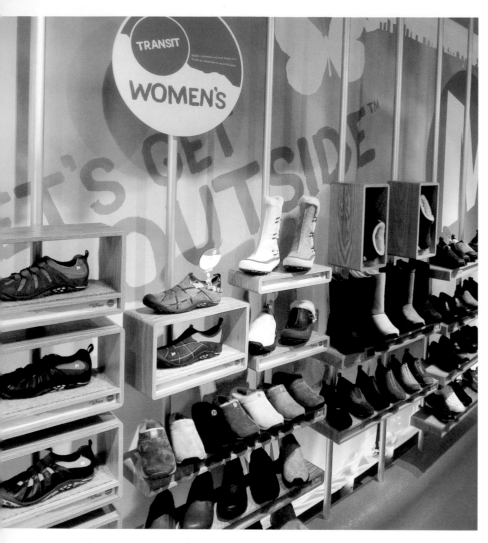

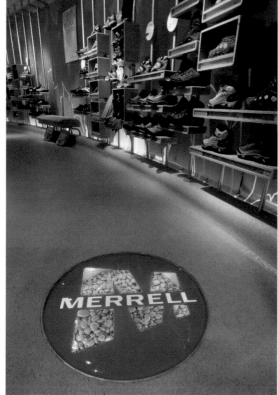

The Huntington, N.Y.-based performance footwear retailer has been outfitting outdoor enthusiasts for over 20 years. Merrell's campaign, "Lets Get Outside" is about encouraging everyone to get out and be active.

The prototype store designed by Fitch (Powell, Ohio) focuses on three distinct consumer types: urban dwellers, comfort seekers and outdoor enthusiasts. It caters to each with a cocktail of style, attitude and natural yet modern elements, such as cork wall paneling, steel rods and faux fur-lined shadow boxes.

Fabric scrim is suspended along perimeter walls, allowing for seasonal design changes. Bright greens, oranges and blues and images of cityscapes, butterflies and the company's manifesto cover the walls. Track lighting follows the curving layout of the store and spotlights the scrim background.

There are no high heels in sight. Comfort reigns supreme. Sporty shoes, hiking boots, clogs and flip-flops rest on modular wood shelving units floating on steel rods.

Client Merrell, Huntington, N.Y. – Keith Anderson, director of marketing *Design* Fitch, Powell, Ohio – Eric Kuhn, art director; Paul Teeples, senior environmental engineer; Garrick Reischman, senior graphic designer; Jim Penn, senior planner/merchandiser; Tom Wilson, implementation manager; Tracy Adkins, implementation coordinator *Architect* AAD:Fitch, Scottsdale, Ariz. *General Contractor* Soupious Construction, Ford Salonga, N.Y. *Engineer* Paul J. Angelides P.E. Consulting, Laurel Hollow, N.Y. *Flooring* Dur-A-Flex, East Hartford, Conn. *Lighting* WAC Lighting, Garden City, N.Y *Fixtures/Furniture/Millwork* GTC: General Theming Contractors LLC, Columbus, Ohio; Hanover Signs, Inc., Columbus, Ohio; Accel Group, Wadsworth, Ohio *Paint Finishes* Benjamin Moore, Montvale, N.J. *Laminates* Pionite, Selton, Conn.; Wilsonart, Temple, Tex. *Signage/Graphics* JDK Design, Burlington, Vt. *Fur Inserts* Interface Flooring *Photography* Brandon King, Fitch, Columbus, Ohio

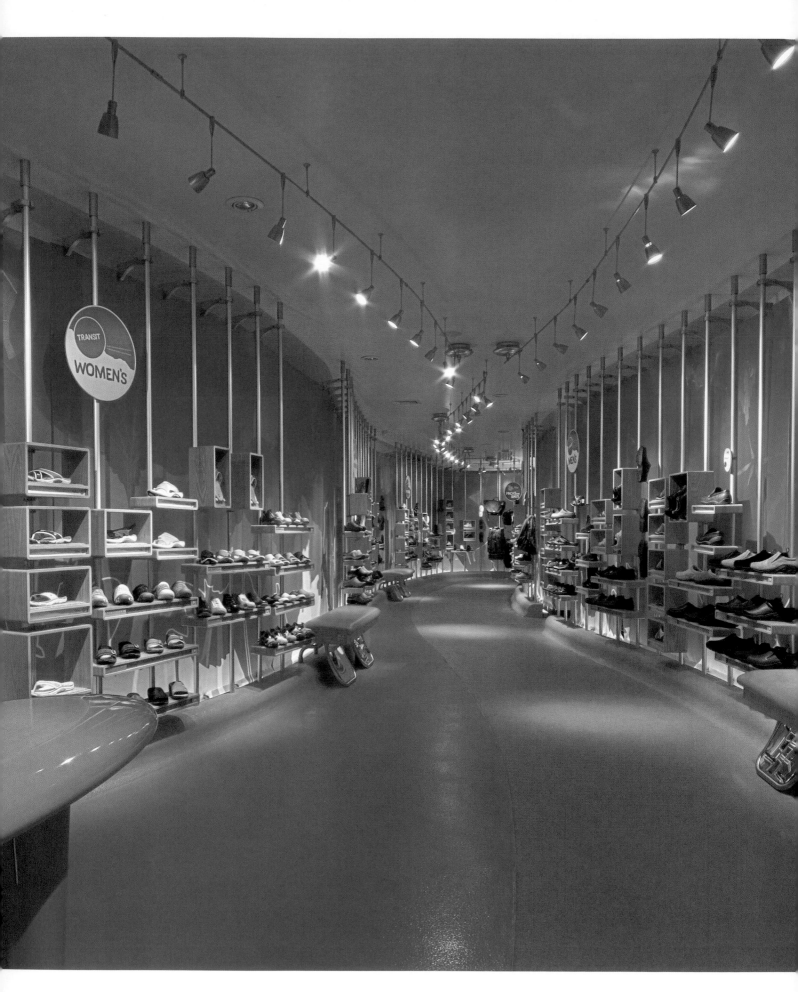

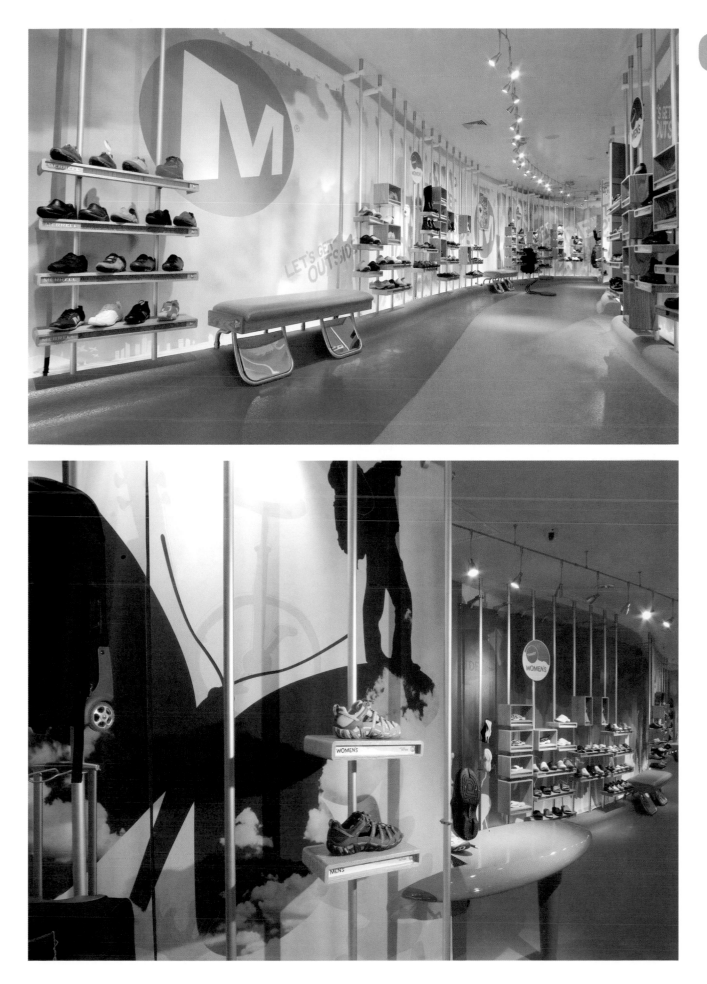

Jesse's, Echuca Victoria, Australia

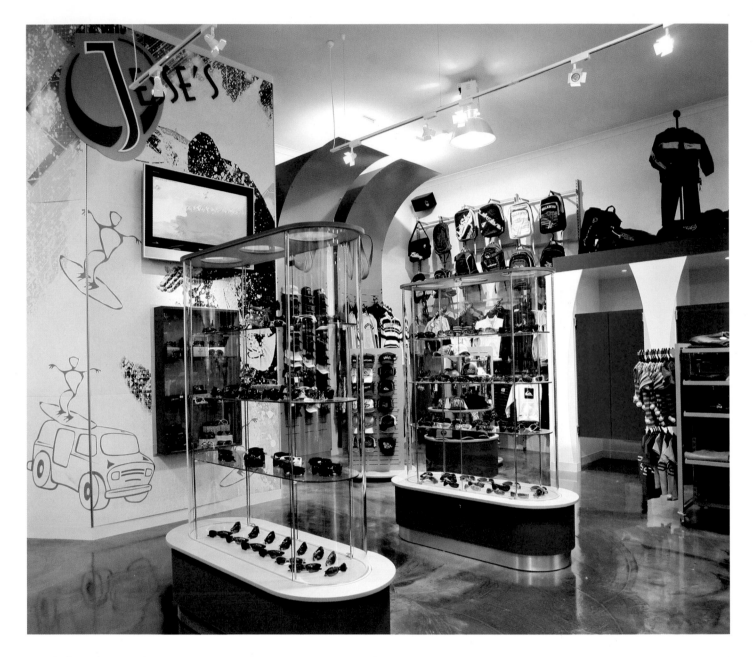

The small, rural community of Echuca Victoria, Australia, is three hours from its much larger, more modern sister city, Melbourne, where urban street and surf culture is big. To bring that ethos to a smaller neighborhood and appeal to a generation Y lifestyle, teen surf shop Jesse's chose Synthesis Design & Display Pty. Ltd. (Bayswater Victoria, Australia) to create a bold and dynamic environment.

The Jesse's logo became the basis for the store's design elements – the curves of its signature "J" were adapted into the fabricated joinery and fixtures, and a wash of cobalt blue and silver makes up the shop's color palette. Industrial touches like curved aluminum walls with internally illuminated J's, polished concrete floors and metallic silver powdercoated panel fixtures provide a strong urban style.

On the store's rear wall, a surf graphic and graffiti-style surfing stick figures are the backdrop for a 50-inch LCD screen playing surf and skate images.

Raising the ceilings from 8 to 16 feet gives the space an airier feel, while a simplified merchandising system creates an uncluttered look.

Client Jesse's, Echuca Victoria, Australia – Neil James, owner *Design* Synthesis Design & Display Pty. Ltd., Bayswater Victoria, Australia – Jason Laity, design director; Les Laity, director; Suzy Suzic, project designer; Renee Harrop, project development *General Contractor* KGB Builders, Echuca Victoria, Australia *Outside Design Consultant* Zaftech Lighting, Mitcham, Australia (lighting) *Suppliers* Zaftech Lighting, Mitcham, Australia; Resolution Imaging, Nunawadding, Australia; Merchandising Systems Australia, Bayswater Victoria, Australia; Continental Furniture Pty. Ltd., Croydon, Australia *Photography* Leanne Whitely, Moama Victoria, Australia

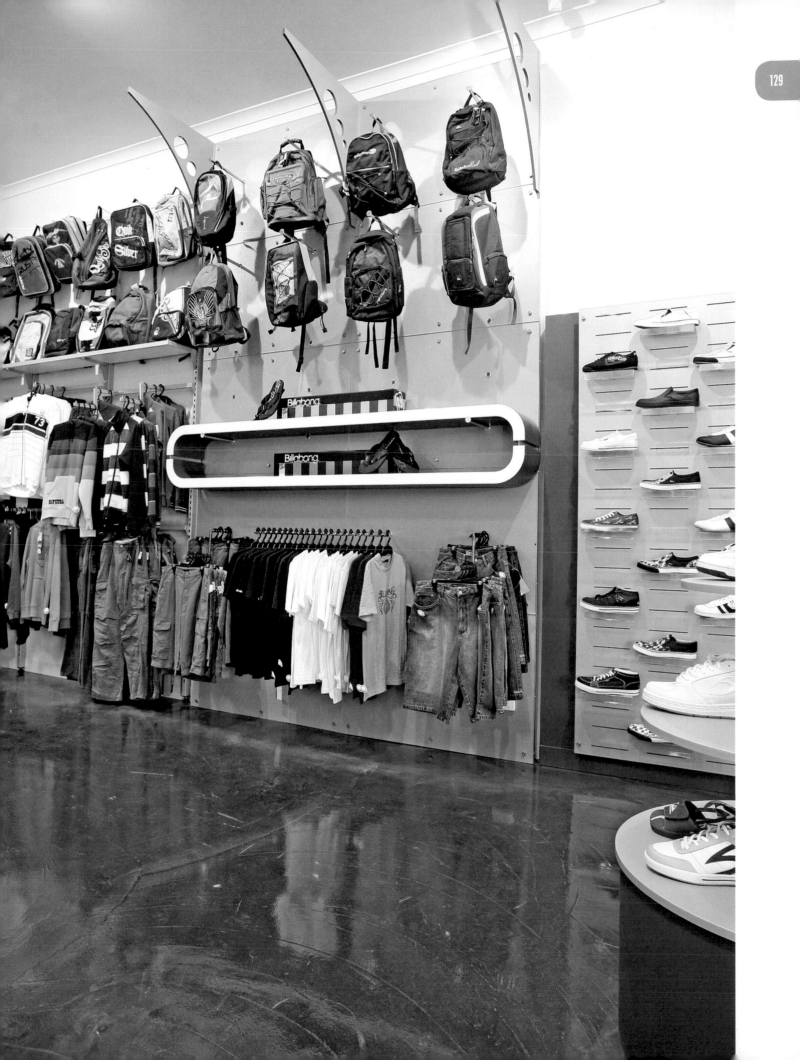

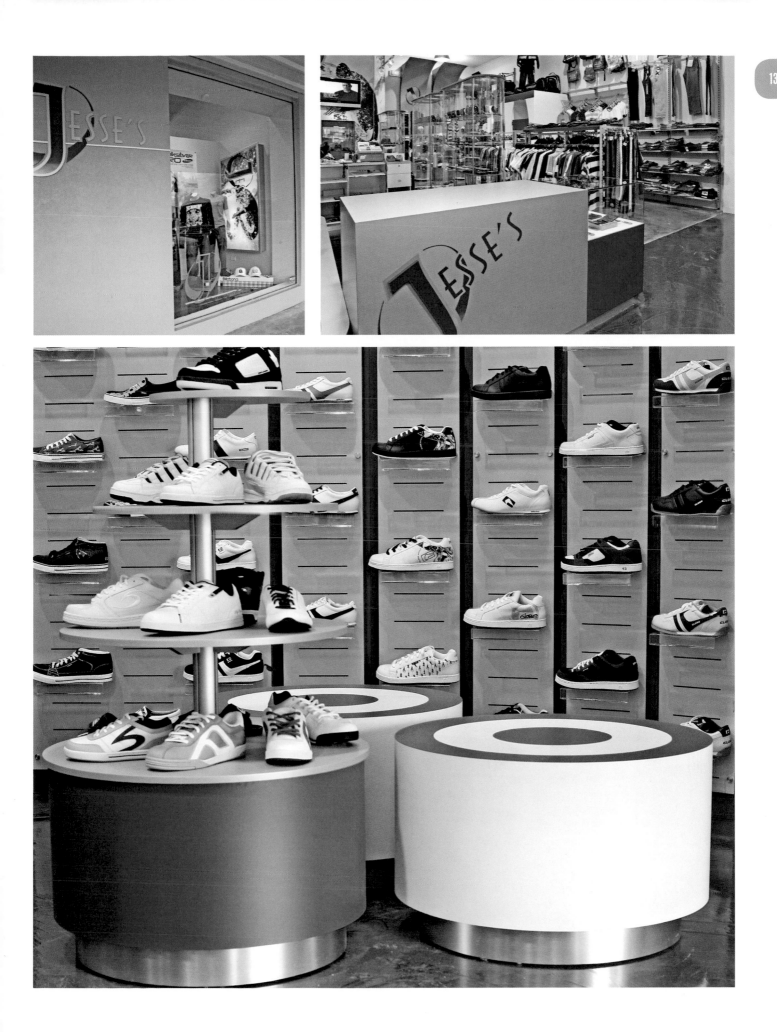

Nokia Flagship Store, New York

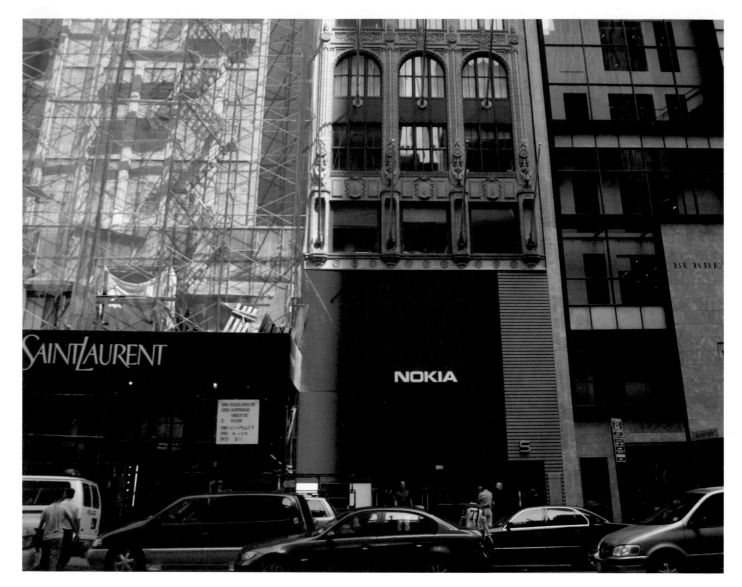

For years, Nokia relied on a worldwide network of in-store shops to sell its mobile phones, handheld gaming and other high-tech gadgets. Next came its experimental "experience centers," 200-square-foot shops in high-traffic malls where visitors could try out all of Nokia's products though they couldn't actually buy anything. Now the company has opened its own retail stores.

At Nokia's New York Flagship, customers get a hands-on chance to try out cell phones and other high-tech gadgets. The technology retailer teamed with Eight Inc. to develop an environment that would showcase the brand in an interactive and high-tech manner.

The storefront features the vivid, monochromatic blue that was back-painted on low-iron glass. Inside, translucent walls backlit with color-changing LEDs and fronted by a series of LCD screens display promotions, special events and brand offers. Each displayed handset rests on black or white fixtures and when examined by a customer, provides an interactive look at its features on a multimedia screen.

The second level features the Nokia Nseries of multimedia solutions such as, speakers, printers and laptops. Products rest on cube fixtures clad in high-polished stainless steel.

And on the top level, the retailer's luxury line, Vertu, has its own high-style modern lounge environment with back-painted black glass, Carrera marble and stainless steel.

Client Nokia, Espoo, Finland – Jeremy Wright, retail concept director; James Rands, retail operations director; Winston Wright, sr. manager flagship retail operations – Americas *Design* Eight Inc., New York – Tim Kobe, partner; Wilhelm Oehl, partner; Doo Ho Lee, studio director, NYC/project architect; Jeff Straesser, senior architect; Jie Siang Yong, junior architect *General Contractor* Shawmut Design and Construction, Boston *Outside Design Consultants* Faithful and Gould, New York (construction); ISP Design, Miami (lighting) *Interior Fixturing/LED Wall Panels* P2 Group, Heemstede, Netherlands *Audio/Visual/ LCDs* Electrosonic Limited, Kent, England *Structural Engineer* Robert Silman Associates, New York *MEP Engineer* Laszlo Bodak Engineer, New York *Storefront Engineer* Haran Glass, Glasgow *Vertu Lounge Design* Shed Design, London *Ceilings* Ceilings Plus, Los Angeles *Stairs* J Frederick Construction, Brookfield, Conn. *Flooring* Produits Chemcraft, Warwick, Que. *Lighting* Delta Lighting *Lighting Control* Lutron, Coopersburg, Pa. *Signage/ Graphics* Thomas Swan Sign Co., San Francisco *Photography* Courtesy of Nokia, New York

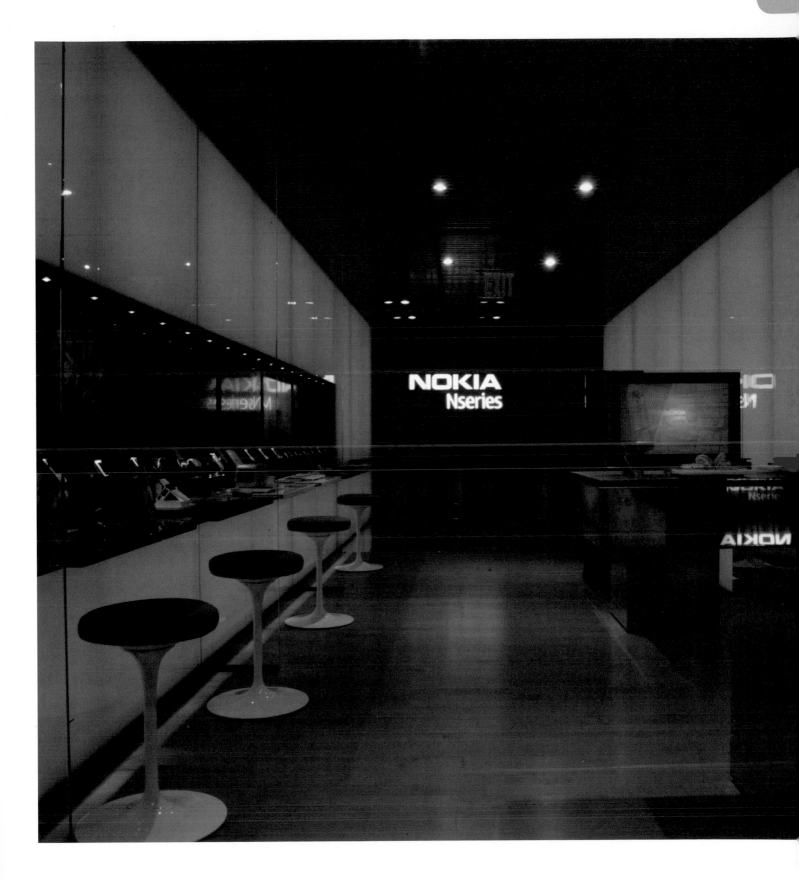

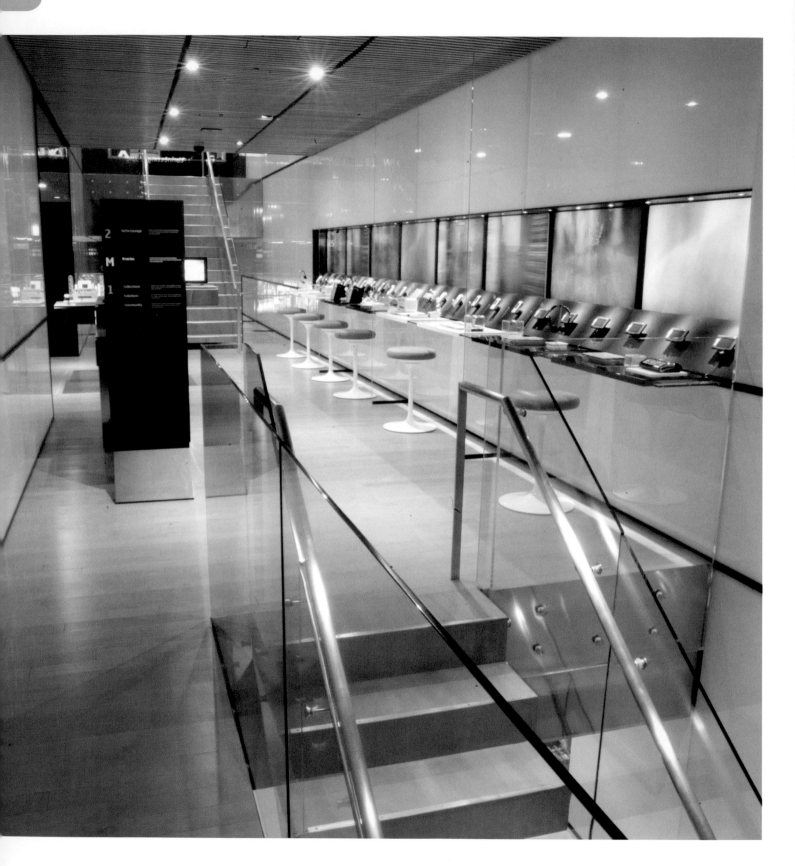

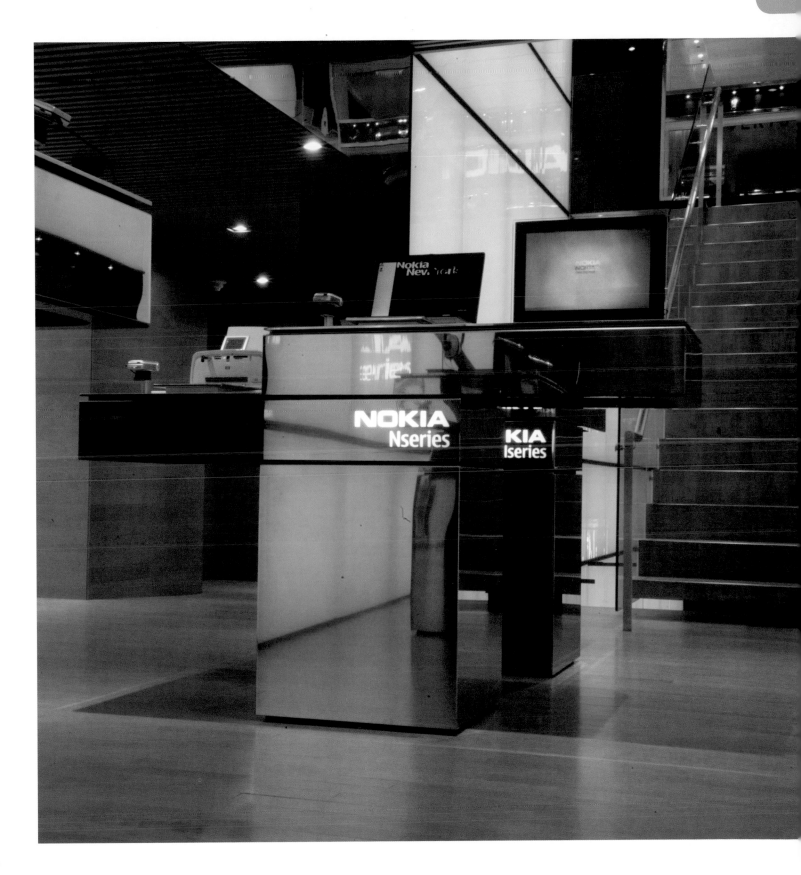

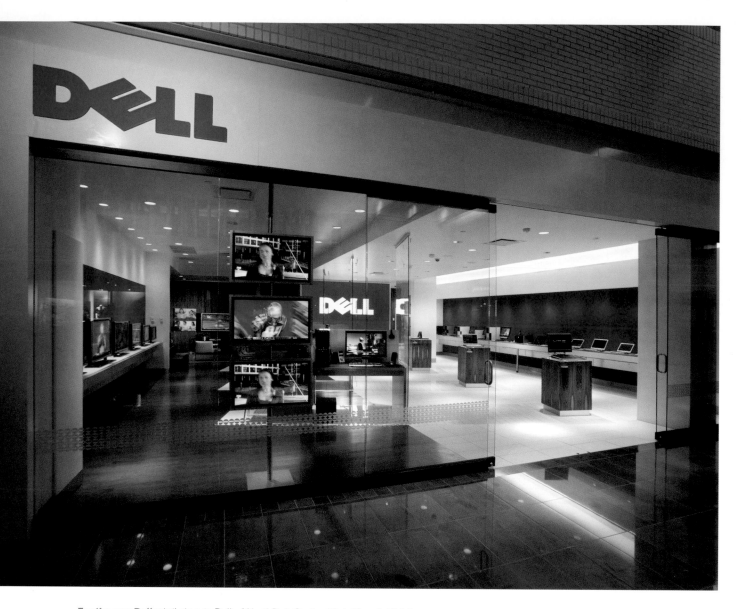

For the new Dell retail store in Dallas' NorthPark Center, Fitch (Powell, Ohio) designed an environment that would increase the computer manufacturer's loyal fan base, but also attract new followers to its camp.

The floorplan is open, allowing the flatscreen televisions, laptops and desktops to stand out, and it's divided into two sections – white ceramic tiles denote a more business-oriented style for the PC side and a warm wood floor gives off a relaxing home environment for large television screens.

Splashes of Dell's signature cerulean color shade perimeter wall niches, tops of fixtures and signage.

On the computer side, a long white table holds laptops and monitors, while wood-paneled fixtures feature the latest Dell models.

That long table is echoed in the form of a shelf on the more lifestyle-oriented side. Toward the back of the store, designers created a mock living room, complete with modern furnishings, wood paneled walls and a patterned rug. The centerpiece is a Dell flatscreen TV, hung on the wall amid lifestyle graphics.

Client Dell, Inc., Round Rock, Tex. *Design* Fitch, Powell, Ohio – Mike Bills, managing partner, the Americas; David Denniston, creative director; Paul Teeples, sr. environmental designer; Gabe Shultz, graphic designer; Amy Theibert, account director; Heather Pellegrini, project manager *Architect* AAD: Fitch, Inc., Scottsdale, Ariz. *General Contractors* Shrader & Martinez Construction, Inc., Sedona, Ariz.; NP Engineering and NP Mechanical, Inc., Phoenix (engineer) *Flooring* Architectural Systems, Inc., New York *Carpet* Masland Contract, Saraland, Ala. *Ceramic tile* Tri-State Distributors, Cincinnati *Lighting* Capitol Light, Hartford, Conn. *Fixtures* Creative Cabinets, Arcanum, Ohio *Paint Finishes* Benjamin Moore, Montvale, N.J. Sherwin Williams, Cleveland *Special Finishes* 3-Form, Salt Lake City *Storefront Sign* Hanover Signs, Columbus, Ohio *Light Box* Corporate Signs, Cave Creek, Ariz. *Photography* Mark Steele, Columbus, Ohio

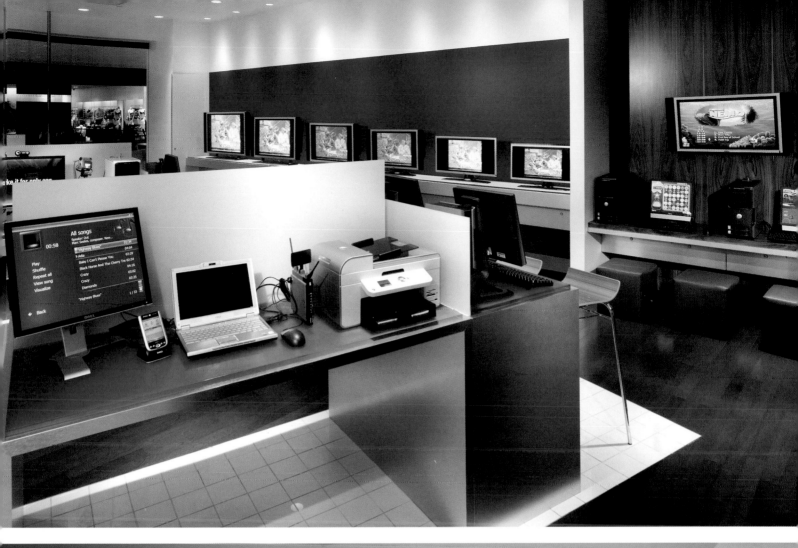

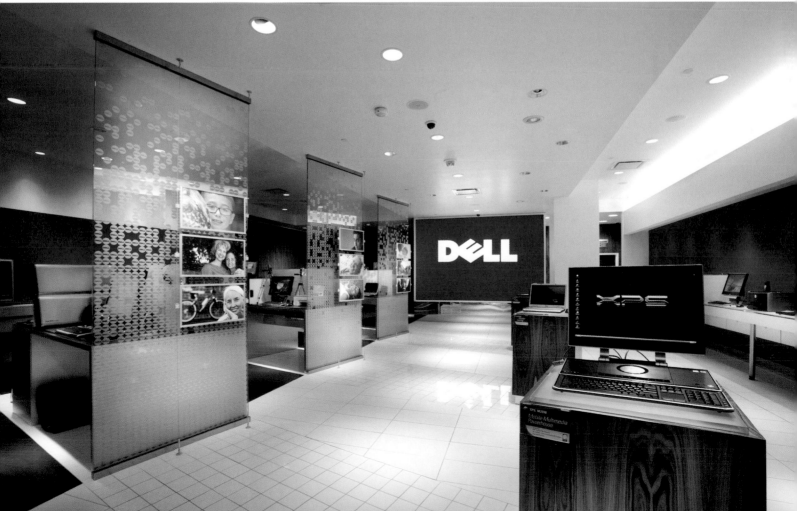

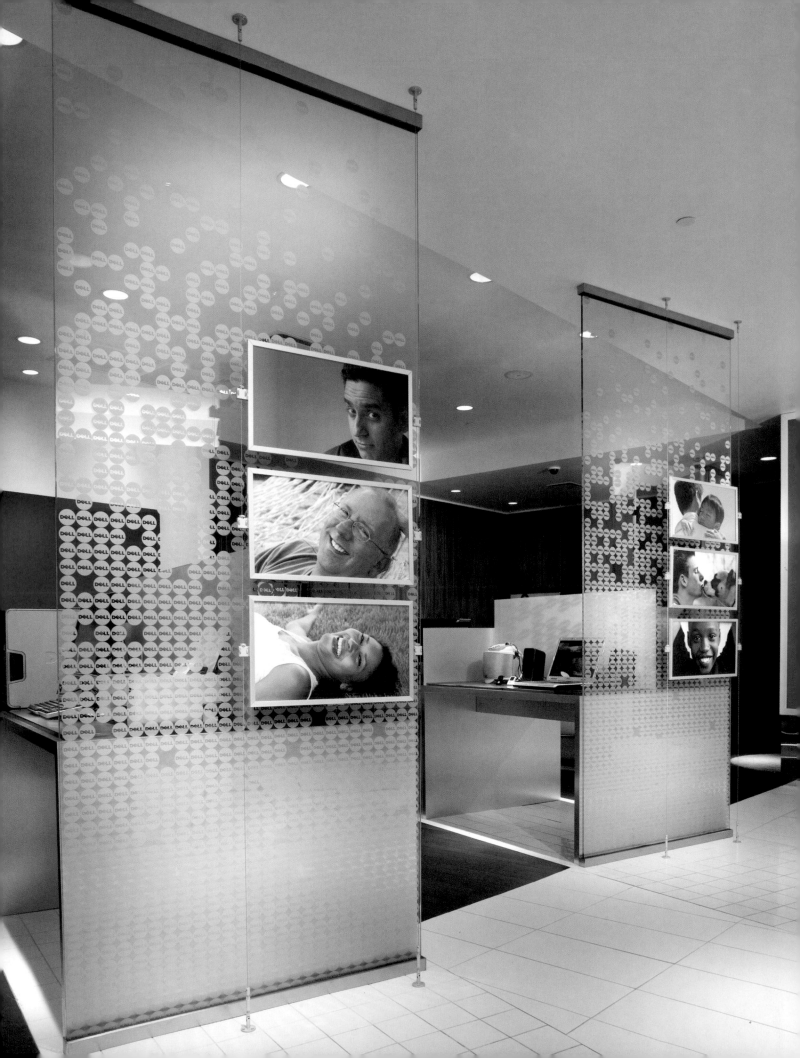

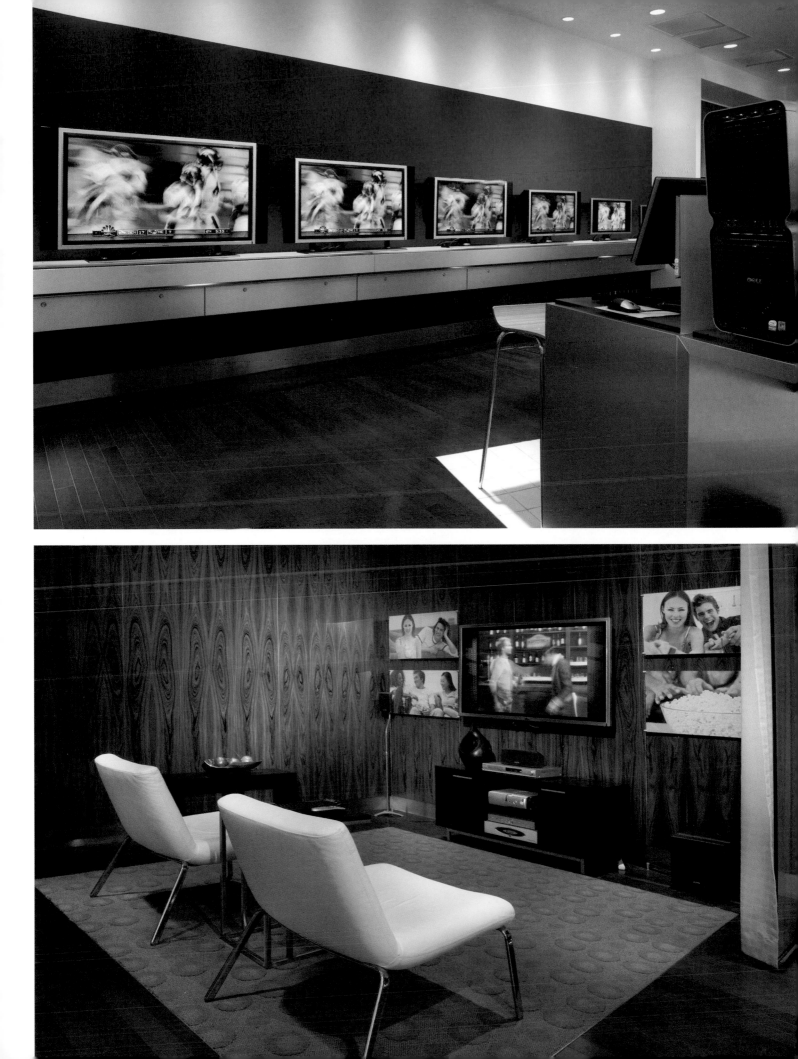

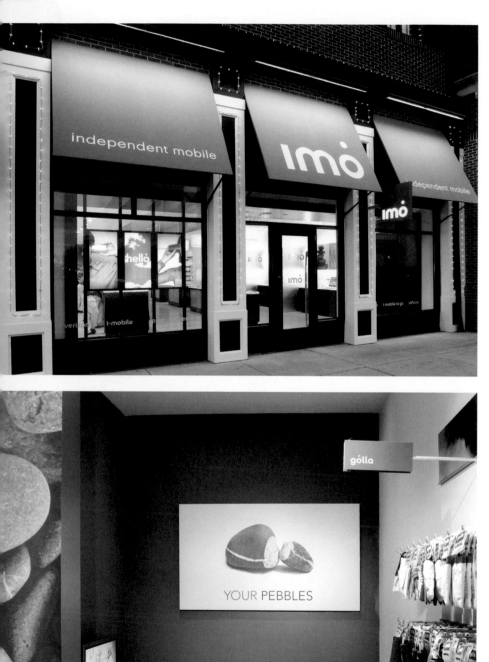

The cellular phone market is crowded with carriers, plans, an array of phones and accessories and so much evolving technology (Read: iPhone) that you could be out of date before you can say, "Can you hear me now?"

At Independent Mobile (IMO for short) in Columbus, Ohio, Bergmeyer Associates Inc. (Boston) created an environment that is both savvy and simple and conveys a high-tech message with a Zen-like twist.

Customers receive the ultimate in individual attention at IMO. So upon entering the space via a black-accented storefront with bright blue awnings (the retailer's signature color), customers are greeted by technologically themed "Explore" stations off to the right, hands-on "Engage" tables in the center and a "Select" bar for custom fitting on the left. These stations represent how every customer has different needs.

Each section has distinct fixtures. For instance, flanked by frosted glass partitions, the Explore stations display technological themes on cabinets and have a band of edge-glowing graphics above. The Select bar features long millwork cabinets with groupings of computer monitors for customer assistance.

A deep azure sky with clouds highlights the left wall, while graphics of pebbles and grass color the back and opposite wall for that Zen-like feel. Light-toned bamboo flooring warms the space.

Client IMO, Waltham, Mass. – Mort Rosenthall, ceo; John Weldon, vp retail operations *Design* Bergmeyer Associates Inc., Boston – Joseph Nevin, principal in charge; Matt Hyatt, supervisor and lead designer; Derek Rubinoff, project manager; Amy Rogovich, interior designer; Bill Ress, retail strategist *General Contractor* Englewood Construction, Schiller Park, Ill. *Outside Design Consultants* Tank Design, New York (graphic design); Collaborative Lighting, Concord, Mass. (lighting design) *Fixtures* Monarch Industries, Warren, R.I. *Flooring* Bamboo Advantage, Boston *Lighting* Specialty Store Lighting, Centerbrook, Conn. *Graphics* Applied Image, Farmingdale, N.J. *Awnings* Durasol, Middlebury, Vt. *Blade Sign* Colite, West Columbia, S.C. *Furniture* Sandler Seating, Baltimore *Photography* Mark Steele, Mark Steele Photography, Columbus, Ohio

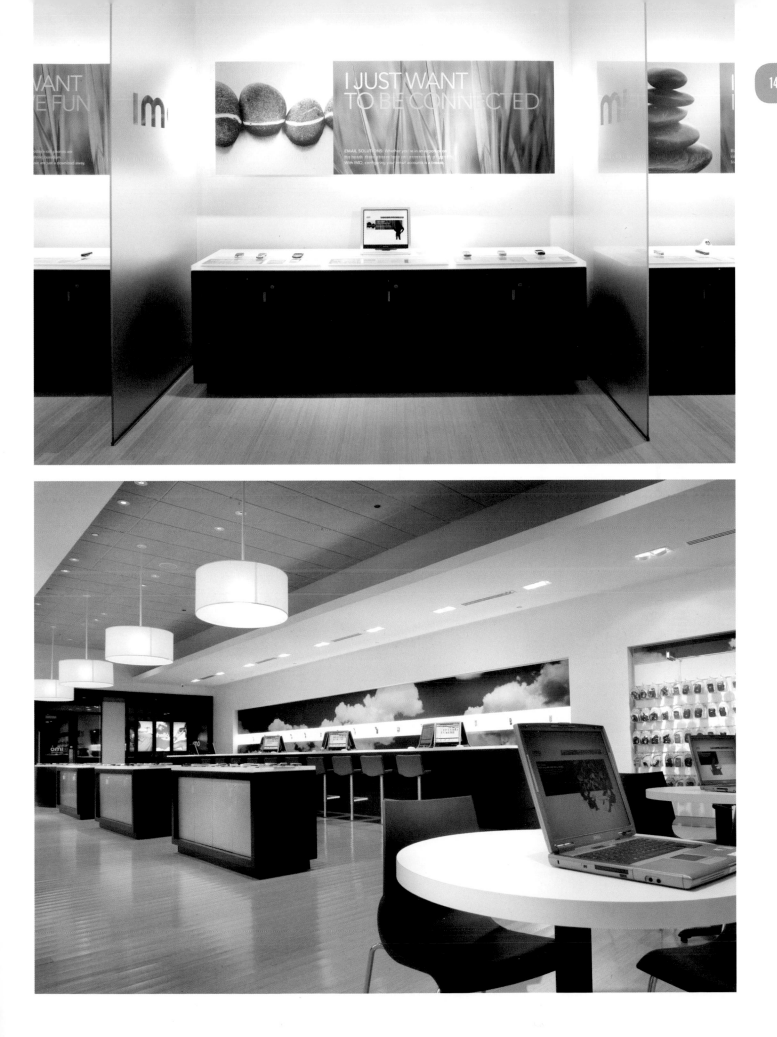

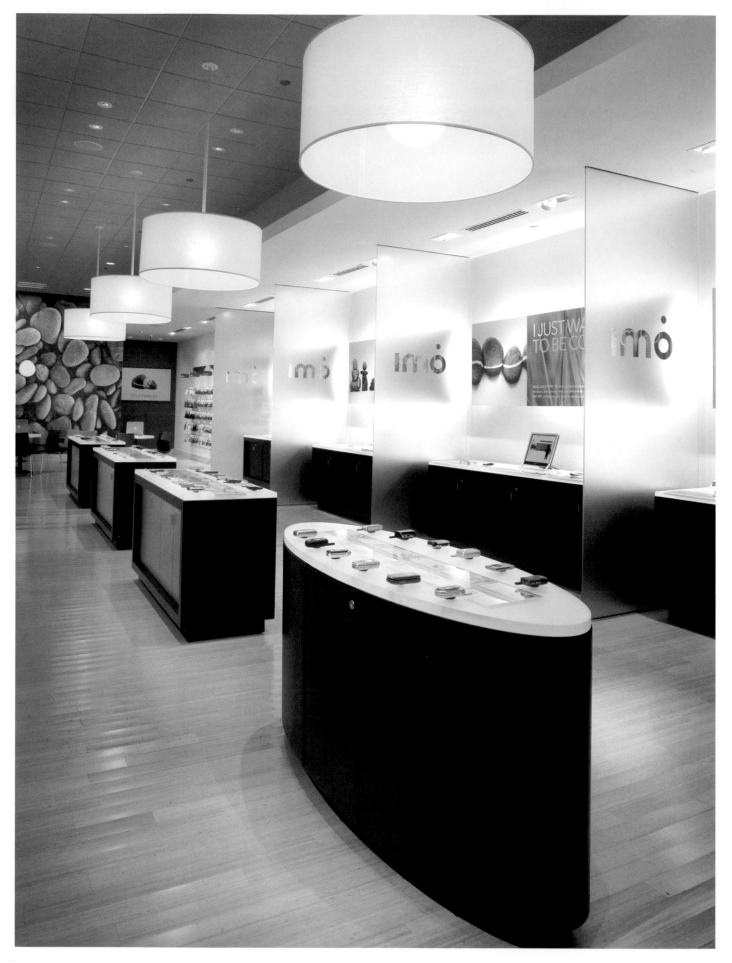

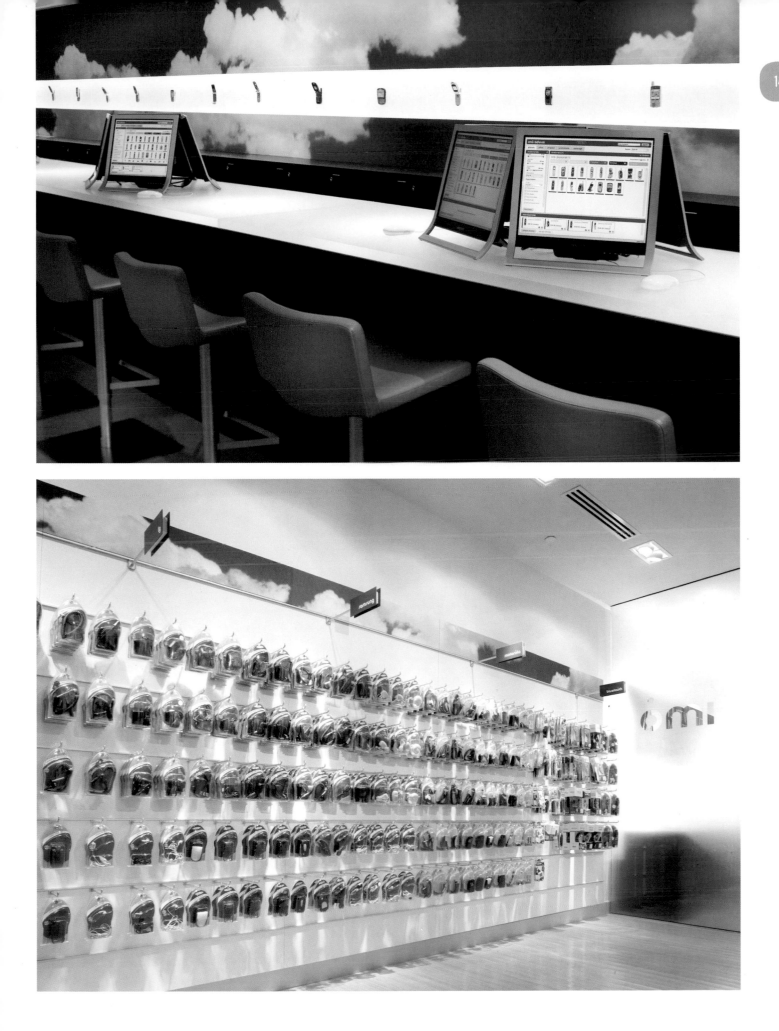

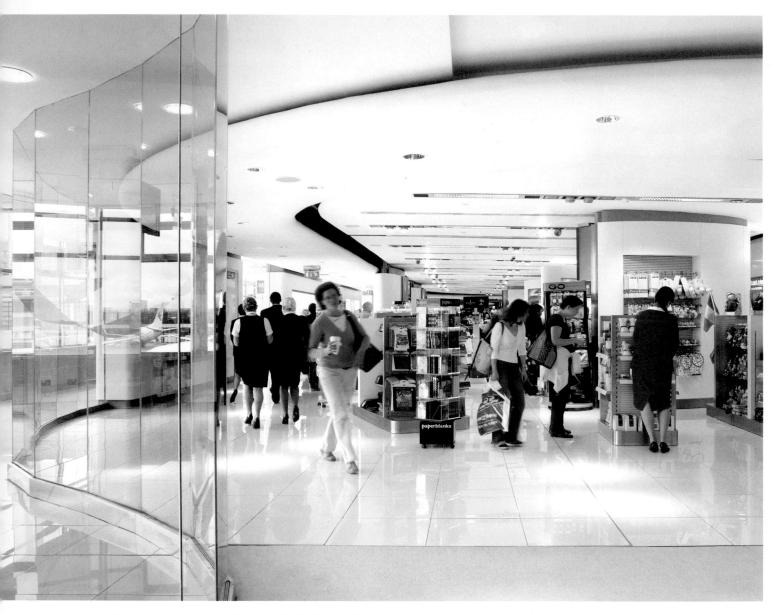

The 4000-square-foot retail space in Dublin Airport's Pier B received a fresh look to keep up with the hub's increasing foot traffic. Douglas Wallace Architects and Designers (Dublin, Ireland) was selected to transform the space into a more visible and enticing retail experience.

Opening the layout allowed a greater number of visitors to view the shop – this was necessary to provide a clearer and more accessible entrance to into Pier B from the airport's primary retail area. And the entire space was integrated through consistent white flooring and ceiling finishes.

To tie the shop's concept together, designers introduced a curved wall that emerges from the floor, slopes upward onto the ceiling and snakes toward the perimeter wall, where it eventually recedes back into the floor. Curvatures are found elsewhere in the shop via metal or white-lacquered fixtures or columns.

A muted color palette with hints of orange evokes a modern and clean retail environment. The neutral tones are reminiscent of airplanes and their interiors.

Client Dublin Airport Authority, Dublin *Design* Douglas Wallace Architects and Designers, Dublin – Adrian Lambe, Caoimhe McKenna *Contractor* Bowen Construction, Cork, Ireland *Lighting* In2 Design, Dublin *Visual Merchandising* Aer Rianta Retail, Dublin *Flooring* PEK Flooring, Dublin *Photography* Gary O'Leary, London

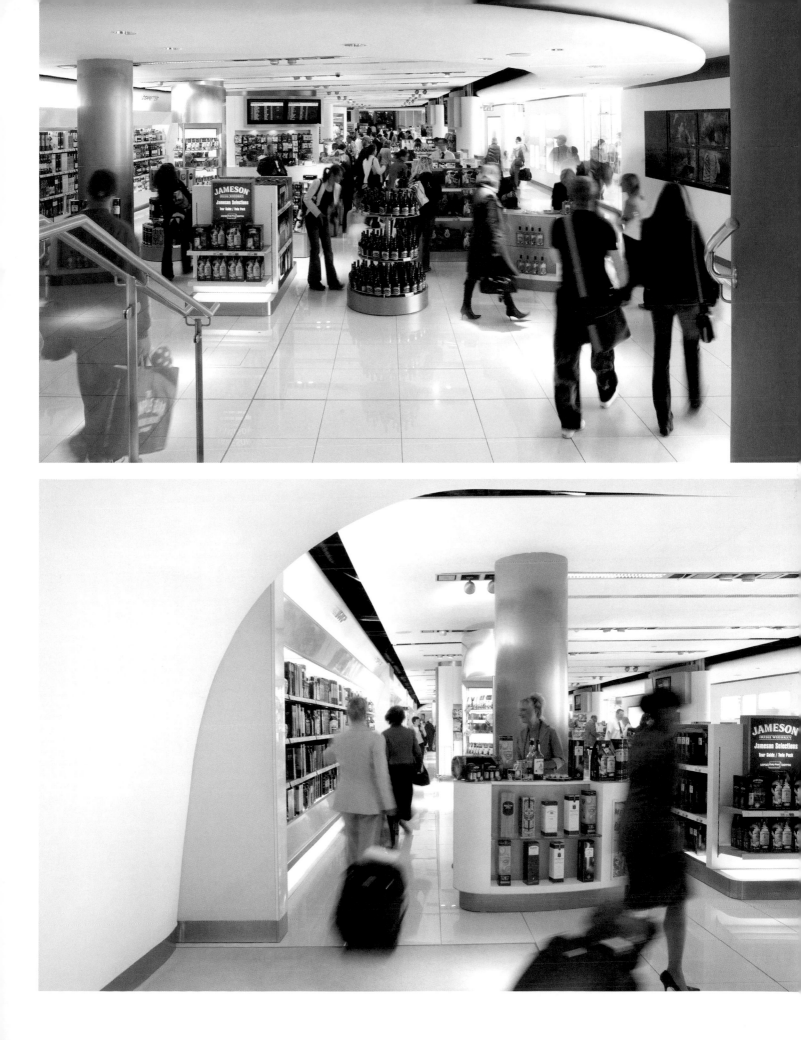

The New York Times Bookstore, Lexington, Ky.

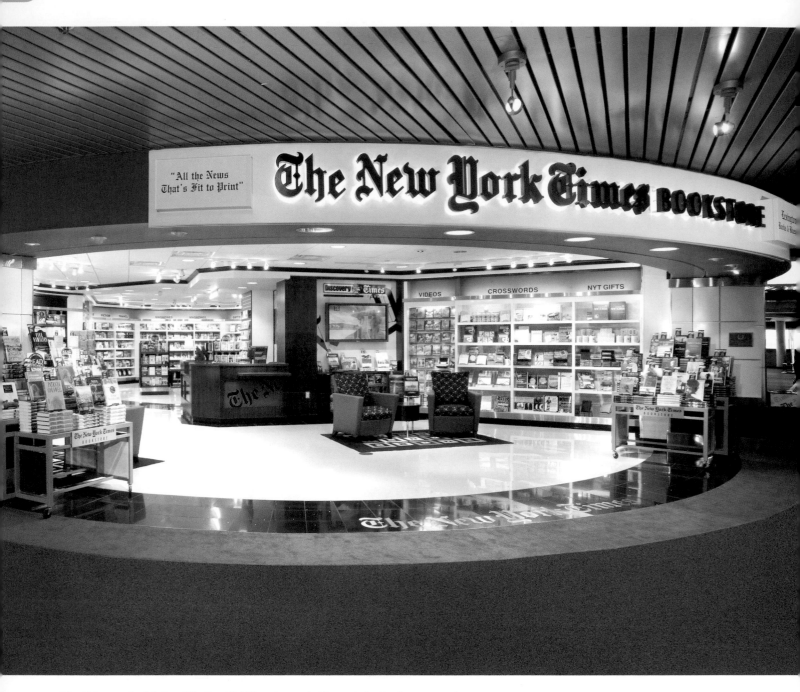

The history and celebrity of *The New York Times* is a central theme in the iconic newspaper's Lexington, Ky., airport bookstore. Designed by Raymond Design Atlanta (Tucker, Ga.), the newspaper's masthead is prominently displayed at the storefront and throughout the store, while historical news reels and documentaries air on plasma screens. There's even a wall devoted to *The Times'* bestseller list, one of the reigning authorities on top-selling books in the U.S.

Paperbacks and hardbacks are presented on perimeter fixtures. As for the few silver floor fixtures, they're spaced far from each other to allow more room for customers to browse. Contemporary blue chairs positioned in front of televisions give tired travelers some time to read and rest.

Durable materials, such as polished granite, limestone and quartz marble, were used on floors to support the constant foot and luggage traffic.

Client The Paradies Shops, Tucker, Ga. – Lynn Bennett, vp marketing; Dick Brunning, director of creative design; Hal Shoemaker, director of store planning; Jim Milligan, project manager *Design* Raymond Design Atlanta, Tucker, Ga. – Charles Raymond, principal; Steven Brunner, creative director/team leader; Karyn Martini, designer *Architect* Summer Wise Architects, Atlanta *General Contractor* St. Clair Construction, Louisville, Ky. *Lighting* E. Sam Jones, Smyrna, Ga. *Flooring* Store Floors, Atlanta *Audio/Visual* MPO Videotronics, Newbury Park, Calif. *Signage* Atlas Signs, West Palm Beach, Fla. *Millwork* Sawitz Store Fixture Group, Carlstadt, N.J. *Photography* Paul Dingham, Atlanta

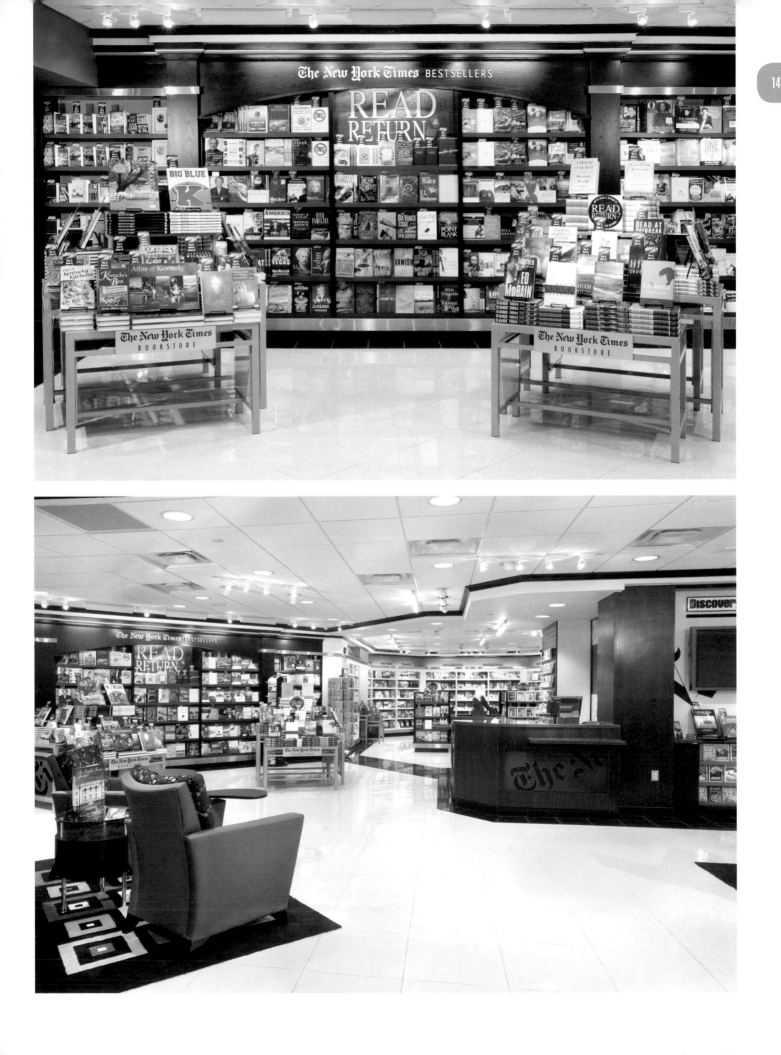

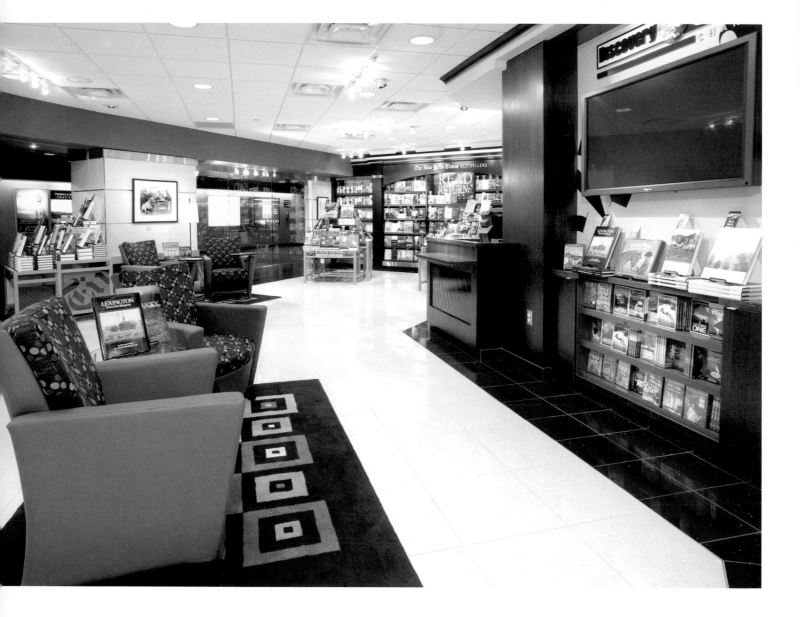

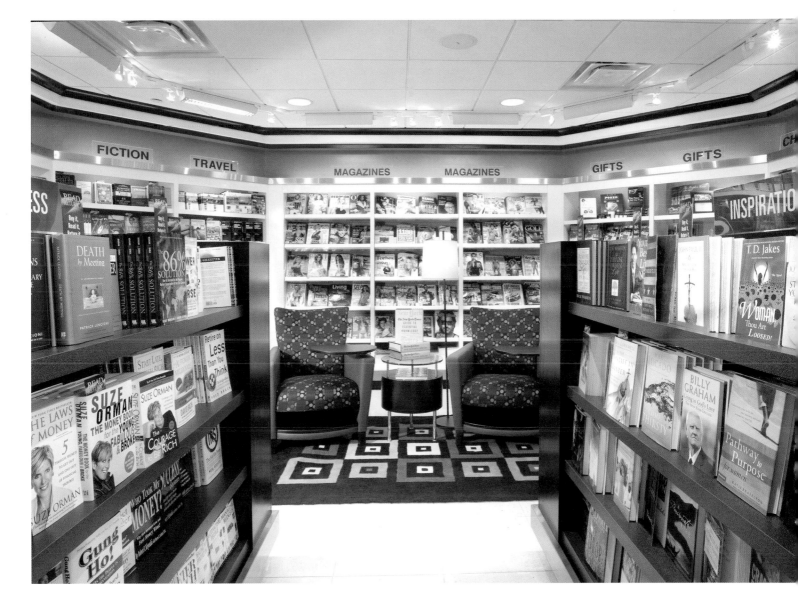

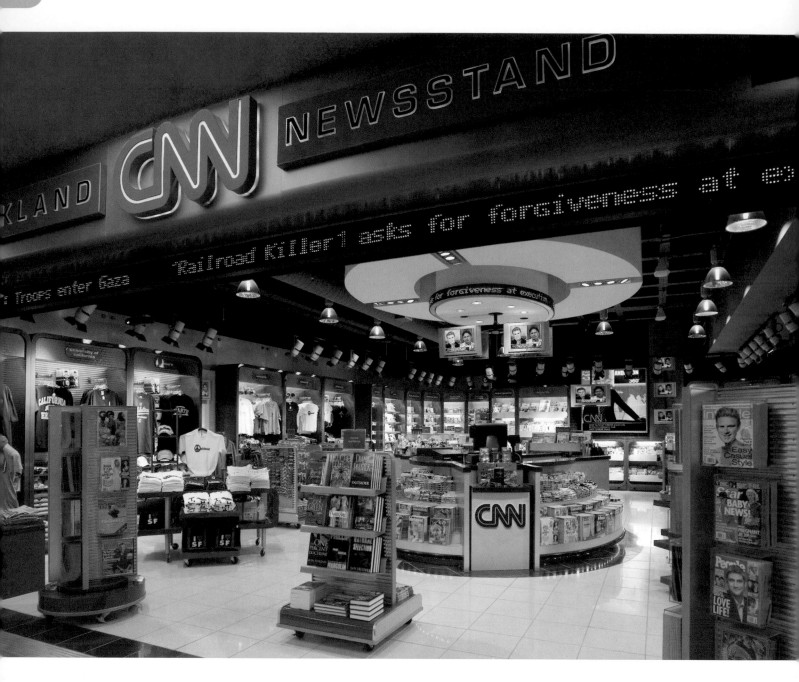

CNN's curved, abbreviated logo and signature red color were the inspiration for its Newsstand store in Oakland's airport. Created by FRCH Design Worldwide (Cincinnati), the retail space features splashes of red and curving shapes at the entrance, in its fixturing and cashwrap.

Lining the entrance is a curved news ticker with a scrolling marquee of news updates in red illuminated lettering. Red fixtures form smooth, curving lines on perimeter walls and throughout the interior, while a center cashwrap acts as a circular news hub with a smaller news marquee.

Televisions (of course) appear in storefront windows, on columns in the rear of the store and above the cashwrap.

Client Delaware North Companies, Buffalo, N.Y. – Laura Alphran, director of business development *Design* FRCH Design Worldwide, Cincinnati – Paul Lechleiter, principal in charge; Steve McGowan, vp creative director; Terri Altenau, director of interior design; Tobias Harris, graphic design director; Lori Kolthoff, resource design director; Katie Stepleton, interior designer; Marty McCauley, interior designer; Brandon Page, sr. graphic designer; Les Bradford, master draftsman; Denise Sharma, project coordinator *Outside Design Consultant* KLH Engineers, Ft. Thomas, Ky. (lighting) *Flooring* Louisville Tile, Cincinnati *Paint Finishes* Matthews Paint Company, Petersburg, Tenn.; Benjamin Moore, Cleveland *Vision Screens* Econoco, Hazelton, Pa. *Photography* FRCH Design Worldwide, Cincinnati

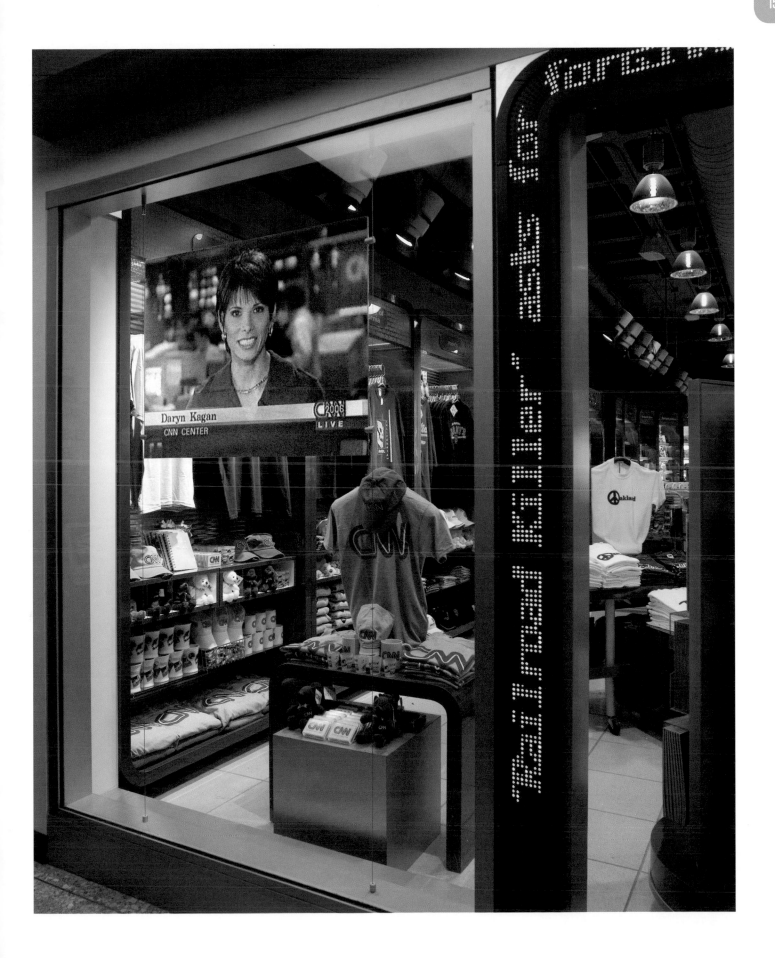

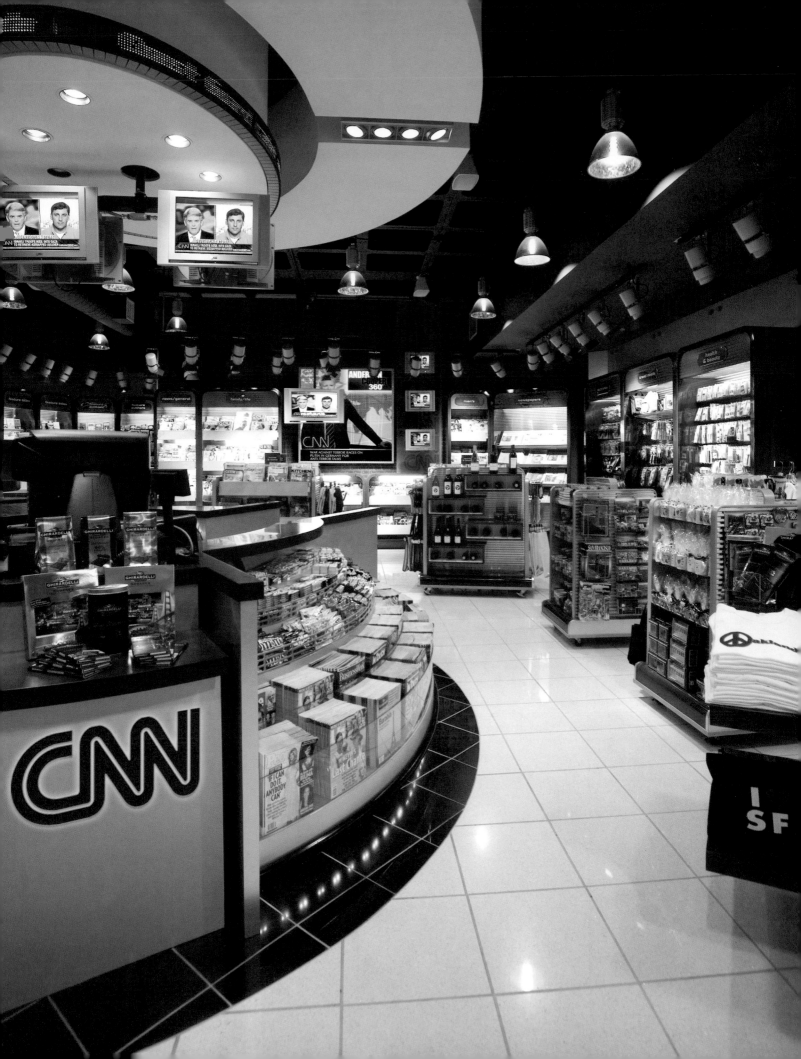

Helen Wang Soho Flagship, New York

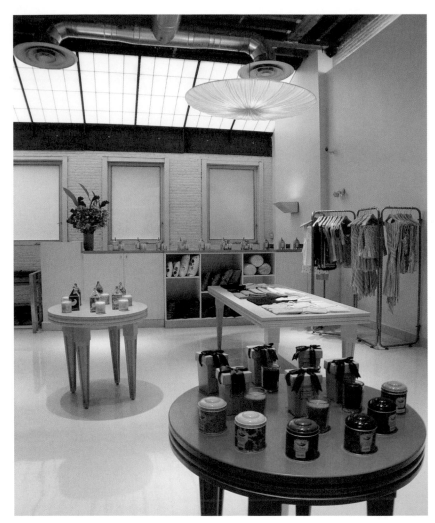

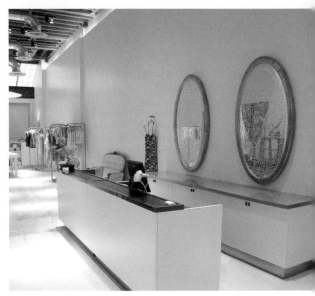

Visiting the Helen Wang boutique on Manhattan's Mercer Street is a lot like visiting the chic loft of a super stylish friend — one who likes to play with textures, mix and match furniture styles and isn't afraid of using bold colors.

Collaborating with Consolidated Design Studios Ltd. (New York), the specialty home and apparel retailer maintained the existing loft-like architectural features of the space. Its skylights were kept intact for natural lighting. To enhance the existing floor, designers poured a seamless powder blue resin material throughout the space.

High ceilings posed a lighting challenge, so the design team used low-hanging pendants to bring a better focus to the selling floor.

The custom fixture system takes on the shape of folding dressing screens — steel tubing frames in a pewter finish are hinged together for different configurations and allow Wang's wares to face outward.

In the back of the store, which is anchored by the home collection, punchy colored tables topped with orchids display merchandise. The bright, Asian-style tables in orange, blue and yellow provide a focal point and accent the muted background.

Client Helen Wang, New York *Design* Consolidated Design Studios Ltd., New York – Thomas Burns, partner; Masako Yamaguchi, project manager *Architect* Aston Associates, New York *General Contractor* La Croix Corp., New York *Suppliers* ABC Carpet & Home, New York; Advanced Epoxy Flooring, Bohemia, N.Y.; Amuneal Manufacturing Group, Philadelphia; Aqua Creations, New York; Architectural Grille, Brooklyn, N.Y.; Bergman Unlimited, Closter, N.J.; Clodan Carpets, New York; Goldsmith, Long Island City, N.Y.; International Custom W.T. Ltd., New York; Lighting by Gregory, New York; Metropolitan Cabinet Works, Fair Lawn, N.J.; Schoolhouse Electric, New York *Photography* Masako Yamaguchi, New York

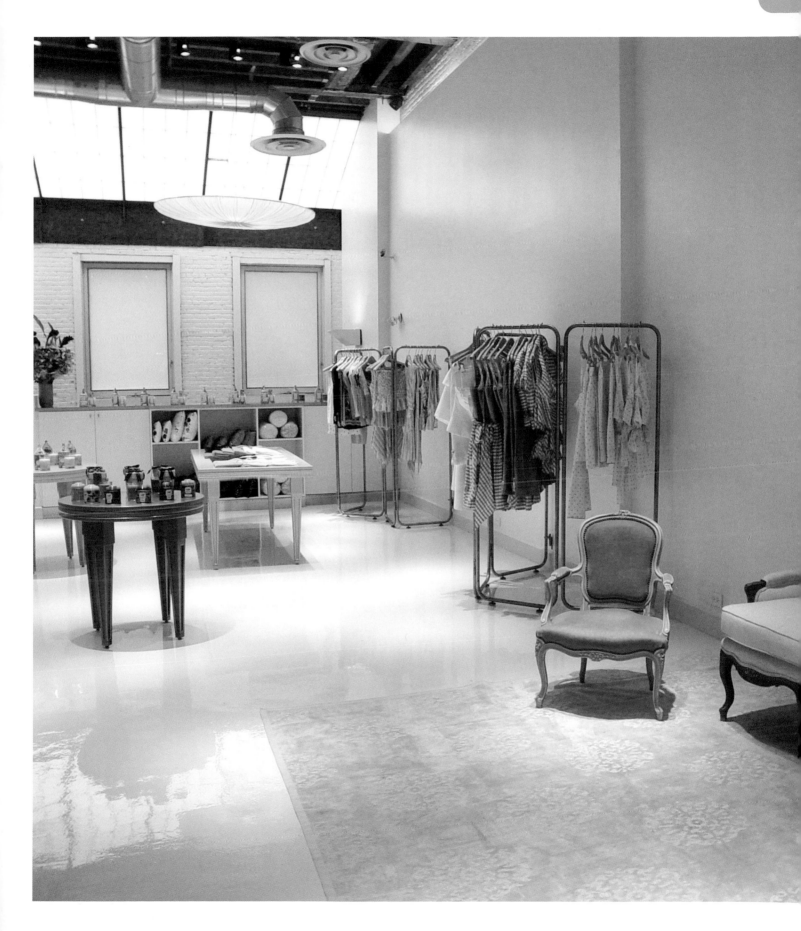

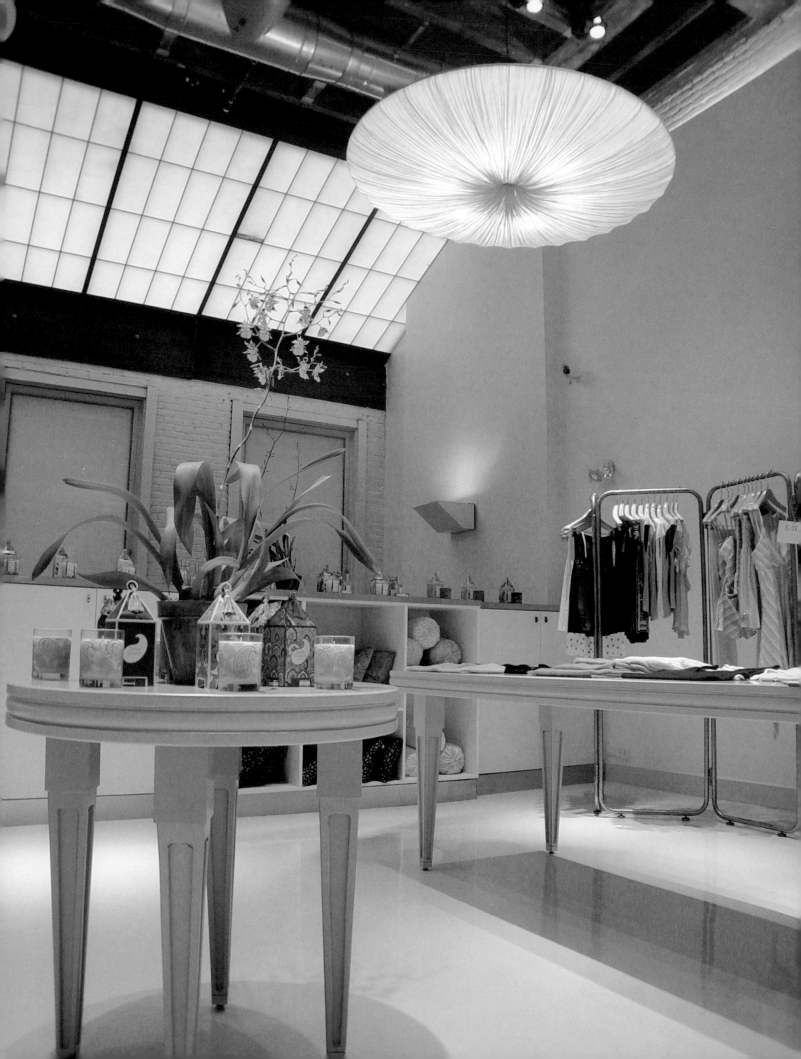

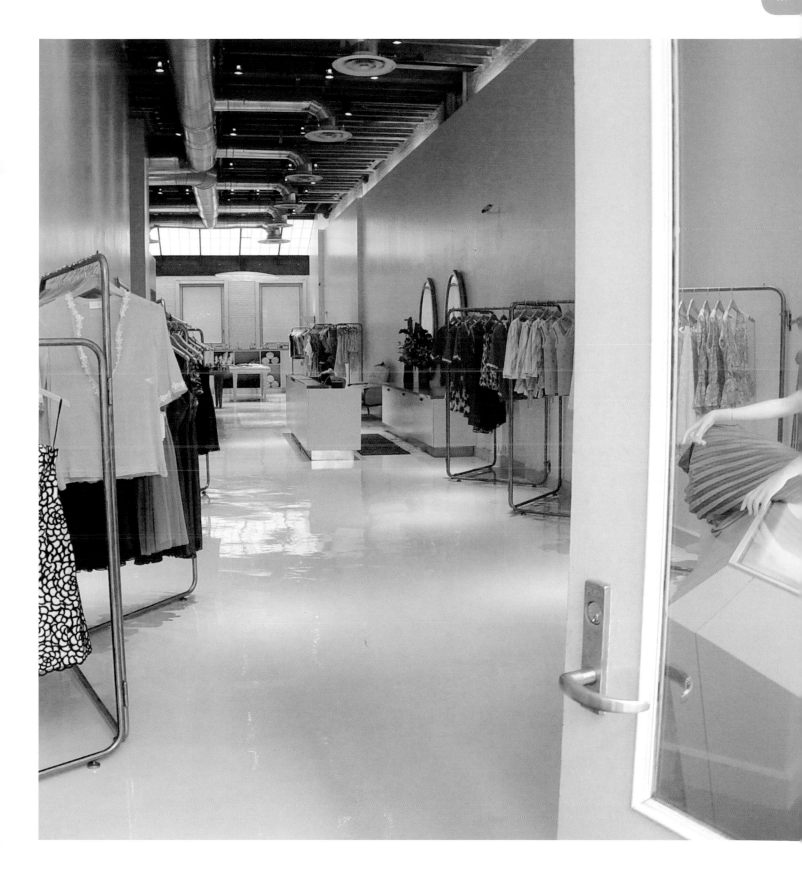

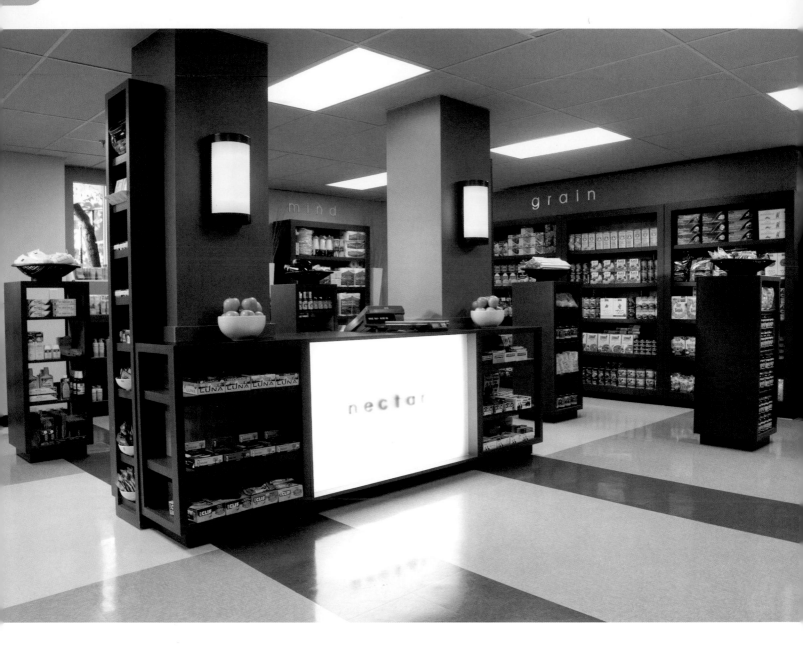

This small, 1200-square-foot space had previously been home to a convenience store on Vanderbilt University's campus. To accommodate the increasing student demand for health food and specialty groceries, college administrators teamed up with Gresham, Smith and Partners (Nashville, Tenn.), to transform the space into Nectar.

Based on a Japanese bento box concept, designers created a symmetrical, compartmentalized layout that allows an intuitive flow of traffic.

Vivid colors, such as avocado green, yellow, orange and deep chocolate, play into the Nectar name and hint at the natural goods within the store.

To define each "compartment," simple signage in brushed silver sits high on the walls. The one-word statements such as body, mind, grain and liquid provide a clean presentation.

Floating fixtures within the store were designed to be modular and interchangeable.

Designers incorporated two existing columns that were in the middle of the store as anchor points that flank the cashwrap. A glowing sign on the front of the counter consists of 3-D lettering between a back-lit white and frosted acrylic pane for a suspended look.

Client Vanderbilt University Dining Services, Nashville, Tenn. – Camp Howard, assistant director, CEC; Frank Gladu, assistant vice chancellor for business services *Design* Gresham, Smith and Partners, Nashville, Tenn. – Jim Harding, principal-in-charge; Phillip Petty, designer; Patrick Gilbert, project architect *General Contractor* R.C. Matthews Contractors, Nashville, Tenn. *Custom Millwork/Fixtures/Lighting* CDM, Nashville, Tenn. *Refrigerated Units* Dykes Restaurant Supply, Nashville, Tenn. *Photography* Monique Larroux, Nashville, Tenn.

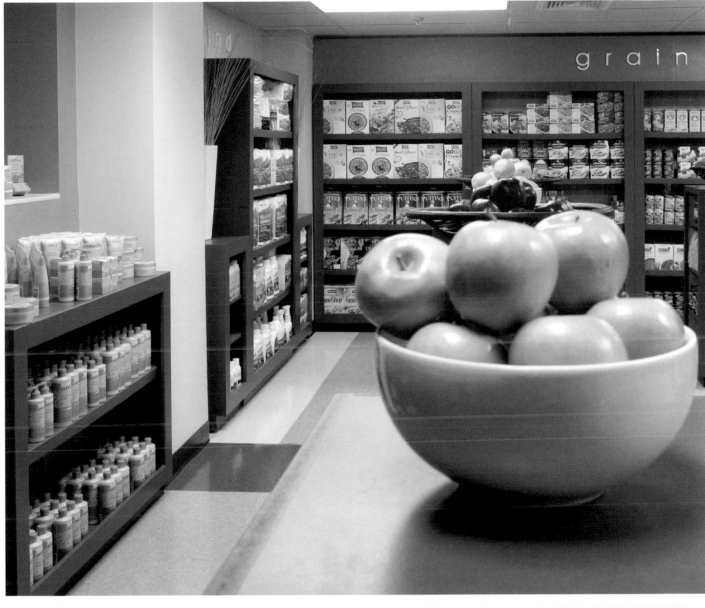

Simon Fraser University Bookstore, Vancouver, B.C.

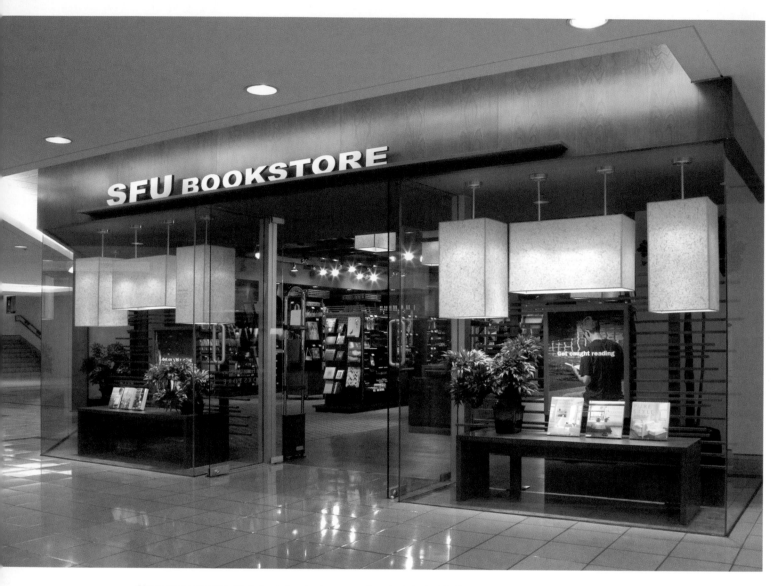

Simon Fraser University's bookstore harbors more than just student traffic. Its downtown location in the heart of Vancouver makes it a prime spot for browsing tourists. And so its merchandise mix includes more than just the typical textbook inventory.

To transform the space into a destination worthy of college students and Vancouver visitors, GHA shoppingscapes (Montreal) used a mixture of Japanese elements with subdued lighting and a monochromatic color palette.

The store's floorplan is segmented into different "living" areas, with the store's entrance acting as a corridor flowing into carpeted rooms on all sides.

The store's look is calming – soft lighting glows from Japanese-inspired grasscloth pendant shades, bamboo covers the central corridor floor and dark-stained wood fixtures and lattices warm the space.

Illuminated photos on backlit grasscloth panels provide a venue for campus-related images and act as beacons of light to attract visitors to less-traveled portions of the store.

Client Simon Fraser University, Vancouver – Mikhail Dzuba, bookstore manager *Design* GHA shoppingscapes, Montreal – Joni Vallon, senior designer; Oxana Boriak, designer *Architect* CEI Architecture, Vancouver *General Contractor* Harbour Centre Complex Ltd., Vancouver *Outside Design Consultant* Keen Engineering, Vancouver (mechanical/electrical) *Fixtures/Millwork* Pearlite Fixture Group Inc., Vancouver *Lighting* Futura, Montreal *Carpet* Lipman, Montreal; Tapitec, Montreal *Flooring* Kraus, Montreal *Wall Covering* Crown, Montreal; Metro, Montreal *Custom Lamps* Lampolite, Montreal *Photography* Roger Brooks Photography, Vancouver

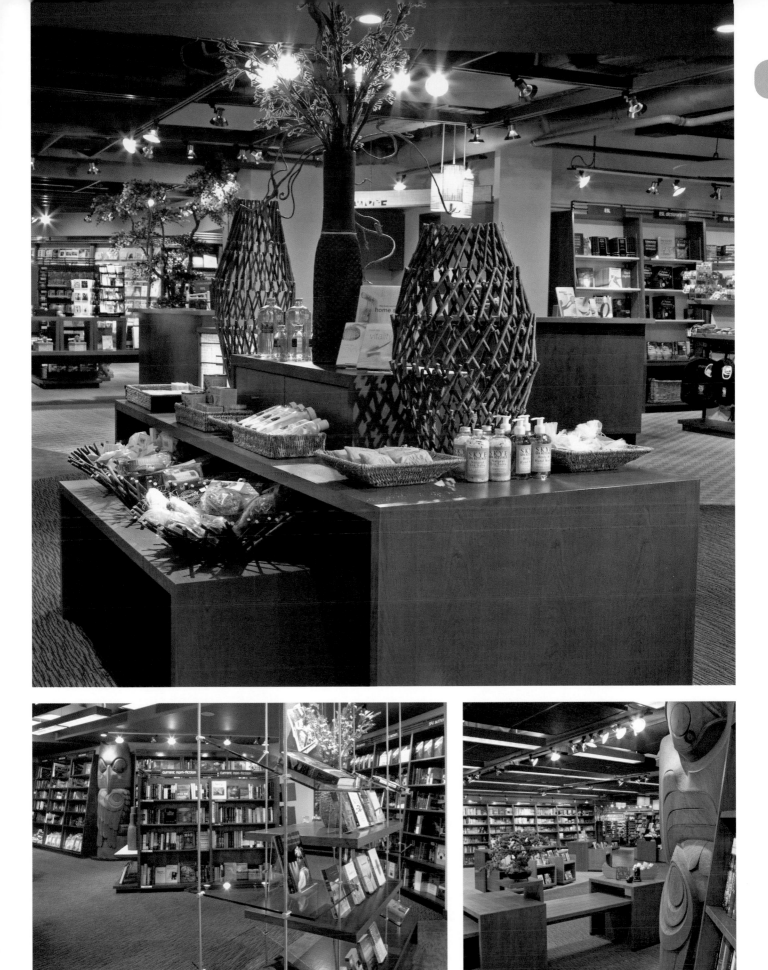

Index of Design Firms / Competition Entrants

For more information on visual merchandising and store design, subscribe to:

Books on visual merchandising and store design
available from ST Media Group International:

Aesthetics of Merchandising Presentation
Budget Guide to Retail Store Planning & Design
Complete Guide to Effective Jewelry Store Display
Feng Shui for Retailers
Retail Renovation
Retail Store Planning & Design Manual
Stores and Retail Spaces
Visual Merchandising
Visual Merchandising and Store Design Workbook

To subscribe, order books or request a complete catalog
of related books and magazines, please contact:

ST Media Group International Inc.
407 Gilbert Avenue | Cincinnati, Ohio 45202

p: 1.800.925.1110 or 513.421.2050
f: 513.421.5144 or 513.744.6999
e: books@stmediagroup.com
www.stmediagroup.com (ST Books)
www.vmsd.com (*VM+SD* Magazine)
www.irdconline.com (International Retail Design Conference)